BELLINI and GIORGIONE

in the House of Taddeo Contarini

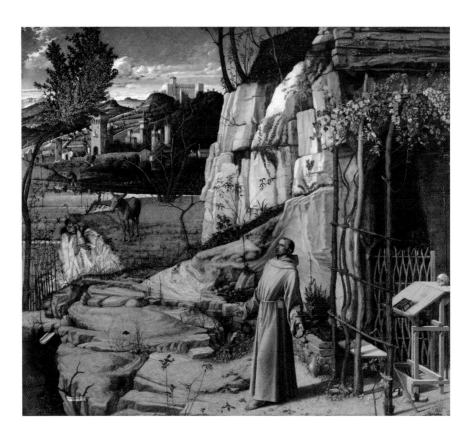

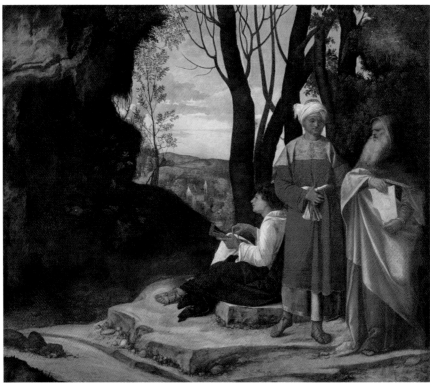

BELLINI and GIORGIONE

in the House of Taddeo Contarini

Xavier F. Salomon

The Frick Collection, New York
in association with D Giles Limited

g

This catalogue is published on the occasion of *Bellini and Giorgione in the House of Taddeo Contarini*, an exhibition on view at Frick Madison (the temporary home of The Frick Collection), from November 9, 2023, to February 4, 2024.

The exhibition is generously funded by David and Julie Tobey, Kathleen Feldstein, the Robert Lehman Foundation, the Estate of Seymour R. Askin Jr., the Gladys Krieble Delmas Foundation, Gini and Randall Barbato, Jerald D. Fessenden, the Malcolm Hewitt Wiener Foundation, Gabelli Funds, Hubert and Mireille Goldschmidt, Constantine P. Sidamon-Eristoff, Mercy Cohen, and an anonymous donor.

First published in 2023 by The Frick Collection
1 East 70th Street
New York, NY 10021
www.frick.org

Michaelyn Mitchell, Editor in Chief

In association with GILES
An imprint of D Giles Limited
66 High Street
Lewes, BN7 1XG, UK
gilesltd.com

Designed by Caroline and Roger Hillier, The Old Chapel Graphic Design
Copyedited and proofread by Sarah Kane
Produced by GILES
Printed and bound in Europe

Front cover and pages 6–7, 13: Giorgio da Castelfranco, known as Giorgione, *The Three Philosophers*, ca. 1508–9 (fig. 3, details)
Back cover and page 12: Giovanni Bellini, *St. Francis in the Desert*, ca. 1475–80 (fig. 4, details)
Frontispiece: *top*, Giovanni Bellini, *St. Francis in the Desert*, ca. 1475–80 (fig. 4);
bottom, Giorgio da Castelfranco, known as Giorgione, *The Three Philosophers*, ca. 1508–9 (fig. 3)

A CIP catalogue record for this book is available from the Library of Congress.

ISBN: 978-1-913875-44-2

MIX
Paper | Supporting
responsible forestry
FSC® C118234

For

JENNIFER FLETCHER

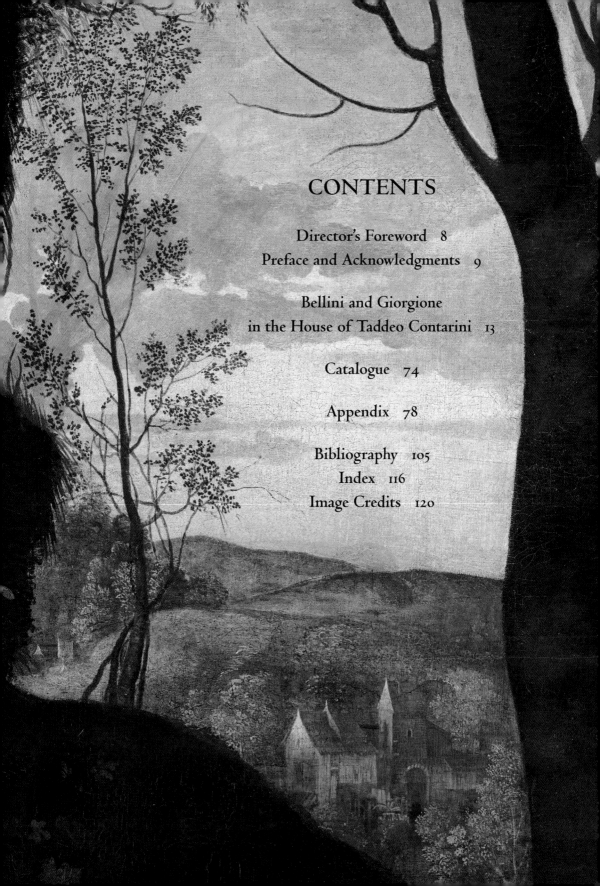

CONTENTS

Director's Foreword 8
Preface and Acknowledgments 9

Bellini and Giorgione
in the House of Taddeo Contarini 13

Catalogue 74

Appendix 78

Bibliography 105
Index 116
Image Credits 120

Director's Foreword

The Frick's *St. Francis in the Desert* is Bellini's most famous work and arguably one of the greatest Renaissance paintings in the United States. Giorgione's enigmatic *Three Philosophers*—one of only about ten paintings attributed to him—is among the most celebrated pictures at the Kunsthistorisches Museum in Vienna. The remarkable circumstance of these two masterpieces having once hung in the same Venetian palazzo, that of Taddeo Contarini, more than four hundred years ago is the tale that Xavier F. Salomon, the Frick's Deputy Director and Peter Jay Sharp Chief Curator, so expertly weaves in this publication. As Xavier movingly describes in his preface, he also has personal history with the paintings, his early encounters with them and subsequent strong ties to both pictures having been foundational to his career as a curator.

These two complex paintings have prompted an enormous amount of theorizing over the years, much of it speculative and much of it disputed. Thanks are due to Xavier for so skillfully untangling in his essay what can be known from what continues to elude. Our deepest gratitude also goes to the Kunsthistorisches Museum, whose generous loan makes it possible to reunite the paintings for the exhibition this catalogue accompanies. I particularly thank my old friend Sabine Haag, Director General of the Kunsthistorisches Museum, for participating in this project, one of several initiatives we have shared over the years. This is the final exhibition to be mounted at Frick Madison; it would be hard to think of a more fitting conclusion to this fascinating chapter in the Frick's history.

Thanks are owed to Editor in Chief Michaelyn Mitchell, who expertly oversaw the production of the publication and, with former Associate Editor Christopher Snow Hopkins, edited the texts. We would also like to acknowledge our publishing partner D Giles Limited.

Finally, our gratitude goes to David and Julie Tobey, Kathleen Feldstein, the Robert Lehman Foundation, the Estate of Seymour R. Askin Jr., the Gladys Krieble Delmas Foundation, Gini and Randall Barbato, Jerald D. Fessenden, the Malcolm Hewitt Wiener Foundation, Gabelli Funds, Hubert and Mireille Goldschmidt, Constantine P. Sidamon-Eristoff, Mercy Cohen, and an anonymous donor for their generous support of the exhibition.

Ian Wardropper
Anna-Maria and Stephen Kellen Director
The Frick Collection

Preface and Acknowledgments

As an undergraduate student at the Courtauld Institute of Art in London, from 1997 to 2000, my favorite courses were those taught by the formidable Jennifer Fletcher. I was very disappointed not to be able to continue to study with her for my postgraduate degree because of her retirement. Jennifer's teachings, however, together with marvelous and illuminating visits with her classes to museums in London and in Europe—Venice and Vienna, in particular—have remained with me ever since. I will never forget the early thrill of seeing Titian's portrait of Benedetto Varchi in the restoration studio at the Kunsthistorisches Museum or the coffee that turned into lunch in a pavilion at Schönbrunn Palace. Jennifer's studies on Venetian art—in particular, on Giovanni Bellini and Marcantonio Michiel—were pioneering, and for those who took her classes, it was a formative and extraordinary experience. At the time, I would never have guessed that I would one day become the chief curator of the institution that owns one of Bellini's masterpieces: the *St. Francis in the Desert.* That I have done so is in large part due to Jennifer and her teaching.

Many scholars have followed in the footsteps of Jennifer Fletcher and her scholarship on the Venetian Renaissance, most recently Susannah Rutherglen and Charlotte Hale in their monographic study *In a New Light: Giovanni Bellini's "St. Francis in the Desert"* (2015). When I arrived at the Frick, in 2014, this book was in production. To this day, it provides the most up-to-date and comprehensive analysis of the painting. What else can be said about this incredible masterpiece? My encounters with the Bellini have always been an intriguing mixture of wonder, poetry, and the feeling of getting closer to some ultimate truth. I suppose that having studied as a child under the tutelage of Franciscan nuns helped make Francis of Assisi (with or without stigmata) a fundamental point of cultural reference for me.

When the possibility of the Frick's collaboration with the Kunsthistorisches Museum in Vienna developed, I could scarcely believe that the painting I first saw and fell in love with as a student (in Vienna, with Jennifer) could one day be seen with Bellini's extraordinary hymn to man and nature, which I have known all my art-historical life—reuniting two paintings last together in Venice, in the collection of the heirs of Taddeo Contarini, centuries ago. Thanks to Sabine Haag, Director General of the Kunsthistorisches Museum; Peter Kerber, Director of the Gemäldegalerie; and Francesca del Torre, Curator of Collections, Giorgione's *Three Philosophers* will travel to the United States for only the second

time (in 2006, it traveled to Washington, DC) and to New York for the first time. I cannot thank them enough for making this momentous loan possible. All those lucky enough to see these two paintings together are hugely indebted to them for the experience. I would also like to thank Sylvia Ferino-Pagden, who welcomed my student group to the Kunsthistorisches Museum in Vienna twenty-five years ago. A chance encounter with her on my last visit to Vienna—together with Francesca—developed into a wonderful conversation about Giorgione and the meaning of *The Three Philosophers*.

When this book was conceived, I knew I would have to face more than a century of literature on Bellini and Giorgione. I expected it to be a daunting task but was not prepared for how disheartening it was. That so much has been written about specific masterpieces of Italian Renaissance painting—of course, Leonardo's *Mona Lisa*, Botticelli's *Primavera*, and Giorgione's *Tempest* are at the top of this list with little else near them—does not necessarily mean that it is all worth reading. I cannot help but imagine Bellini and Giorgione sniggering at so many pitiable attempts to interpret their works. Separating the serious and worthy material from the debris has been arduous, yet much of the scholarship has advanced our knowledge in meaningful ways. There are many heroes and heroines in the world of Bellini and Giorgione studies, and to them I am hugely thankful.

As I spent the past year in the company of Taddeo Contarini, I realized more and more that everything we thought we knew about him had to be reconsidered, that every piece of so-called established fact had to be reexamined. This book attempts to set the record straight about what we know—and, more important, what we do not know—about Taddeo Contarini, Bellini's *St. Francis*, and Giorgione's *Three Philosophers*, to pare away hypothesis and conjecture. I hope this book is of use to the future generations that return to this topic and, hopefully, increase our knowledge on the subjects.

A number of people deserve my thanks. At the Frick, I want to acknowledge Ian Wardropper (Anna-Maria and Stephen Kellen Director) and Betty Eveillard (Chair of the Board of Trustees), as well as the entire Board of Trustees, for their support of books like this and the exhibitions they accompany. Michaelyn Mitchell, with the assistance of Christopher Snow Hopkins, has exquisitely edited this volume and coordinated its production. I would also like to thank, in particular, Rebecca Leonard for her assistance with research and images. My gratitude also goes to Anna Baccaglini, Tia Chapman, Giulio Dalvit, Taylor Elyea, Allison Galea, Joe Godla, Anita Jorgensen, Bailey Keiger, Patrick King, Regan Martin, Gemma McElroy, Cheryl Miller Mullally, Aimee Ng, Jenna Nugent,

Michael Paccione, Christopher Roberson, Stephen Saitas, and Alexis Sandler. Thanks also go to Adrian Kitzinger for drawing the two maps in this publication. In Venice, Claudia and Mara Vittori and Nicola Tonutti were always generous in helping me at every step. Attempting to identify Taddeo Contarini's palazzo was a long and complicated Venetian adventure. I would like to thank those who made it possible for me to visit both the wrong and right houses where Taddeo Contarini lived (or was said to have lived): Guido Beltramini, Antonio and Barbara Foscari, Ferigo Foscari, Silvia Mastrandrea, and Claudia Miotti. The evening spent in Taddeo Contarini's *portego* just before Christmas 2022—and around the house, exploring every corner of it—together with Alessandro Bogliolo, Elena Bordigoni, and Gianmario Guidarelli was an exceptional experience. I felt the spirit of Taddeo with us that evening and could imagine Bellini's and Giorgione's paintings in the spaces we were visiting. Thank you also to Melissa Conn, Davide Gasparotto, Gabriele Matino, and Mario Rosso.

And thank you, as always, to M, for everything, and more.

Xavier F. Salomon
Deputy Director and Peter Jay Sharp Chief Curator
The Frick Collection
February 2023

BELLINI and GIORGIONE

in the House of Taddeo Contarini

1525 – Marcantonio Michiel's Notes

Around 1521, the Venetian art collector Marcantonio Michiel (1484–1552) began to compile a list of the works of art in churches and houses in Venice, as well as in the northern Italian cities of Bergamo, Crema, Cremona, Milan, Padua, and Pavia.[1] When he visited the noble Marcello, Foscarini, Venier, Grimani, and Vendramin families (among others), as well as prominent art collectors such as Andrea Odoni (1488–1545), Antonio Pasqualino, and Giovanni Ram, Michiel recorded the works of art they owned in his notebook. We do not know if he meant for these notes—which he continued to compile until about 1543—to be the basis of a printed book or if they were merely for personal reference. Neither do we know if his hosts knew what he was doing, perhaps guiding him through their homes for this purpose, or if Michiel simply took advantage of social occasions, independently recording the art he observed. In any event, the notes were eventually published—first in 1800—and they are preserved in the Biblioteca Nazionale Marciana in Venice, where they have become an important source of information on Venetian Renaissance art.[2] The manuscript is titled "Pittorj e Pitture in diversi luoghi" (Painters and Paintings in Different Places) but has become known in its printed versions as the *Notizia d'opere di disegno* (Information on Works of Design).

At some point during the year 1525, Michiel visited the home of the prominent aristocrat Taddeo Contarini (ca. 1466–1540). While there, he recorded two masterpieces of Venetian painting (figs. 1, 2) that are now among the most celebrated pictures at the Kunsthistorisches Museum in Vienna and The Frick Collection in New York, respectively. Michiel's list of the paintings "in the house of Messer Taddeo Contarini" begins with a description of Giorgione's *Three Philosophers* (fig. 3): "The canvas in oil of the three philosophers in the landscape, two standing and one seated who is contemplating the sun's rays, with that stone finished so marvelously, was begun by Giorgio from Castelfranco [Giorgione], and finished by Sebastiano Veneziano [Sebastiano del Piombo]."[3] His two pages of notes on the Contarini collection conclude with remarks on Bellini's *St. Francis in the Desert* (fig. 4): "The Panel of St. Francis in the desert, in oil, was the work of Zuan [Giovanni] Bellini, begun by him for Messer Zuan [Giovanni] Michiel, and it has a landscape nearby wonderfully finished and refined."[4]

These notes constitute the first documentation of the two paintings and provide significant information. First, Michiel coins the titles by which the paintings are known to this day: *The Three Philosophers* ("3 phylosophi") and *St.*

Francis in the Desert ("S. Francesco nel diserto"). He does not delve into the iconography of either work but simply describes them—the philosophers standing and seated "contemplating the sun's rays," St. Francis "in the desert"— paying particular attention to the landscape elements in both pictures. He focuses on "that stone finished so marvelously" ("quel saxo finto cusi mirabilmente") in the Giorgione and the "landscape nearby wonderfully finished and refined" ("un paese propinquo finito et ricercato mirabilmente") in the Bellini. He specifies the medium and support of each work ("canvas in oil" and "panel … in oil"), attributes the paintings to the two artists, and provides these additional comments: *The Three Philosophers* was "begun" ("fu cominciata") by Giorgione and "finished" ("finita") by Sebastiano del Piombo; the *St. Francis* was painted to begin with ("cominciata da lui") not for Contarini but for a man called Giovanni (Zuan in Venetian dialect) Michiel. Much of the information Michiel provides, as well as that which he does not provide, is the source of scholarly debate. We remain uncertain about authorship, patronage, dating, and the significance of both paintings, and countless texts have been written to address these issues.

For the first time since the Contarini collection was dispersed more than four hundred years ago, the Bellini and Giorgione are to be seen together as they once were in Taddeo Contarini's house. The present publication commemorates this momentous event with a re-evaluation of the history of the two paintings in the Contarini collection and of the collection in general. The basis of much of the scholarship on the paintings—what we know, or think we know, and what the paintings meant to Contarini—is somewhat precarious. I have tried to steer clear of the more fanciful proposals and interpretations and, instead, have relied on what the early documents tell us. When it comes to Giorgione's *Three Philosophers* and Bellini's *St. Francis in the Desert*, we know much less than we think we do. It is important to step back from these two masterpieces and the rivers of ink spilled on both. This book is neither an exhaustive text on the two paintings (a much larger book would be needed) nor an examination of every aspect of their histories but rather an exploration of their origins meant to serve as a means of gaining fuller, more accurate understandings of them.

Returning to Michiel, it is important to note that he lists only ten paintings—and no other works of art or objects—as being in Contarini's house. In addition to the descriptions of the Giorgione and the Bellini (by far the most extensive and detailed descriptions in the Contarini entry), he records another eight pictures:

Opere in Venecia

In casa de m. Tadeo Contarino 1525/

La tela delli 3. phylosophi nel paese, dui ritti et uno sentado
che contempla gli raggii solari, cun quel saxo finto cusì
mirabilmente, fu cominciata da Zorzo da Castel
Franco, et finita da Sebastiano Venitiano/

La tela grande a colla, della ordinanza de cavalli, fo de mano
de Girolimo romanin bressano/

La tela grande a oglio de l'inferno cun Enea et Anchise, fo
de mano de Zorzo da Castel Franco/

El quadro de fo de mano de Jaco Palma zo mancho

El quadro delle 3. donne retratte dal naturale in sino
al cinto, fo de mà el palma/

El quadretto della donna retratta al naturale i sino alle
spalle, fo de mà de Zuan bellino/

El quadro del Christo cun la croce i spalla i sino alle spalle
fo de mano de Zuan bellino/

El retratto i profilo i sino alle spalle de m fiola
del sigr lodovico de milano maritata nel lo impe-
ratore Maximiliano, fo de mano de . . . milanese/

Fig. 1. Page from Marcantonio Michiel's account of the collection of Taddeo Contarini, 1525.
Biblioteca Nazionale Marciana, Venice, Ms. It. XI, 67 (=7351, *olim* Apostolo Zeno 346), f. 54r

Opere in Venetia

In casa d[e] m[esser] Tadie Contarino · 1525 ·

La Tela dil pa[e]se cũ el nascim[en]to d[e] pa[r]is cũ li dui
pastori ritti i[n] piedi, Fu d[e] mano d[e] Zorzo da castel
Franco it fu d[e]le sue prim[e] opere /

La Tavola d[e] S. Fran[cesc]o ÷ nel diserto, a oglio, Fu
opera d[e] Zuã bel[li]no, g[i]mincim[en]to da lui a Zuã zuã
michiel / it ha i[l] pa[e]se propinquo finito it
ricercato mirabilment[e] /

Fig. 2. Page from Marcantonio Michiel's account of the collection of Taddeo Contarini, 1525.
Biblioteca Nazionale Marciana, Venice, Ms. It. XI, 67 (=7351, *olim* Apostolo Zeno 346), f. 54v

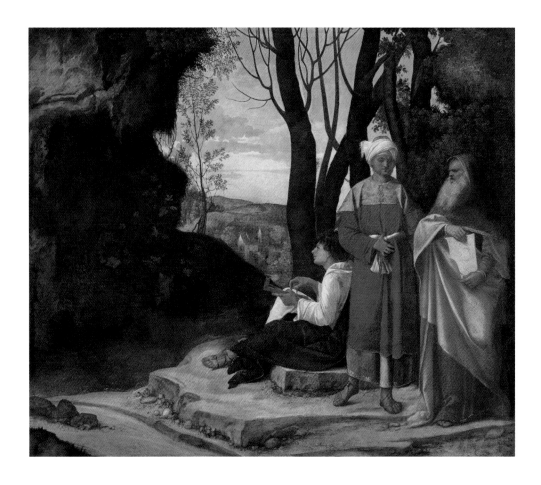

Fig. 3. Giorgio da Castelfranco, known as Giorgione, *The Three Philosophers*, ca. 1508–9.
Oil on canvas, 49⁷⁄₁₆ × 57⁹⁄₁₆ in. (125.5 × 146.2 cm). Kunsthistorisches Museum, Vienna

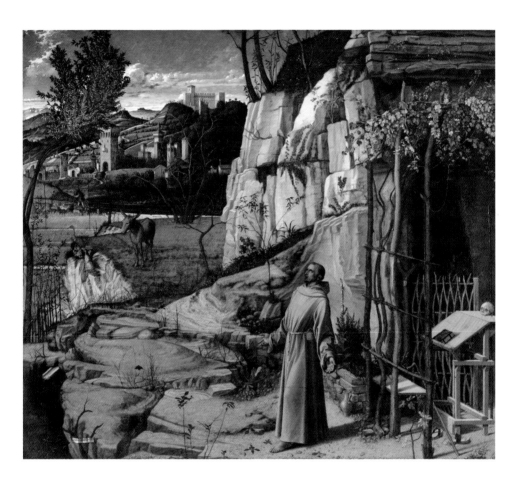

Fig. 4. Giovanni Bellini, *St. Francis in the Desert*, ca. 1475–80.
Oil on canvas, 49 1/16 × 55 7/8 in. (124.6 × 142 cm). The Frick Collection, New York

The large Canvas in tempera, of the drawing up of horses, was by the hand of
Girolamo Romanino from Brescia.

The large Canvas in oil of hell with Aeneas and Anchises, was by the hand of
Giorgio from Castelfranco.

The painting of was by the hand of Jacopo Palma from Bergamo.

The painting of the three women portrayed life-size up to the waist, was by the
hand of Palma.

The small painting of the woman portrayed life-size up to her shoulders, was by
the hand of Giovanni Bellini.

The painting of Christ with the cross on his shoulders, up to the shoulders, was
by the hand of Giovanni Bellini.

The portrait in profile, up to the shoulders, of Lady daughter of Signor
Ludovico of Milan, married to the emperor Maximilian, was by the hand of
..... Milanese.

The Canvas of the landscape with the birth of Paris with two shepherds standing,
was by the hand of Giorgio from Castelfranco, and was among his early
works.[5]

Of the eight other paintings mentioned, two were mythological depictions
by Giorgione: one of Aeneas and his father, Anchises, in the underworld, the
other of the birth of the Trojan prince Paris. Two others were by Bellini, one
of a woman and another of Christ carrying the cross. Michiel lists another
four paintings. Two were by Jacopo Palma (ca. 1480–1528) from Bergamo,
more commonly known as Palma il Vecchio. The subject of the first one is not
identified. Michiel just leaves five dots—something that occurs at various points
in his notes and at least three times in the Contarini section—as if he were
planning to fill it in later. The second painting is of three women—possibly
courtesans—and is sometimes known as *The Three Sisters* (fig. 5). It is the only
other painting in the Contarini collection notes—other than *The Three Philosophers*
and the *St. Francis in the Desert*—that can be firmly identified with a known work of
art. Another large canvas, painted in tempera ("a colla") by Girolamo Romanino
(ca. 1485–ca. 1566), showed a cavalry scene. The only portrait on the list is of a
female in profile. Michiel knows the artist to be Milanese but does not record
his name. He indicates that the woman is the daughter of Duke Ludovico Sforza
"il Moro" (1452–1508) of Milan and the wife of Holy Roman emperor
Maximilian I (1459–1519); this allows us to identify her as Bianca Maria Sforza
(1472–1510), the third wife of the emperor and the daughter of Galeazzo Maria
Sforza (1444–1476) who was raised by Ludovico (Galeazzo Maria's younger
brother), after her father's death.

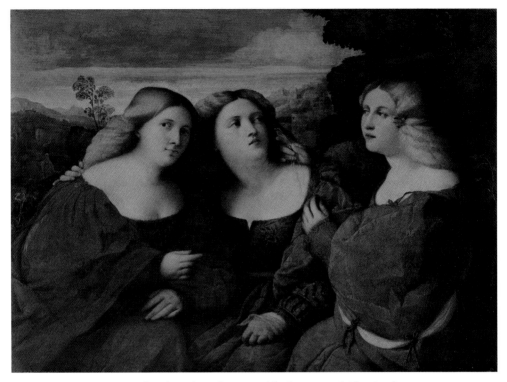

Fig. 5. Jacopo Palma il Vecchio, *Three Women* (also known as *The Three Sisters*), ca. 1520.
Oil on panel, 35⅝ × 48⁷⁄₁₆ in. (88 × 123 cm).
Gemäldegalerie Alte Meister, Staatliche Kunstsammlungen, Dresden

The paintings Michiel details are varied in size, with two referred to as being large ("grande") and one as being small ("quadretto"). They are also varied in authorship (by artists from Venice, Bergamo, Brescia, and Milan) and subject matter (one portrait, two mythological paintings, two sacred images, and five with unidentified subjects). Two lines in the notes suggest that he saw the paintings in three different rooms of the house.[6] In the first room, he encountered the largest paintings: the horse scene by Romanino, the Giorgione with Aeneas and Anchises, the Palma with the unknown subject, and Giorgione's *Three Philosophers*. In a second space, Michiel describes Palma's *Three Women*, Bellini's *Woman* and his *Christ Carrying the Cross*, and the Milanese portrait of Bianca Maria Sforza. In the third and final room were two paintings: Giorgione's *Birth of Paris* and Bellini's *St. Francis in the Desert*.

Michiel's list of ten paintings tells us what Taddeo Contarini owned, but we do not know what connections there may have been among the paintings or how they came to be in his possession. For that, we have to go back to the creation of

Bellini's *St. Francis in the Desert* and Giorgione's *Three Philosophers*. After all, Michiel first records these paintings about forty-five years after the *St. Francis in the Desert* was painted and about seventeen years after *The Three Philosophers* was created. By the time Michiel encountered them, Giorgione had been dead for fifteen years and Bellini for nine.

Ca. 1475–80 – Giovanni Bellini's *St. Francis in the Desert*

According to Michiel's notes, Bellini's *St. Francis in the Desert* was originally painted for Giovanni Michiel (no relation to Marcantonio). Stylistically, the painting has been dated between 1475 and 1480, the height of the artist's career. Bellini's biography is somewhat tangled. Although he is generally believed to have been born between 1425 and 1435, a date in the second half of the 1430s is more likely. He was probably the son of the Venetian painter Jacopo Bellini (ca. 1400–ca. 1470) and the brother of Gentile Bellini (ca. 1429–1507), although it has recently been proposed, not altogether convincingly, that Giovanni was instead Jacopo's younger half-brother and Gentile's uncle.[7] The first documented works by Giovanni date to the late 1450s and early 1460s. This is when he first appeared on the Venetian artistic scene, though at that point he seems to have been very much in the shadow of his brother-in-law, Andrea Mantegna (ca. 1431–1506). Throughout most of his remarkable five-decade-long career, Bellini was praised as Venice's leading artist. His work focused principally on large altarpieces for churches and smaller devotional pieces—countless Virgin and Child paintings—for the citizens of his city, aristocratic and otherwise. He also produced some portraits. By the mid-1470s, Bellini had painted the *Coronation of the Virgin*, a spectacular altarpiece for the Franciscan church of Pesaro, on the Adriatic coast. Less than a decade later, in February 1483, he was appointed the official painter to the Venetian Republic.[8]

Bellini probably painted the *St. Francis in the Desert* sometime between the completion of the Pesaro altarpiece (ca. 1475) and his appointment as official painter to the Serenissima (Most Serene Republic, as Venice was known).[9] The painting is not firmly dated but is signed, at bottom left, on a small painted piece of paper (a *cartellino*). As Keith Christiansen has observed, the *St. Francis* "invites slow and attentive viewing: total absorption, absolute engagement."[10] Its size—small for an altarpiece but large for a devotional private work—prompts questions as to how it was originally meant to be used. In it, the founder of the Franciscan order, St. Francis of Assisi (ca. 1181–1226), is depicted virtually alone

in a large landscape.[11] The only other person is a solitary shepherd tending to his flock in the middle ground. The natural setting of the painting is divided into two sections. The foreground is rocky, with large greenish boulders descending diagonally from top right toward the bottom left corner. At the extreme right, a rocky outcrop opens to reveal a cave, at the entrance of which is a small gate; it is impossible to penetrate the darkness of the cave. Outside, a vine flourishes over a man-made trellis; below this are a wooden bench and lectern. A few objects reveal the presence of the human being who inhabits this dark cave: a small bell placed on the trellis to alert the resident to visitors, a closed book on the lectern, a nearby skull on which to meditate, and a pair of clogs left near the lectern together with a wooden walking stick. Beyond the rocky plateau, a less rugged landscape opens up toward a seemingly thriving walled city, punctuated by towers, by a river. A bridge leads to the entrance of the city, within which a castle and bell-towers can be discerned. Above it is another castle that overlooks the city. The stony part of the landscape is punctuated by wild plants—except for the vine, the rosemary bush, and hollyhock, most likely planted by the individual living in the cave. A rabbit and a kingfisher can be seen in the wilderness, and a donkey and a heron are between the rocky outcrop, where St. Francis is placed, and the quieter landscape of the shepherd and the city. By painting a city in the background, Bellini makes the wilderness—the desert—in which Francis lives a focal point. As Kenneth Clark has written, "no other great painting, perhaps, contains such a quantity of natural details observed and rendered with incredible patience: for no other painter has been able to give to such an accumulation the unity which is only achieved by love."[12]

Francis, wearing his Franciscan habit, is slightly to the right of the center of the painting, his arms open in a gesture of acceptance. Focusing on a laurel bush at top left, he looks up, mouth slightly open, moved by a divine, invisible wind and bathed in supernatural light. His hands and foot are marked by tiny bloody wounds. A small part of the painting (about two inches) has been cut off at the top, but it is unlikely that it included further compositional elements of significance. Although Michiel describes the saint as within a "desert" landscape, a more accurate interpretation is that the painting depicts the Stigmatization of St. Francis. This is also one of the most popular scenes in the iconography of St. Francis and one that both Bellini and his father had depicted before. In both of his surviving albums of drawings (now at the British Museum in London and the Louvre in Paris), Jacopo rendered compositions for the Stigmatization of St. Francis. In the Paris album (fig. 6), Francis is shown in a similarly rocky

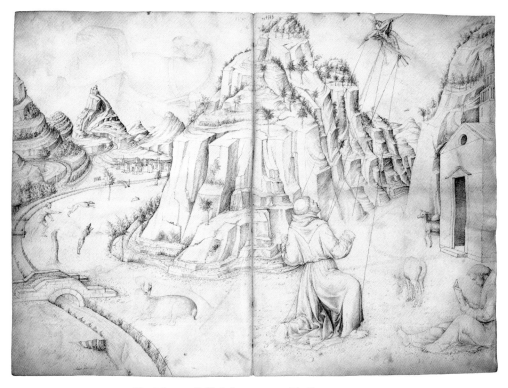

Fig. 6. Jacopo Bellini, *Stigmatization of St. Francis*, ca. 1445.
Metalpoint with pen and brown ink on parchment, each leaf 14¹⁵⁄₁₆ × 10¼ in. (380 × 260 mm).
Département des Arts Graphiques, Musée du Louvre, Paris

landscape, with a city by a river in the distance to the left. A range of animals and
a hunter with his dogs chasing a rabbit inhabit the scene. Instead of a cave, there
is a small church to the right. Francis is seen kneeling toward it, while a seraph
inflicts on him the wounds of Christ's Passion. To the right is Brother Leo (d.
ca. 1270), seated and reading. In many ways, this drawing is a direct precursor of
the Contarini *St. Francis*. Giovanni's previous depiction of the scene, as part of the
predella of the Pesaro altarpiece (fig. 7), also juxtaposes the rocky "desert" with a city
(this time to the right). Brother Leo is still absorbed in his reading, while Francis
receives the stigmata from the minuscule, almost invisible, seraph. In the summer
of 1224, two years before his death, Francis, accompanied by Brother Leo, is said
to have received the stigmata—the wounds Christ received during the Passion—at
the mountain site of La Verna, in the Casentino region of the Apennine Mountains
in central Italy. The scene became one of the most iconic in the iconography of
the saint but seems not to have been a part of his saintly narrative until after his

death.[13] The Bellini painting in the Contarini collection lacks two key elements of the standard imagery of the stigmatization of St. Francis: the seraph and Brother Leo. Nonetheless, Millard Meiss is surely correct in identifying the scene, in his seminal study, as an exceptionally original rendering of the subject.[14] Instead of representing the seraph, Bellini chose to represent the divine nature of Christ's wounds appearing on Francis's body through Nature, through the celestial light and wind that descend in the picture from the top left. Most scholars have agreed with this traditional reading of the painting, but two other interpretations have their adherents. For some, Francis is shown not as receiving the stigmata but rather as composing his famous prayer, the *Canticle of the Creatures*, in which he celebrates Brother Sun, Sister Moon, Brother Wind, Sister Water, Brother Fire, Sister Mother Earth, and Sister Bodily Death.[15] Others have suggested that the painting does not depict a specific episode in the life of St. Francis but is, instead, a more iconic image of the saint, combining a number of different aspects, including the stigmatization and the *Canticle*.[16] Beyond these three proposals, "the work has

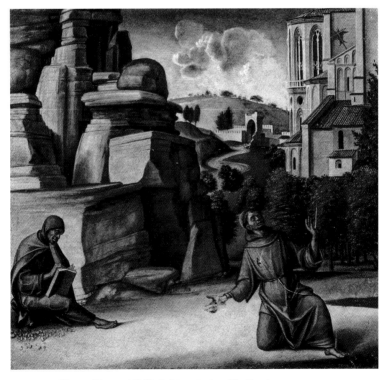

Fig. 7. Giovanni Bellini, *Stigmatization of St. Francis*, ca. 1472–75.
Oil and tempera on panel, 15¾ × 16⁹⁄₁₆ in. (40 × 42 cm). Pinacoteca, Musei Civici, Pesaro

become a testing ground for wild iconology, inventing iconographies otherwise never attested," as Andrea De Marchi writes.[17] Jennifer Fletcher concluded that "no item contained in the Frick picture contradicts a stigmatization; it is only features that are not represented that create obstacles to recognition."[18] As also pointed out by her, "a white oxen may be a beast of burden, it may be a sacrificial Old Testament symbol or it may be a highly desired aesthetically necessary patch of white paint needed to balance a white shirt on the other side of the painting. Rarely will it be all these three things at once."[19]

Linked to the issue of the iconography is that of the original location of the painting. Giovanni Michiel, the individual who Michiel indicates as having commissioned the painting, has been identified by Fletcher as among "a handful of Giovanni or Zuan Michiels [that] are mentioned in Sanudo's 'Diarii.' Among these are custodians of small castles, a male prostitute and a famous cardinal."[20] Zuan Jacomo Michiel (d. 1513) was a *cittadino originario* (original citizen) of Venice—"a loyal civil servant, a good man, trained in law, and learned in philosophy"—who was secretary to the Council of Ten between at least 1497 and his death in June 1513 and twice Guardian Grande of the Scuola Grande di San Marco.[21] Apart from the Bellini panel, Zuan Jacomo is known to have owned an illuminated manuscript by Jacometto Veneziano (act. 1472–97). Both Bellini and Zuan Jacomo lived in the parish of Santa Marina, and Bellini was also a member of the Scuola headed by Zuan Jacomo; both were buried in the church of Santi Giovanni e Paolo, adjacent to the Scuola. Little else is known about the original patron of the *St. Francis in the Desert*. Just as mysterious are the location and purpose for which the panel was painted. Was it a private devotional work for Zuan Jacomo's home or an altarpiece for a church? It has been suggested that the painting may have been connected to the church of San Francesco del Deserto, a Franciscan establishment on a remote island in the Venetian lagoon. Even though the panel is based somewhat on the format of other altarpieces by Bellini from the 1470s, it seems more likely that it was intended for a secular setting.[22]

Ca. 1508–9 – Giorgione's *Three Philosophers*

The facts of Bellini's early life and career may be cloudy, but his style is relatively consistent, and there is consensus on his artistic oeuvre. The same cannot be said of Giorgio from Castelfranco, known as Giorgione. His story is much murkier. As the art historian Roberto Longhi famously observed, "the subject of Giorgione . . .

unfortunately is treated from above and wrapping oneself in smoke screens. If one day it's possible to talk about it more simply, without speaking about music, lutes, poetry and without getting intoxicated with 'tone,' it will be so much the better."[23] André Chastel wrote that it is "almost impossible, finally, to give an account of Giorgione's art."[24] Giorgione was born around 1477, about the time that Bellini painted his *St. Francis*, in the town of Castelfranco Veneto, northwest of Venice, between Treviso and Vicenza. He died of the plague in his late thirties, in Venice on September 17, 1510. Giorgio Vasari (1511–1574) provides a brief biography of the artist in his *Lives*.[25] Vasari wrote that Giorgione was particularly fond of music and that he studied in the Bellini workshop before coming under the influence of the art of Leonardo da Vinci (1452–1519). He described his work as being mostly devotional subjects and portraits, with a focus on his fresco cycles for facades of Venetian buildings, the most prominent of these being his wall paintings on the exterior of the Fondaco dei Tedeschi, at Rialto, of which only a few, very damaged, fragments survive. Vasari noted how these works suffered from the humidity in Venice, as well as the salt rising from floodwaters. Present-day scholars agree on the attribution to Giorgione of about ten paintings, none of which are mentioned by Vasari. It is in Marcantonio Michiel's lists that we see the first mention of many of the works we now consider Giorgione masterpieces. His oeuvre remains problematic, however, because it is hard to believe that paintings such as the *Castelfranco Madonna* (Duomo, Castelfranco Veneto), the *Tempest* (fig. 8), *Judith* (Hermitage, St. Petersburg), *Laura* (Kunsthistorisches Museum, Vienna), the *Vecchia* (Gallerie dell'Accademia, Venice), and the *Sleeping Venus* (Gemäldegalerie, Dresden) were painted by the same artist in a relatively short period of time. Notwithstanding the extensive literature on the subject, Giorgione therefore remains an enduring mystery.[26]

Taddeo Contarini owned three paintings by Giorgione, two of which— the *Hell with Aeneas and Anchises* and the *Birth of Paris*—are now lost. *The Three Philosophers*—like Bellini's *St. Francis*, first documented by Michiel in 1525—has been assumed to have been commissioned by Contarini.[27] However, there is no evidence of this. It is generally presumed, on stylistic grounds, that *The Three Philosophers* dates to the end of Giorgione's short life, around 1508–9, and, if that is correct, Contarini could have been the original patron. But it is also possible that he purchased the painting from another patron, as he did the *St. Francis*.

There are striking similarities between Giorgione's *Three Philosophers* and Bellini's *St. Francis*. They are about the same size, even though the Bellini was originally larger at the top and the Giorgione was cut on the left side. They both

depict human figures, proportionally similar in size, set within broad landscapes. Giorgione's canvas also depicts a rocky plateau, with a cave opening to the left of the composition (on the opposite side to the one in Bellini's panel). The landscape is also composed of both verdant trees and bare ones, and it opens at the back toward rolling hills and a group of buildings, possibly a hamlet. Instead of the lonely figure of St. Francis, Giorgione punctuates his landscape with three figures—two standing and one seated, as described by Michiel. To the right is an old, bearded man, dressed in purple and yellow, with a hooded mantle, holding a tablet with lunar diagrams. To the left of him is a younger man in an unusual red-and-blue outfit and a white turban that could identify him as a Muslim. The seated man, the youngest, holds a compass and a square and, like St. Francis, is looking up toward a source of light; as Michiel notes, he "is contemplating the sun's rays." The sun is either setting or rising on the horizon line.[28]

Apart from Giorgione's *Tempest*, very few Venetian Renaissance works have received as much attention and been as widely interpreted as *The Three Philosophers*. Salvatore Settis, who published his brilliant findings on Giorgione's paintings in a book and numerous essays, perfectly summarized how, around 1500 in Venice, "a few significant painters, including Giovanni Bellini, Giorgione and Titian, displayed in their work sophisticated 'inventions' and 'compositions' which, in order to be fully grasped, required lengthy and careful observation, as well as deliberate reference to a shared literary culture and to highly codified poetic allusions and moral or intellectual meanings."[29] This has given rise to the problem of identifying what these subjects may have been. Michiel clearly recognizes the mythological figures of Aeneas, Anchises, and Paris in two of the Giorgione paintings in Contarini's palazzo, but he describes the figures in the third painting only as "three philosophers in the landscape." When interpreting the subject matter of paintings like Giorgione's *Three Philosophers*, we should keep in mind what Martin Conway wrote in 1929:

> the peculiar subjects chosen by our artist for his pictures, many of which are to us inexplicable, may have been dictated by the mystical lucubrations of some society of amateurs feeling their puzzled way into an intellectual world that was posing new problems to the awakening intelligence of the young men of a new age.[30]

Particularly germane to our assessment of the farfetched theories of recent iconographers and iconologists are the words of Charles Hope: "If we do not understand a particular image of this period, it is usually not because we are not

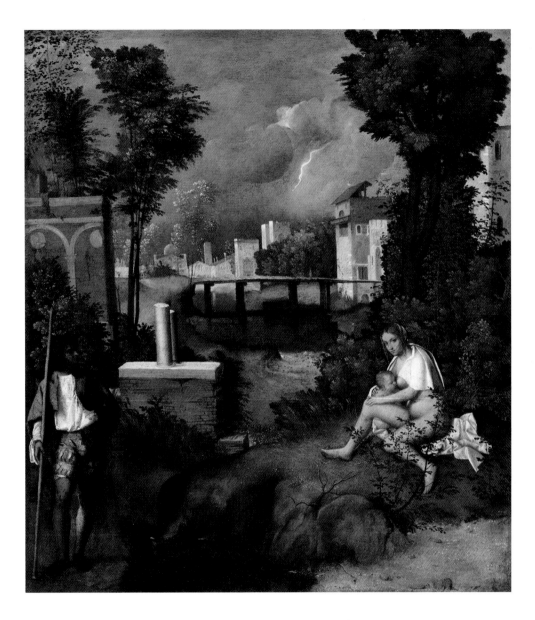

Fig. 8. Giorgio da Castelfranco, known as Giorgione, *The Tempest*, ca. 1504–8.
Oil on canvas, 32¹¹⁄₁₆ × 28¾ in. (82 × 73 cm). Gallerie dell'Accademia, Venice

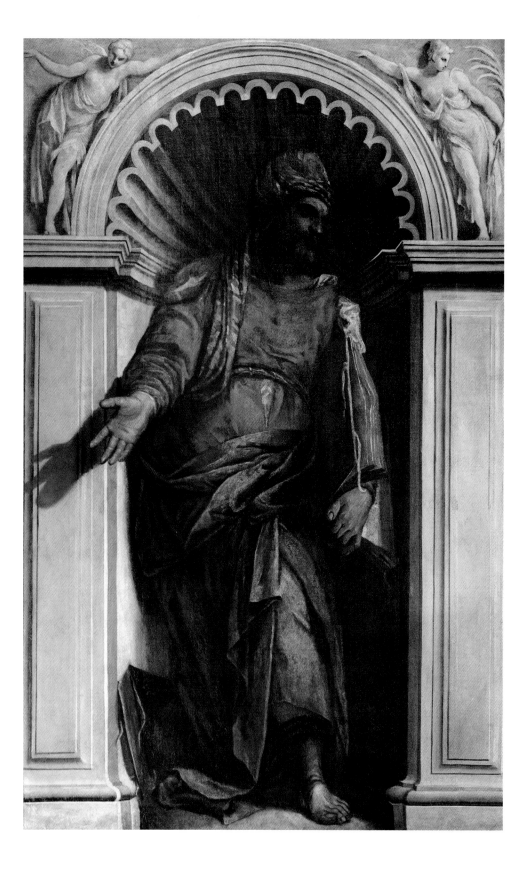

clever enough, but because we expect a quite inappropriate kind of cleverness on the part of the artist and his adviser."[31]

The Three Philosophers has been understood in two principal ways. The first closely follows Michiel's reading of it as three philosophers from antiquity. In Venice around 1500, one would have seen such depictions. For example, in his life of Giovanni Bellini, Claudio Ridolfi (1560–1644) records some lost paintings by the artist: "in the house of the Grimani at Sant'Ermagora he painted in the great hall two large paintings of Cosmography, with figures of Ptolemy, Strabo, Pliny and Pomponius Mella, and inscribed his name thereon."[32] In the second half of the sixteenth century, the main hall of the Library of St. Mark's was decorated with paintings of philosophers, by Giuseppe Porta Salviati (1520–1575), Jacopo Tintoretto (1518–1594), and Paolo Veronese (1528–1588; fig. 9). Philosophers also appear in Venetian prints from the first half of the sixteenth century (fig. 10).[33] Most scholars have retained the Michiel title for the painting and generally only identify Giorgione's three figures as "philosophers."[34] For some, they represent specific historical figures. However, as Jay Williams writes, "[they] appear to be specific individuals, yet they cannot be identified."[35] Jaynie Anderson believed that "Giorgione certainly intended to represent particular philosophers, although it may be impossible to discover their actual identities."[36] Nonetheless, she and other scholars have put forward a number of theories. The names of the three philosophers may be Archimedes, Ptolemy, and Pythagoras;[37] Aristotle, Averroes, and Virgil;[38] Regiomontanus, Aristotle, and Ptolemy;[39] Ptolemy, Al-Battani, and Copernicus;[40] Aristotle, Averroes, and a humanist;[41] or Plato, Aristotle, and Pythagoras.[42] The philosophical subject may have been a broader one, based on the different ages of the three philosophers and their apparently different geographical origins. The painting may represent three degrees of hermetic initiation;[43] three phases of Aristotelianism;[44] a comparison between medieval Aristotelianism, Averroism, and Renaissance philosophy;[45] or a representation of the education of philosophers according to Plato's *Republic*.[46] The three men may, instead, represent topics such as astronomy, philosophy, and geometry; three of the four seasons; or the three monotheistic religions—Judaism, Christianity, and Islam—possibly through the figures of Abraham (or Moses), Zoroaster, and Pythagoras.[47] Of all the attempts to identify the philosophers, that of Karin Zeleny is the best argued and most convincing. Zeleny proposes that the

Fig. 9. Paolo Veronese, *Philosopher*, ca. 1560. Oil on canvas, 98⁷⁄₁₆ × 63 in. (250 × 160 cm). Biblioteca Nazionale Marciana, Venice

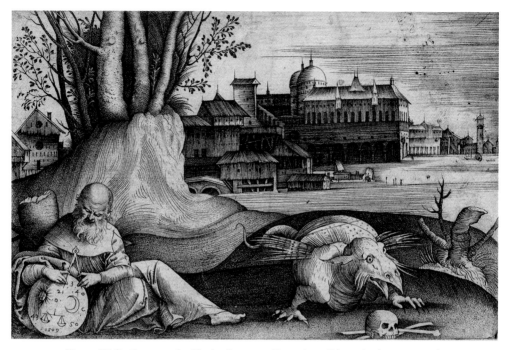

Fig. 10. Giulio Campagnola, *The Astrologer*, 1509. Engraving, 3¹⁵⁄₁₆ × 6 in. (100 × 153 mm).
The British Museum, London

philosophers are Pythagoras with his two teachers—Thales of Miletus and
Pherecydes of Syros—the first three philosophers of the Western tradition
shown while at the Oracle of Apollo at Didyma.[48]

The other popular theory sees *The Three Philosophers* as representing
the Three Kings (or Magi) who followed a star to Bethlehem to worship the
newborn Christ. In 1871, Joseph Archer Crowe and Giovanni Battista Cavalcaselle
described them as Chaldean Sages—"a company of astronomers watching the
heavens in the shadow of a glade."[49] For many art historians, the three figures are
the Magi either before or at the time of the apparition of the star.[50]

Numerous other theories have been advanced. Among the few that
deserve mention for the sake of completeness are the proposals that *The Three
Philosophers* represents a specific narrative, such as the emperor Marcus Aurelius
being educated by two philosophers on the Caelian Hill;[51] Abraham teaching
astronomy to the Egyptians;[52] Evander and Pallas showing Aeneas the rock on
which the Capitol will be built;[53] or the meeting between Sultan Mehmet II and
Patriarch Gennadios Scholarios in Constantinople.[54] For others, the three figures
are identifiable but not as philosophers. Instead, they could be St. Luke, David,

and St. Jerome;[55] the builders of the Temple in Jerusalem—King Solomon, King Hiram of Tyre, and Hiram of Tyre the Master Craftsman;[56] or even a depiction of Giovanni Bellini, Vittore Carpaccio, and Giorgione himself.[57] One solution is to propose that the subject of *The Three Philosophers* and Giorgione's work in general was intended to be ambiguous: "such ambiguous paintings are like visual traps set to capture the viewer's curiosity and speculation while at the same time excluding the possibility of confronting release into a final conclusion."[58] Indeed, some have suggested that his paintings do not have a subject at all.[59] Vasari, for his part, was already struggling with the meaning of Giorgione's paintings.[60] Personally, I agree with Settis, who wrote,

> If on the one hand there are those who—without always denying the subject— study almost only the style, on the other there are those who—without wanting to find symbols and allegories at all costs—study almost only the meanings, then the separation of form and content in a certain way has become an opposition, it has resulted in a dramatic laceration not only for the individuality of the artist, but also within each single "work of art"... if it makes sense to tell even an absolute trivial truth, form and content are born together; and the style changes according to the best expression of the subject.[61]

Giorgione must have been depicting a specific subject for his patron (who may or may not have been Taddeo Contarini), but that subject, whatever it was, was unclear to Michiel almost twenty years later and remains so.

Art historians have used technical analysis to bolster various interpretations. In 1932, Johannes Wilde published findings linked to the X-ray examination of Giorgione's *Three Philosophers*.[62] It had already been established, thanks to copies by David Teniers the Younger (1610–1690)—in both painting (fig. 11) and print (fig. 12)—that the Giorgione painting had been significantly cut on the left side and that a part of the cave was no longer present. X-rays, however, provided new evidence as to various modifications to the composition during the painting's creation. The landscape and the town originally had different locations, a few changes to figures took place after the first version was sketched, and the philosopher to the right originally wore exotic, spiked headgear (fig. 13).[63] Learning of these changes led to a number of misunderstandings, starting with the idea that the face of the central figure in the painting was originally darker.[64] This detail has been used to support the idea that Giorgione originally planned to represent the three biblical Magi but then changed the subject or that, while retaining the Magi as the subject, he decided to depart from the standard iconography.[65]

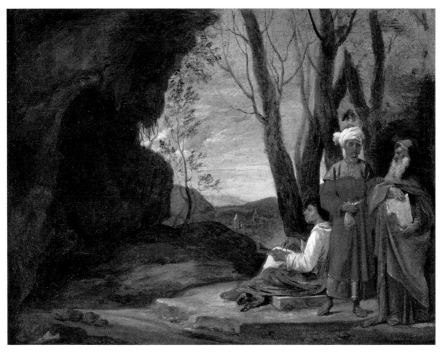

Fig. 11. David Teniers the Younger, copy of Giorgione's *Three Philosophers*, detail from *Archduke Leopold Wilhelm in His Gallery at Brussels*, ca. 1651. Oil on canvas, 48^{13}⁄₁₆ × 64^{15}⁄₁₆ in. (124 × 165 cm). Kunsthistorisches Museum, Vienna

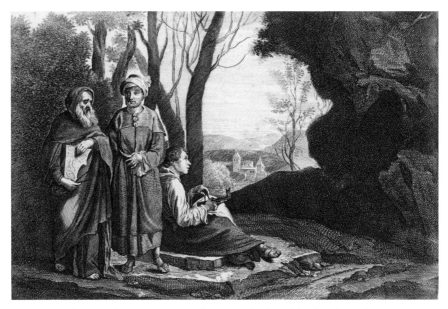

Fig. 12. David Teniers the Younger, copy of Giorgione's *Three Philosophers*, from *Theatrum Pictorium* (Antwerp, 1673). Engraving on paper, 8⅛ × 11^{13}⁄₁₆ in. (250 × 299 mm)

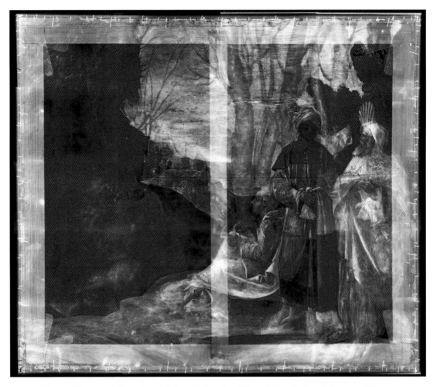

Fig. 13. X-ray of Giorgione's *Three Philosophers*. Kunsthistorisches Museum, Vienna

Technical analysis of the painting has resolved an issue that arose from Michiel's description. Michiel states that the painting "was begun" by Giorgione and "finished" by Sebastiano del Piombo. This assertion was questioned by Crowe and Cavalcaselle in 1871.[66] Art historians have tried to identify Sebastiano's contribution to Giorgione's painting but have not reached a unanimous conclusion. Michiel seems to suggest that the painting was not finished when Giorgione died (in 1510) and that Sebastiano completed it.[67] Following Giorgione's design, Sebastiano may have painted the two standing philosophers;[68] or just their clothes;[69] or, instead, the seated young philosopher was painted by Sebastiano;[70] or the landscape.[71] Many scholars have addressed the meaning and implications of Michiel's note. Wilde came to the conclusion, in 1932, that "no tangible basis can be found for Michiel's statement and that it should be left out of the discussion."[72] Pietro Zampetti wrote that "with regard to the collaboration with Sebastiano del Piombo, of which Michiel speaks, it is very difficult to say what it consists of and problematic to trace its elements with certainty: in fact, the work appears admirably unitary."[73] And Jaynie Anderson said that "indeed, we may doubt Michiel's testimony that Sebastiano made any significant contribution

to the work, except as an assistant in preparing Giorgione's colors."[74] The most recent technical examination of the painting took place in the early 2000s; the resulting study determined that its surface is not consistent with two painters having worked on it and firmly attributed it to Giorgione.[75] One last theory, however, remains to be explored. Charles Hope offered an astute evaluation of the painting that has been unfairly ignored by scholars. For Hope,

> modern writers on Giorgione almost always say that the painting looks like the work of only one artist, and that although the heads of two of the figures are very similar to those in paintings that are certainly by Sebastiano, *The Three Philosophers* must be almost entirely by Giorgione. It would be more consistent with the evidence to suppose that the picture was designed by Giorgione and largely painted by Sebastiano, perhaps after Giorgione's death; but this possibility has never been seriously discussed.[76]

It is not my intention to shift the attribution of *The Three Philosophers* from Giorgione to Sebastiano del Piombo, but Hope's suggestion should be investigated, not least because it takes into consideration Michiel's information. *The Three Philosophers* is indeed closer stylistically to the work of the young Sebastiano del Piombo, and it is not inconceivable that Giorgione established the composition of the painting and maybe even started sketching it in but that, with his death, Sebastiano made changes and painted the composition as we see it today. Not only are the dating, patronage, and subject matter of *The Three Philosophers* based on assumptions, but its authorship is as well.[77]

Bellini and Giorgione: Pendant Paintings?

When Franz Wickhoff interpreted *The Three Philosophers* as representing Evander and Pallas with Aeneas in front of the rock on which the Capitol will rise, he proposed that, since the subject derived from Virgil's *Aeneid*, Giorgione's painting was a pendant of another picture by the artist in the Contarini collection, the *Hell with Aeneas and Anchises*.[78] This theory has not found much favor, but the idea of matching Giorgione's *Three Philosophers* with another painting in the house of Contarini has often been explored.[79] Friederike von Klauner, for example, paired *The Three Philosophers* with the *Birth of Paris*.[80] The closeness in size and compositional structure of Giorgione's *Three Philosophers* and Bellini's *St. Francis*—if not in subject matter—has prompted this valid question: "could the two paintings be related,

in the sense that Contarini commissioned Giorgione to paint a pendant for his newly-acquired Bellini?"[81] Ellis Waterhouse perfectly explained what he saw as the main connection between the two works:

> this wonderful picture [the *St. Francis in the Desert*], in which Bellini anticipates more than in any other Giorgione's use of landscape, seems to me to be a picture of dawn or of early morning light. It is pretty well the same size as *The Three Philosophers* (one should in fairness mention that some scholars believe that both pictures have been cut down) and I would suggest that what Contarini commissioned was a picture of evening which should be its companion. In the discussion of the subject matter it might have been suggested that, since Bellini's picture was concerned with the Christian dispensation, Giorgione's companion piece might be concerned with the old order. Hence the three sages—possibly with a side glance at the Magi—who represent the wisdom of the Ancient World. This seems to me to be much more in the spirit of Giorgione than to suppose that they are Ptolemy, Al-Battani, and Copernicus.[82]

It is tempting to posit such direct links between the two paintings—Bellini's as a Christian hymn to nature and Giorgione's as an ancient pagan one.[83] Both paintings could also be religious images linked to supernatural visions: the divine light inflicts on Francis the wounds, while another light, the star, guides the Magi to Bethlehem. There are, however, two complications here. First, while we know that the Bellini was created independently for Giovanni Michiel, we do not know for whom *The Three Philosophers* was painted. It is generally assumed that the *St. Francis in the Desert* passed from Michiel to Contarini at the time of Michiel's death, in 1513, three years after Giorgione's death. If Contarini commissioned *The Three Philosophers* from Giorgione, he is unlikely to have asked for a pendant of a painting that belonged to someone else.[84] He may have purchased the *St. Francis* before Michiel's death, but this cannot be established. Second, Michiel lists the Bellini and the Giorgione as being in two different rooms of Contarini's palazzo. Notwithstanding all this, and acknowledging that it is highly unlikely that Giorgione painted his *Three Philosophers* as a pendant to Bellini's *St. Francis*, it has to be said that the painting by Giorgione could not have been conceived without the example of the Bellini. Giorgione must have known the Bellini *St. Francis* well, in either Giovanni Michiel's or Taddeo Contarini's homes, and he must have been influenced by it. Rather than considering Giorgione's painting a pendant of Bellini's, we should think of it as an homage to the older painter.

Taddeo Contarini

The Contarini family was a large and extended one—"perhaps the largest and most ramified among the Venetian patrician families."[85] In the early 1500s, the Contarini had 172 male family members serving in the Maggior Consiglio (Great Council), more than any other family.[86] Several men named Taddeo Contarini appear in documents from early sixteenth-century Venice. In 1884, Jacopo Morelli and Gustavo Frizzoni identified the Taddeo whose collection is described by Michiel as the Taddeo Contarini buried in the cloister of the church of Santo Stefano in Venice.[87] Jennifer Fletcher expanded on this, identifying Taddeo as a member of the Santi Apostoli branch of the Contarini family who had been a member of the Council of Ten and a Savio di Terraferma (Sage of the Mainland); consistent with her predecessors' research, this Taddeo died in 1545 and was buried at Santo Stefano.[88] She did not agree with Arnaldo Ferriguto's proposal that the owner of the collection must be Taddeo di (son of) Sigismondo Contarini.[89] The *Diaries* of Marin Sanudo (1466–1536), a principal source about Venice from the end of the fourteenth to the beginning of the fifteenth century, provides most, if not all, the information we have on the several men by the name of Taddeo Contarini living in Venice at the time.[90] Ferriguto's Taddeo di Sigismondo (d. 1527) was the *castellano* at the harbor of Legnano and had a role in the defense of Venetian lands on the *terraferma* between 1510 and 1516.[91] In September 1524, he is mentioned for his inability to pay his debts.[92]

Another candidate, Taddeo—di Andrea—Contarini, appears often in Sanudo. Between 1503 and 1509, he was actively involved in the political life of Venice, as Procurator sopra le Acque (Procurator of the Waterways), Procurator of St. Mark's, Senator in Pregadi (Senate) and Provveditore alle Pompe (Supervisor of Pomp/Luxury), and Savio di Terraferma.[93] However, he died in 1510 and so cannot be the owner of the collection described by Michiel in 1525. A Taddeo di Alvise Contarini is mentioned by Sanudo, but very little is known about him.[94]

The correct Taddeo Contarini was not identified until 1978, by Salvatore Settis.[95] Taddeo di Nicolò del Naso (of the Nose) Contarini appears with some frequency in Sanudo's *Diaries*. He was born around 1466 to Nicolò di Andrea Contarini and Dolfinella Malipiero.[96] Contarini was wealthy and well connected but showed little interest in politics. Sanudo mentions him, in January 1517, as "one of four from the Contarini family, greatly wealthy" and again refers to him, in April 1525, as "el richo" (the wealthy).[97] In February 1497, he was supposed to be sent to the area of Padua as Procuratore delle Biade (Procurator

for Wheat), but apparently he never went.[98] In January 1510, he was facilitating the transport of wheat on ships to Istria.[99] He seems to have made a fortune dealing in wheat, as well as trading wood to "Syo" (probably the Greek island of Chios) and cured meat to Constantinople; he also had business in Corfu.[100] In May 1519, he is documented as having traded "cloth of gold and silk for a great value," and for this he went on trial for smuggling.[101] Most of Contarini's business in the mid-1520s seems to have been focused on the *becarie* (butcher shops) of Venice, on which he apparently had something of a monopoly. This seems to have led to a popular uprising in 1526.[102] Because of his considerable wealth, Contarini was often (between March 1510 and at least May 1528) forced to provide substantial loans to the Republic, as were other aristocrats of the city.[103] He occasionally held public office: in September 1513, he was on the Council of Ten; from September to at least January 1517, he was Provveditore alle Biade; from November 1517 to May 1520, Savio sopra la Mercadantia (Officer of Commerce); and in July 1527, one of the noblemen voting for the three Savi of the Council of Zonta (the Senate).[104] Sanudo, the ultimate political animal, was somewhat critical of Contarini's feeble involvement in the Republic's politics. On at least two occasions—both in July 1527—he lists "Taddeo Contarini, son of Nicolò, and his sons" as among those who "rarely attended the Council."[105] Contarini was closely related to Doge Andrea Gritti (r. 1523–38), and he was one of the "relatives of the Doge, dressed in silk, velvet, and damask and scarlet" at the coronation of Gritti on May 21, 1523.[106] In September 1527, he was among the aristocrats, all relatives of Gritti, removed from the list of candidates to be voted into office, in an attempt to disparage the Doge.[107] On a couple of occasions, Contarini shared with the state intelligence he had inadvertently come by. In January 1514, for instance, he had seen a letter in the Fondaco dei Tedeschi that included information about the movements of the imperial troops, and, in December 1524, he had received a letter from a Jewish man in Ragusa (Dubrovnik) informing him that the Turkish army was marching toward Valona (Vlorë) in Albania; on both occasions, he promptly informed officials of the Republic.[108] He also probably owned a ship for his trade and had a "large" ship that between May and September 1518 was on its way to Jerusalem with eighty-five German pilgrims on board.[109]

Over the years, more information has been gathered about Taddeo Contarini.[110] In 1495, he married Maria di Leonardo Vendramin, the sister of Gabriele Vendramin (1484–1552), a leading art collector in Venice, whose collection was also documented in Michiel's notes.[111] The couple had four

sons—Girolamo, Pierfrancesco, Andrea, and Dario—and at least one daughter, whom Sanudo recorded as having married Marco da Molin on January 18, 1522, with a dowry of more than 5,000 ducats.[112] Three of Taddeo's four sons made their mark: Pierfrancesco (1502–1555) was Patriarch of Venice for a few months between 1554 and 1555. Girolamo had a number of important roles. Between November 1524 and March 1525, he was nominated "sindaco" in Dalmatia and traveled there between April and September 1525. He was also involved with the Arsenal from August 1526, in Pregadi from March 1528, and "podestà e capitano" in Belluno by October 1532.[113] Dario is described in Sanudo's *Diaries* as "mato" (mad), but he nevertheless appears on the political scene in Venice from at least 1523.[114] As for Andrea, almost nothing is known about him. Taddeo Contarini died in Venice on October 11, 1540, and left no will.[115]

A number of hasty conclusions about Contarini have been based on Michiel's notes. Rodolfo Pallucchini writes about "Taddeo Contarini, one of the most prominent intellectuals of the time," and Annalisa Perissa Torrini describes Contarini as "one of the most famous intellectuals of the time."[116] For Settis, Contarini is a "humanist merchant," and even recently "the extremely wealthy Contarini" has been defined as someone who "may have focused on collecting paintings" and was also "an intellectual who borrowed classical texts from the library at San Marco in 1524."[117] However, when it comes to Contarini's involvement with the arts and culture in Venice, we have, besides Michiel's list of paintings, only a few rather tenuous sources. For example, between 1511 and 1519, Contarini was one of the aristocratic *mallevadori* (guarantors) when the banker and art patron Agostino Chigi (1466–1520) sold alum from Tolfa to Venice.[118] That this business experience put Contarini in touch with artists patronized by Chigi—Sebastiano del Piombo in particular—is conjectural at best. Much significance has been attached to Taddeo's return of four books, on August 1, 1524, to the Biblioteca Marciana: two volumes of Galen, one of Appian, and one of Philo Judaeus. These had been borrowed by his son, Pierfrancesco.[119] In 1517, Andrea Navagero (1483–1529), the librarian of St. Mark's, and Pietro Bembo (1470–1547) corresponded about a missing volume of Homer that, it turned out, had been borrowed by Girolamo, "son of Taddeo Contarini."[120] In 1531, Bembo, having himself become the librarian of St. Mark's, was complaining about a missing volume of Ptolemy borrowed by Girolamo.[121] The fact that Taddeo's children, Pierfrancesco and Girolamo, borrowed (and did not return) volumes by ancient writers from the Biblioteca Marciana hardly makes Taddeo "a reader of ancient manuscripts of astronomy and philosophy."[122] More balanced

assessments, based on solid evidence, are those of Piermario Vescovo and Rosella Lauber. The former describes Taddeo as "a very wealthy merchant specialized in maritime trade and, in particular, in the importation of foodstuff and above all meat, a powerful financier, a refined and unscrupulous man."[123] Lauber echoes this sentiment, writing that, "in his *Diaries*, Sanudo outlines an unflattering cameo of the character; powerful financier, refined but unscrupulous man."[124]

Taddeo Contarini's interest in the arts is reflected only in Michiel's list of the ten paintings in his palazzo and in a letter of November 8, 1510, from Taddeo Albano, an agent of Isabella d'Este (1474–1539), the Marchioness of Mantua, to his employer. Having heard that Giorgione had died, Isabella wrote to Albano on October 25, asking him to procure for her "a painting of a night, very beautiful and singular" by the artist that was "among the things and inheritance" of the painter. Albano informed the marchioness that Giorgione had died of the plague and that, having spoken to a number of people who knew him well, he could tell her that no such painting existed among the objects left by the artist. Giorgione had, in fact, painted two pictures of that subject: one for Taddeo Contarini that was not "according to the information I received, very perfect as you would like," and another of "much better design and better finished" for a certain Vittorio Becharo. Albano had to disappoint Isabella because Vittorio was away from Venice, and neither he nor Contarini were planning to sell their paintings "for any price, because they had commissioned them to enjoy them themselves."[125] This letter proves a number of things. Most important, even if Contarini's painting was not as good as the one belonging to Vittorio Becharo, he did directly commission a painting by Giorgione. This does not allow us to establish that the nine paintings described by Michiel (besides Bellini's *St. Francis*) were commissioned by Taddeo Contarini, but it shows that he was in touch with the artist before his death. What the "pictura de una notte" (painting of a night) represented is uncertain. It is, however, possible that the definition of "night" would encompass a devotional painting depicting the Nativity. Vescovo, followed by Nichols, believes that the better of the two Nativities, the one belonging to Vittorio Becharo, can be identified with Giorgione's *Allendale Nativity* (fig. 14) and the one belonging to Contarini with a version of it now at the Kunsthistorisches Museum in Vienna.[126] It is, however, impossible to link these paintings to the two patrons. All that can be reasonably proposed is that Taddeo Contarini and Vittorio Becharo each owned a *Nativity*—possibly similar in format to the *Allendale Nativity*—by Giorgione. Two things are curious about this. Vittorio, the patron of the better painting, is described as "Becharo"—that is, "Butcher."

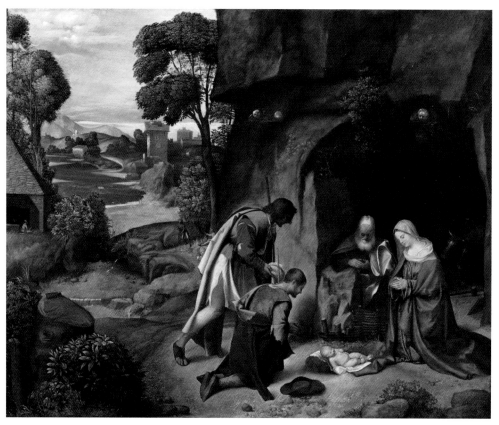

Fig. 14. Giorgio da Castelfranco, known as Giorgione, *The Adoration of the Shepherds*
(Allendale Nativity), ca. 1505–10. Oil on panel, 35 ¾ × 43 ½ in. (90.8 × 110.5 cm).
National Gallery of Art, Washington; Samuel H. Kress Collection

Surely there is a link between this wealthy butcher who commissioned a painting
from Giorgione and Taddeo Contarini, who owned most of the butcher shops
in Venice.[127] Furthermore, and more important, if Taddeo owned this "nocte"
by Giorgione, why is it not described by Michiel in 1525? Either the *Nativity*
had been sold by 1525, was displayed in another house belonging to Contarini,
or was in a part of the house that Michiel did not have access to. This last
consideration raises the question of how complete Michiel's list is. Did he record
all the paintings he saw in Contarini's house or only those he considered to be
the highlights of the collection?

Taddeo Contarini's House at Santa Fosca

Michiel prefaces the section listing the paintings belonging to Taddeo Contarini with "In casa de Ms. Tadio Contarino" (In the house of Messer Taddeo Contarini) but does not indicate the location of the house. In 1978, Salvatore Settis—the first to try to identify the building—writes that "Taddeo Contarini lived until his death in the parish of Santa Fosca, and therefore in the gothic Palazzo Contarini, then Correr, on Strada Nuova (Cannaregio 2217)."[128] The palazzo (fig. 15), which had belonged to the Correr family since the seventeenth century, had previously belonged to the Contarini family.[129] Settis's identification of the house is important because "a hundred paces away, as soon as one crosses the Rio di Santa Fosca on the bridge of the same name, or on the other that has kept the Vendramin name, is the palazzo (Cannaregio 2400), with elegant Lombardesque forms, where Gabriele

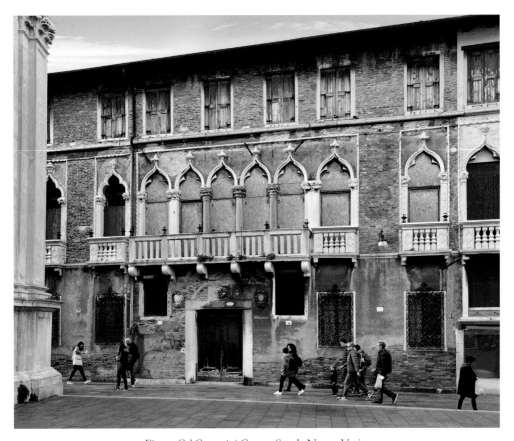

Fig. 15. Ca' Contarini Correr, Strada Nuova, Venice

1. Ca' Vendramin 4. Church of Santa Fosca
2. Ca' Vendramin Costa 5. Ca' Diedo
3. Ca' Correr Contarini 6. Church of San Marziale

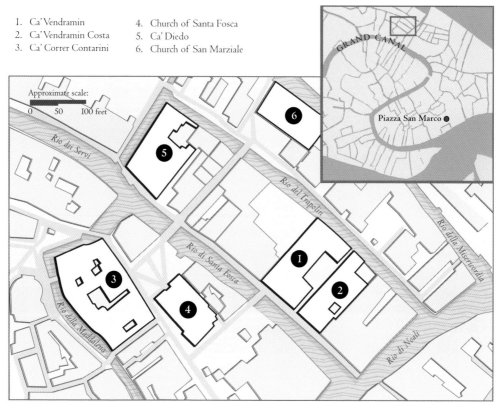

Fig. 16. Map of area around the church of Santa Fosca with the houses of the Contarini and Vendramin families

Vendramin lived, and therefore the *Tempest* … Gabriele Vendramin and Taddeo Contarini, the *Tempest* and *The Three Philosophers* were therefore also neighbors" (fig. 16).[130] According to Michiel (who described the collection in 1530), Vendramin, Contarini's brother-in-law, owned an art collection—even more important than Taddeo's—that included Giorgione's *Tempest* and a *Dead Christ*, along with works by Bellini, by Titian (ca. 1488/90–1576), and by northern artists, as well as a significant group of antiquities.[131]

In 1994, Donata Battilotti corrected Settis's identification.[132] Although the Ca' Correr on Strada Nuova seems to have belonged to a branch of the Contarini family in the sixteenth century, no evidence links it to Taddeo. Probably around 1495, when Taddeo married Marietta Vendramin, he moved to "a house of the Vendramin family at Santa Fosca 'built for him,' contiguous to the house of the brother-in-law."[133] In 1524, Federico Vendramin and his brothers recorded "at

Santa Fosca a rental house, in which Messer Taddeo Contarini lives and which was built for him" next to the palazzo of the Vendramin family.[134] It seems, therefore, that the Vendramin had leased a "casa da statio" (rental property) to Contarini next to their palazzo and that this house was rebuilt for him ("per lui fabrichada"). The Contarini family continued to live in this house after Taddeo's death. In a codicil (see Appendix, doc. 1) to his will of March 13, 1552 (a few days before his death on the 15th), Gabriele Vendramin asked his nephews Pierfrancesco and Dario Contarini to resolve the contentious situation regarding the house they were living in. The nephews had lived in the house since their father moved in more than fifty years before; Vendramin had paid for the building of it as a loan to Contarini, and, since the nephews were paying only 50 ducats per year, he asked them to return the property.[135] It is unclear when or if the Contarini returned the house to the Vendramin. Battilotti thus concluded that the house where Taddeo Contarini lived was not the Ca' Correr on Strada Nuova but rather a property contiguous to Ca' Vendramin.[136] Settis acknowledged Battilotti's correction while pointing out, "My main point was, and remains, alongside the close kinship between Gabriele Vendramin and Taddeo Contarini, their close physical proximity; and the house indicated by the two scholars is *closer* to Ca' Vendramin than the one I had identified."[137] He also made this valid observation: "it is a bit strange that Contarini, one of the wealthiest men in Venice, lived in a house that was not his own."[138] Apparently, Contarini rented another house belonging to the Vendramin, on the Giudecca, which he used "for pleasure."[139] A shrewd businessman, Taddeo Contarini relied on cheap rentals from his wife's family rather than spend his money to buy properties.

The proximity of Taddeo Contarini to Gabriele Vendramin was therefore not only a family one through marriage but also a physical one, with their houses adjacent to one another. Their ownership of paintings by the same artists— Giovanni Bellini and Giorgione—also prompts the question of whether the two men developed a taste for those artists at the same time or if one introduced them to the other. While Vendramin's collecting practices were clearly more sophisticated than Contarini's (he also owned albums of drawings and antiquities), it should be pointed out that Michiel visited Contarini's collection first, in 1525, and Vendramin's—next door—five years later.

So, where was Contarini's house at Santa Fosca? Although Battilotti concluded from a number of documentary sources that it was a "casa da statio" next to Ca' Vendramin, no one tried to identify it. Few scholars discussing the Contarini collection in the past thirty years have focused on this issue. The house is

typically described vaguely as being near Ca' Vendramin.[140] The 1556 inventory of the possessions of Dario Contarini (fully discussed below; see Appendix, doc. 3) mentions two spaces in Contarini's house that allow us to confirm Battilotti's conclusion and to propose a specific identification of the house. One space is the "camera sopra il canal de Santa Foscha" (room overlooking the canal of Santa Fosca) and the other is the "camera granda posta sopra il canal de San Marcilian" (large room overlooking the canal of San Marziale). This proves that the house of Taddeo Contarini (and of his son Dario) was located, like Ca' Vendramin, between the canal of Santa Fosca (now Rio de Santa Fosca) and that of San Marziale (now Rio del Trapolin). This further confirms that Taddeo and his collection were not located at Ca' Correr on Strada Nuova as it is on the opposite side of the church of Santa Fosca and away from both canals. The block between the two canals is not particularly large (see fig. 16) and is occupied at its

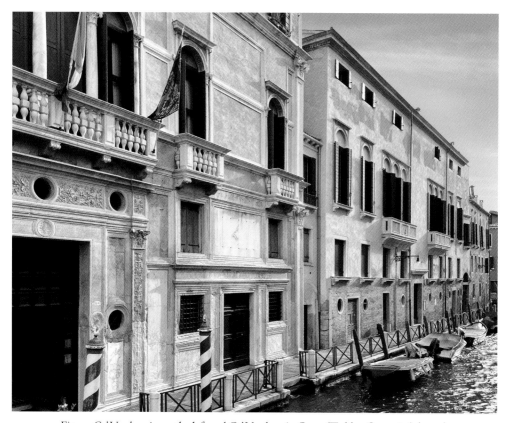

Fig. 17. Ca' Vendramin on the left and Ca' Vendramin Costa (Taddeo Contarini's house) on the right, facade on the Fondamenta de Ca' Vendramin

northwestern side by the large block of Ca' Diedo and toward its center by Ca' Vendramin. The buildings in this area are modest, with the exception of the one immediately to the right of the main facade of Ca' Vendramin, now known as Ca' Vendramin Costa (Cannaregio 2396—fig. 17). There is no literature on the history of this palazzo, but my firsthand study of the building and its architectural components reveals that this is most likely the "casa da statio" the Contarini rented from the Vendramin.[141] It is clear from the exterior of the building and from its plan that it was built over some pre-existing structures at the time of Taddeo Contarini and later heavily remodeled, especially on the side toward the Rio de Santa Fosca. The facade next to Ca' Vendramin, with a land entrance on the Fondamenta de Ca' Vendramin, was clearly refashioned after the Contarini, possibly in the seventeenth or eighteenth centuries, with a new facade that also included further adjacent buildings. In the interior, the rooms overlooking the Rio de Santa Fosca have nineteenth-century frescoes on the ceilings. At the back, however, toward the Rio del Trapolin (fig. 18), the architecture is probably intact from the time of Taddeo Contarini. The structure of the building, the shape of the windows, and the ceiling with wooden beams in the interior are all consistent with a late fifteenth- or early sixteenth-century style. The current plan of the building is centered around a small courtyard (fig. 19). In this courtyard is the main staircase of the house, now covered but originally probably an open-air staircase, as was common in many Venetian palazzi before the fifteenth century. The staircase leads to a landing on the *piano nobile* with two monumental doors, decorated with marble entablatures, that led to the rooms toward the canal of Santa Fosca and to the main *portego* (reception hall) of the house. The interiors were recently renovated to convert them into luxury apartments. The *portego* survives intact with its wooden ceiling. Toward Santa Fosca, there are at least two large rooms—though these spaces may have been created as we now see them later. To the left of the *portego*, toward Ca' Vendramin, is an enfilade of six rooms, which culminates in a large room that projects from the main body of the house, surely the "camera granda posta sopra il canal de San Marcilian." These were probably originally four rooms, which have been divided into smaller rooms. To the right of the *portego* were one or more rooms and a service staircase.[142] The only space that today maintains its original shape and size is the *portego*. Michiel's description of the Contarini collection, as we have seen, is divided over three rooms. Surely a wealthy man like Taddeo Contarini would have lived in a house with more than three rooms. How the collection was dispersed throughout the house can be understood by looking at two other documents.

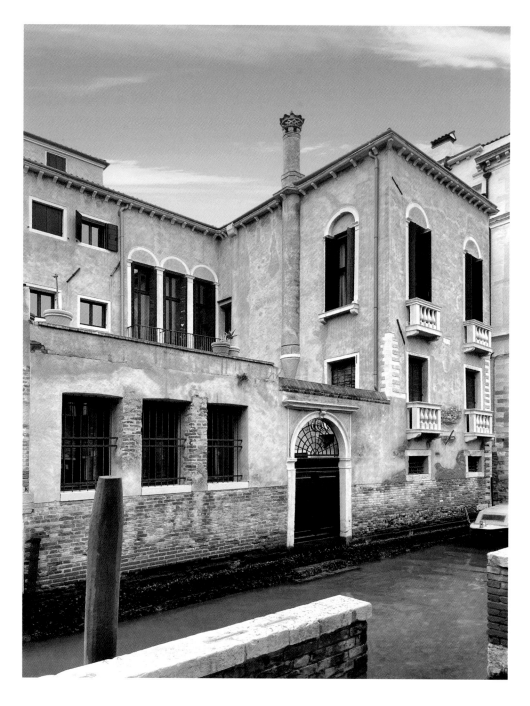

Fig. 18. Ca' Vendramin Costa (Taddeo Contarini's house), facade on the Rio del Trapolin

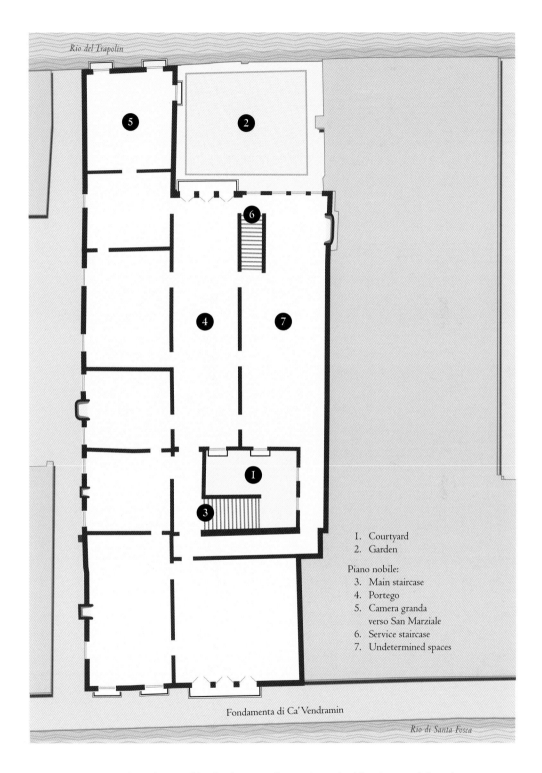

Fig. 19. Plan of *piano nobile* of Palazzo Vendramin Costa (Taddeo Contarini's house)

1556 – The Will and Inventory of Dario Contarini

We learn more about the Contarini family from the will of Dario—the "mato"—the son of Taddeo Contarini (see Appendix, doc. 2), which was written on August 24, 1556.[143] Dario had a natural brother, Nicolò, and two sisters, Andriana and Lucrezia (all three illegitimate children of Taddeo). By the time of his will, his brothers Pierfrancesco and Giovanni Andrea (Zuanandrea) were deceased. Dario left behind a wife, Elisabetta Corner, six sons, and two daughters. Three of his sons—Nicolò, Andrea, and Girolamo—were adults; the other three—Taddeo, Federico, and Marcantonio—were minors. His daughter Maria Colombina was a nun in the convent of San Zaccaria, and his instructions were that his other daughter, Elena, also become a nun. Dario's will included a family *fidecomisso*, a legal mechanism by which his heirs were to keep the inheritance intact until the twenty-fourth birthday of the youngest son (Marcantonio). Dario stipulated to his heirs: "in no way I want you to be able to divide or split, but I command you and I want you to always live and be united, as it has always been the custom of our family, and if you will do so you will be feared and respected."[144] He also asked that his sons "be and live always together in love and charity as good and loving brothers do."[145]

It was a few months after Dario's death—between October 17 and November 13, 1556—that the inventory of his possessions was compiled, and it is published here in full for the first time (see Appendix, doc. 3).[146] From it, we can see that more than thirty years after Michiel visited Taddeo Contarini's house, most of Taddeo's collection was intact and in the same house. The inventory lists all of Dario's possessions in the "home of the abovementioned noble family of Ca' Contarini, placed in the parish of Santa Fosca." Overseen by Dario's widow, Elisabetta, and his sons, Nicolò, Andrea, and Girolamo, the inventory was compiled over five days, beginning on October 17 and continuing on November 12, 13, 14, and 16.

As with most inventories of the time, it begins with the most valuable items, the cash and jewelry that were kept in small pouches and boxes in caskets in Taddeo's bedroom. These included some impressive objects, such as a gold ring with a turquoise that had belonged to Pierfrancesco (Taddeo's son) in his role as Patriarch of Venice, and a medal with a phoenix in enamel, decorated with six diamonds and six rubies. Several bags of money and many necklaces and rings are listed, as well as silver vessels, some of which were decorated with the Contarini and Corner coat of arms. It took almost two days (October 17 and

November 12) to record these objects, all of which were locked in a "large casket," the key to which was kept by Nicolò (the eldest son) by agreement with his mother and brothers. After listing the precious objects, the inventory continues, on the same day, with items in Dario's bedroom, "the room that the said deceased magnificent Messer Dario Contarini used to live in" ("la camera che solea habitar il ditto quondam magnifico misser Dario Contarini"). The inventory begins with a list of five paintings, three of which were described in 1525 by Michiel. The "small painting with the figure of Our Lord Messer Jesus Christ" is Bellini's *Christ Carrying the Cross*; the "large painting with its gilded frame with the image of St. Francis" is Bellini's *St. Francis in the Desert*; and the "other largish painting with three figures of naked women with its gilded frame" is Palma il Vecchio's *Three Women*.[147] Two other paintings are described as "a painting by Giovanni Bellini with a figure of a woman" and "a largish painting with its gilded frame with a woman looking at herself in the mirror."[148] The first one must be the "small painting of the woman portrayed life-size up to her shoulders" by Bellini mentioned by Michiel. Although the entry does not mention Bellini, the second painting has been connected with his *Woman with a Mirror* in Vienna (fig. 20).[149] It may have been acquired by Contarini after Michiel's visit in 1525. From this list of five paintings, we can conclude that while the paintings mentioned by Michiel were still in Dario's house, some of their locations must have changed after Taddeo's death. While the Palma and the Bellini *Christ* and *Woman* were in the same room, according to Michiel, the *St. Francis in the Desert* was not. It is fascinating to consider what Taddeo's bedroom would have looked like with two devotional paintings by Bellini (the *Christ Carrying the Cross* and the *St. Francis*) accompanied by three paintings of women more or less clothed by Bellini and Palma. The grouping of these paintings may have been intended to display Bellini's works all together, in a room devoted to the painter.[150] We know from the inventory that the room had at least two windows (*balcon*) and a fireplace (*fogher*). In it was Taddeo's bed, with the Contarini and Corner coat of arms, and a large mirror with the Contarini and Vendramin arms (clearly inherited from his parents). Around the room were eight walnut cassoni, which contained clothes belonging to Dario and his wife (skirts and shirts, hats, fur) and some children's clothes. This room was likely one of those off the *portego* toward Ca' Vendramin, with two windows and a fireplace.

The inventory resumes the next day, November 13, in Taddeo's bedroom with a list of a few more objects and then moves to a room "overlooking the canal of Santa Fosca." Again, the list starts with the paintings: Giorgione's *Birth of*

Fig. 20. Giovanni Bellini, *Woman with a Mirror*, 1515.
Oil on panel, 24¾ × 30¹³⁄₁₆ in. (62.9 × 78.3 cm.). Kunsthistorisches Museum, Vienna

Paris ("a large painting with two figures painted standing leaning on two trees with the figure of a seated man who plays the flute"); two small paintings of the Virgin Mary; and a small picture showing "various figures among which is painted a woman with a lyre in her hand and a man nearby."[151] Of these four, only the Giorgione seems to have been described by Michiel. However, he leaves blank the subject of one of the two paintings by Palma il Vecchio in the house, so it cannot be excluded that one of the paintings in the inventory was this picture. Michiel describes Bellini's *St. Francis* and Giorgione's *Birth of Paris* as being in the same room, whereas they were in different rooms by Dario's time.[152] The room toward the canal of Santa Fosca also had a fireplace and five more wooden cassoni with gilded frames. In them were rugs, curtains, cushions, and more clothes. This room also had a bed and a small area described as a *studiolo*. The next room is described as being "next to the abovesaid in which are the

household goods" ("appresso l'anteditta nel qual sta le massare"). Here were a bed and three cassoni containing tapestries, rugs, and fabrics. The inventory then goes to the opposite side of the house, to the "large room overlooking the canal of San Marziale" ("camera granda posta sopra il canal de San Marcilian"). Upon entering, there was a cassone containing tablecloths, napkins, and other textiles. Three paintings are listed, none of which seem to be mentioned by Michiel: "a figure of Our Lady in a small, gilded painting, a largish painting with the figure of Our Lady and St. John with its walnut frame profiled in gold, another large painting framed and old with the figure of Our Lady."[153] It is not specified who these paintings were by. There were another eight cassoni—containing clothes, tapestries, wall hangings, tablecloths, and pewter dishes—in the room, along with a bed, some chairs, and a desk (*studieto*). The inventory then goes to the mezzanines, where Dario's children had their apartments. First, we visit the "mezzanine in which lives the abovesaid magnificent Messer Andrea" ("mezzado nel qual sta il preditto magnifico misser Andrea"). This room had a bed, a desk, and four cassoni with the Contarini coat of arms—two of which had more items of clothing and textiles and some candlesticks, while the other two contained "various books of humanities and philosophy, large and small, printed and manuscript." There was also a bookshelf with "various books of the said magnificent Messer Andrea for his studies."[154] Andrea was clearly the scholar in the family. Dario writes in his will that Andrea "takes pleasure in literature" and expresses his hope that he continue to study in the future.[155] At the end of November 13, the inventory moves to the "mezzanine of Messer Nicolò" ("mezado de misser Nicolò"), the eldest son of Taddeo, where there were eight empty cassoni, also decorated with the Contarini arms. The last space accounted for on that day was the "room adjacent to the said mezzanine in which the reverend maestro di casa lives" ("camera contigua al predetto mezzado nella qual sta et habita il reverendo maistro di casa"). Only a bed and old furniture are listed there. The inventory resumes the next day with the objects in the kitchen (dishes, vessels, and utensils of different kinds). It is unclear from the document on which floor it was located. Next, "the room of Nena [Elena] located near the *guardaroba* [wardrobe]" ("camera della Nena posta appresso il salva robba"), which was decorated with a single small painting of the Virgin Mary. In terms of furniture, there were two cassoni with clothes and bed linen in them, as well as a bed. The "salva robba" was the room in which numerous household objects were kept: napkins, small buckets, baskets, and "old things of little value." From there, the inventory moves to the "mezzanine above the large staircase" ("mezado sopra

la scalla granda"). Five more chests, containing still more textiles, are described in this space; the chests bear the Contarini arms and are covered with five Turkish rugs. Interestingly, the objects listed here are a large map on paper glued on canvas and framed ("un napamondo de carta incolado su la tella con il suo teller indorado et soazado") and "over the fireplace two figures in marble, with their walnut boxes, namely one is Portia and the other Dido" ("sopra la nappa del camin de ditto mezado, due figure di marmoro fornide con le sue casse di nogara videlicet una Portia et l'altra Dido"). It is unclear why the two sculptures—the only ones mentioned in the entire inventory—were in wooden boxes, and it is strange that the only decorated chimneypiece was on a mezzanine. No trace of this fireplace remains in the house today. From this space, we move to a room "on the right overlooking the rio of San Marziale." We do not know if this room is above or below the "large room" toward San Marziale or if it is a room (on one of the various levels) to the right of the *portego*; it had a number of chests, some of which were empty, and was clearly a service space.

The inventory then moves to the central space in the house: the "large *portego* above" ("portego grando di sopra"), the main reception room of a Venetian house. Once more, the first objects listed are paintings. Three of the four listed also appear in Michiel's notebooks: "a large painting on canvas, framed, in which Hell is depicted" (Giorgione's *Hell with Aeneas and Anchises*); "a ragged old framed painting with a number of figures on horseback" (Girolamo Romanino's scene with horses); and "another largish painting on canvas, framed in walnut, with three figures" (Giorgione's *Three Philosophers*).[156] The last painting mentioned is "a largish painting with the figure of Our Lord and other figures with its gilded frame" by an unknown artist.[157] While the contents of the *portego* are listed toward the end of the inventory, it is clear that Michiel had started in the *portego*. The first room he describes in 1525 had the two Giorgione paintings and the Romanino, as well as a painting of an unknown subject by Palma il Vecchio. It is possible that the painting of Christ and other figures mentioned in the inventory of 1556 was the Palma and that the display of paintings in the *portego* of the palazzo had not changed over thirty years.[158] The furnishings in the *portego* included a large table and seven wooden benches painted in red. In this space was an altar (*giesiola*) and a sink (*lavello*), as well as a number of cassoni, some of them containing clothes belonging to Pierfrancesco Contarini, Dario's deceased brother who had been Patriarch of Venice. The inventory concluded that day with another service space: "the dark room under the room of Nena, near the mezzanine of Messer Nicolò" ("camera scura sotto la camera della nena, appresso il mezado

de misser Nicolò"), where various household objects were kept. The final day of the inventory—November 16—focuses on more service spaces: the "room of the domestics" ("camera di famegli"), two storerooms ("magazen"), and the cellar ("caneva"), where more objects were kept, as well as fourteen variously sized barrels for wine and two containers for oil. The last space described is the *portego* on the ground floor, the entrance to the house from the water side (on the Rio del Trapolin), directly below the *portego* on the *piano nobile*. This is where barrels and wooden beams were stored and where, just outside along the canal, the family kept "a used gondola with its covered cabin, oars, and all of its accessories" ("una gondola usada con suo felce, remi et tutti li sui fornimenti"). With this quintessential Venetian object, the inventory ends: "And this is the end of the said inventory" ("Et hic finis est dicti inventarii").

The 1556 inventory is an invaluable window onto the house of the Contarini family at Santa Fosca. If Michiel listed the highlights of the collection in three separate rooms of the house, the inventory demonstrates that the paintings had remained more or less where Taddeo displayed them. Only one work mentioned by Michiel was missing: the Milanese portrait of Bianca Maria Sforza. And it is unclear which painting is the Palma il Vecchio of uncertain subject that Michiel lists (but does not describe). As is the case with Michiel's notes, it is clear that the inventory does not describe every space in the palazzo. Apart from the *portego*, only three rooms on the *piano nobile* were inspected; the house surely had plenty more rooms.

Taddeo Contarini's Tomb at Santa Maria dei Miracoli

In his will of August 24, 1556, Dario Contarini asked to be buried in the church of Santa Maria dei Miracoli (fig. 21), where his father and brother (Andrea) were buried.[159] His father, Taddeo, had commissioned an altar in the church "in marble and with a painting of Saint Jerome," and Dario asked that his heirs build a tomb ("una archa") in front of it for his body and those of his father and brother, as well as his widow and children. But the tomb was never built. On April 1, 1611, when Dario's youngest child, Taddeo, wrote his will, he also asked to be buried in Santa Maria dei Miracoli, where, in the meantime, his mother and siblings had been buried.[160] He asked that his heirs commission a tomb, as his father had asked, but, as none of Dario's children had done so between 1556 and 1611, it is likely that Taddeo's children followed suit; so the tomb was never built. The

Fig. 21. Church of Santa Maria dei Miracoli, Venice

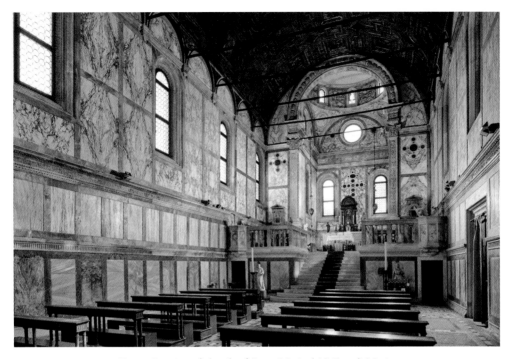

Fig. 22. Interior of church of Santa Maria dei Miracoli, Venice

family continued to be buried in front of the altar of St. Jerome, commissioned by Taddeo before his death in 1540. Four generations of the Contarini family seem to have been buried in front of this altar—for a century, between 1540 and the 1650s.[161]

No trace of an altarpiece with St. Jerome or of the Contarini tombs survives today in the interior of Santa Maria dei Miracoli (fig. 22). However, in his 1581 guidebook to Venice, Francesco Sansovino (1521–1586) writes that in the church of Santa Maria dei Miracoli "Giovanni Bellini painted there a Saint Jerome in the Desert."[162] This is further confirmed in a guidebook of 1664, in which Marco Boschini (1602–1681) writes: "entering the church, through the main door, on the left is the panel with Saint Jerome, and on the sides of the said altar there are saints Francis and Clare; all by the hand of Giovanni Bellini."[163] Roger Rearick has argued convincingly that Bellini's *St. Jerome in the Desert* was the painting now at the Uffizi in Florence (fig. 23), previously in the Papafava collection in Padua in the nineteenth century and subsequently in the Contini Bonacossi collection.[164] He also proposed, persuasively, that the saints Francis and Clare at the sides of the altarpiece—which Boschini describes, but not Sansovino—were, in fact,

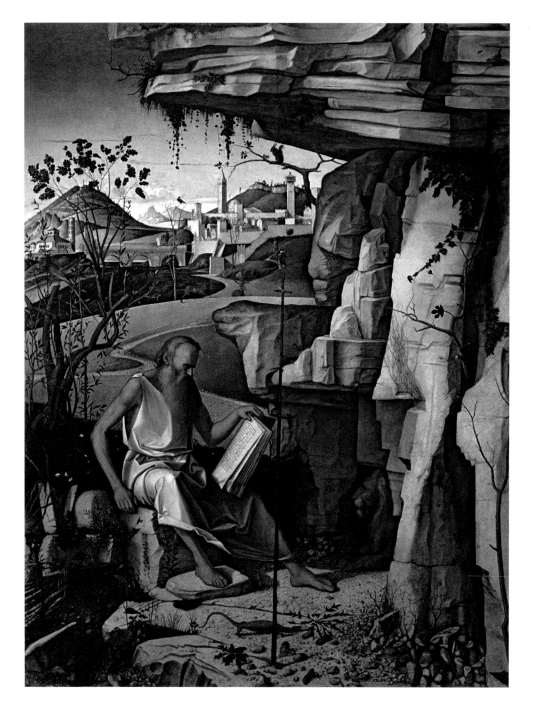

Fig. 23. Giovanni Bellini, *St. Jerome in the Desert*, ca. 1480–85. Oil on panel,
59¾ × 44¾ in. (151.7 × 113.7 cm). Gallerie degli Uffizi, Collezione Contini Bonacossi, Florence

two sculptures by Girolamo Campagna (1549–1625) today still in the church, and which Boschini misidentified as by Bellini.[165] Taken together, the evidence about Taddeo Contarini's altar and tomb at Santa Maria dei Miracoli and the identification of Bellini's *St. Jerome in the Desert* in Florence as the altarpiece demonstrates that Taddeo not only lived with a splendid painting by Bellini but that he also had a second, very similar one, near his tomb, placed on an altar he commissioned.

The *St. Jerome in the Desert* closely follows the composition of the *St. Francis in the Desert* and is believed to date from a few years later, in the early 1480s.[166] The saint is seated outside a cave, surrounded by a rocky landscape inhabited by various animals, including the saint's pet lion, a large lizard, a squirrel, and a pheasant. He is shown reading, seated on a stone, next to a wooden cross planted in the ground. At the far back, a theatrical curtain of boulders opens to a verdant landscape leading, yet again, to a city. The subject of St. Jerome meditating in the wilderness, a common iconographical choice for the saint, is treated by Bellini in a very similar manner to the *St. Francis*.

Once the link between the painting and the tomb of Contarini is made, it is reasonable to conclude that Taddeo must have been the patron of the painting, as has been maintained—if tentatively—by a number of scholars.[167] As we know that the *St. Francis in the Desert* was painted for Giovanni Michiel and later acquired by Taddeo Contarini (before or after Michiel's death in 1513?), one might assume that Taddeo commissioned the *St. Jerome* after purchasing the *St. Francis*. However, the *St. Jerome* can be dated, on stylistic grounds, to the early 1480s, probably to the first half of that decade; and Contarini was born around 1466. He would therefore have commissioned the painting when he was in his teens or early twenties—not impossible but unlikely. More important, Santa Maria dei Miracoli was only consecrated as a church in 1489. The dating of the painting to the early 1480s is not unanimous, with Rearick pushing the date to 1485–87, arguing that it was being painted as the church was being built.[168] The question of whom Bellini's *St. Jerome* was painted for and the location for which it was intended remains unanswered. If Contarini purchased the *St. Francis* after Giovanni Michiel's death, he would have done so almost twenty years after the *St. Jerome* was painted. It is also possible that Contarini's purchase of the *St. Francis* postdated the acquisition of the *St. Jerome*, that he purchased the painting from Michiel after having placed the *St. Jerome* over his altar.

What Taddeo Contarini commissioned remains unknown.[169] He purchased the *St. Francis* on the market, so it is possible that he acquired the *St. Jerome* on the

secondary market and then placed it in Santa Maria dei Miracoli in the altar he commissioned for the church (the family's connection to the church also remains to be established). We have the same problem with the Giorgione. When Michiel describes the *Birth of Paris*, he specifies that it is one of Giorgione's "first works" ("fu delle sue prime opere"), placing it in the 1490s. Contarini could have been in touch with Giorgione in the 1490s, around the time of his marriage to Marietta Vendramin, and he could have later commissioned two other works: the *Hell with Aeneas and Anchises* (date unknown) and—at the end of Giorgione's life—*The Three Philosophers*. One of the many unknowns about Taddeo Contarini is whether he was a visionary patron, commissioning works directly from Bellini and Giorgione, or a shrewd collector who purchased several of their paintings as they appeared on the market. And what was his relationship to his younger (almost by twenty years), more refined brother-in-law, Gabriele Vendramin? Was Contarini a model for him, or, instead, did he follow his example as a collector, after marrying his sister (when Gabriele was still a teenager) and moving into the adjacent palazzo?

Taddeo Contarini's Collection and Its Afterlife

This catalogue celebrates the reunion of Bellini's *St. Francis* with Giorgione's *Three Philosophers* for the first time since they left the Contarini collection, probably about four centuries ago. By the time the American industrialist and collector Henry Clay Frick (1849–1919) purchased the Bellini, in 1915, it had been more than one hundred years since the panel had been in Venice. Its full provenance has been brilliantly charted by Anne-Marie Eze and Rosella Lauber; there is no need to reiterate every detail about the painting's journey from Venice to New York.[170] Suffice it to say that, by 1915, the Bellini had been in collections in Milan, Paris, London, and rural Berkshire, from where the dealers Colnaghi, Knoedler, and Agnew's placed it on the market, after purchasing it in 1912. Up until at least 1796, the Bellini had not left the Contarini family. Notwithstanding the fact that Dario Contarini had six sons, the inheritance passed through the female line. Two of the six brothers had illegitimate children: Andrea's daughter Cecilia, and Taddeo's son Pietro Francesco.[171] Girolamo had married Agustina Contarini, and they had three children: Nicolò, Maria, and Elisabetta. Nicolò—who seems to have been the last Contarini buried at Santa Maria dei Miracoli—died without children, and the inheritance passed to Elisabetta and her husband, Giulio Giustinian (delle Aquile d'Oro, of San Stae). The painting was then passed through her

Fig. 24. David Teniers the Younger, after Giorgione, *The Finding of the Infant Paris*, after 1651. Oil on panel, 9 1/16 × 12 3/8 in. (23 × 31.5 cm). Private collection

children into the Giustinian family, and through several generations and a second marriage of Alba Giustinian, into the Corner (of the Ca' Granda) family. It is unclear when Taddeo's family vacated the Vendramin property at Santa Fosca, but, because of the extinction of the male line of Taddeo's family, the Bellini was to adorn first the Ca' Giustinian at San Stae—where Marco Boschini described it in 1660—and then the monumental Ca' Corner, known as the Ca' Granda. By contrast, Giorgione's *Three Philosophers* arrived at its final destination much earlier. From the inventory of 1556, we know that at that time the two paintings were still together in the Contarini collection. By 1636, however, the Giorgione belonged to Bartolomeo dalla Nave (1571/79–1632) in Venice.[172] After a brief period in England, the canvas reached the collection of Archduke Leopold Wilhelm of Austria (1614–1662), in Brussels and then in Vienna, by at least 1659; it then remained in Vienna in the imperial collection, which subsequently became the foundation of today's Kunsthistorisches Museum. We can, therefore, conclude that the last time Bellini's *St. Francis* and Giorgione's *Three Philosophers* were seen together was between 1556 and 1636.

As for the other paintings in the Contarini collection, we can trace only three pictures after the collection's dispersion: Palma il Vecchio's *Three Women*, Giorgione's *Birth of Paris*, and Giovanni Bellini's *Woman with a Mirror*. Palma's *Three Women* traveled with Bellini's *St. Francis* through the Giustinian and Corner families and was sold for 600 gold ducats, in 1743, by Alba Corner to Francesco Algarotti (1712–1764), who was acting as an agent on behalf of the Elector of Saxony and brought the painting to Dresden, where it remains to this day.[173] The *Birth of Paris* and the *Woman with a Mirror* also reached Archduke Leopold Wilhelm in Vienna.[174] While the *Woman with a Mirror* remains, like *The Three Philosophers*, in the collection of the Kunsthistorisches Museum, the *Birth of Paris* passed from the Dalla Nave collection to England and then to Leopold Wilhelm, before disappearing.[175] The painting, when sold to James Hamilton, 3rd Marquess of Hamilton (1606–1649), through Basil Fielding (ca. 1608–1675), was now described as "another picture of the history of the Amazons with 5 figures to the full and other figures in a Landskip of the same greatness made by the same Giorgione."[176] The entry directly followed that for "A picture with 3 Astronomers and Geometricians in a Landskip who contemplate and measure … of Giorgione de Castelfranco."[177] This confirms that *The Three Philosophers* and the *Birth of Paris* were about the same size ("of the same greatness") and therefore about the same dimensions as the Bellini *St. Francis*. Before disappearing from the collection of Leopold Wilhelm, the *Birth of Paris* was copied by David Teniers the Younger (fig. 24), and his copy matches Michiel's descriptions and is consistent with the elements of the composition recorded in the 1556 inventory: "two figures … standing leaning on two trees with the figure of a seated man who plays the flute." It would be more accurate to title the work *The Finding of the Infant Paris*. The Trojan prince was abandoned soon after his birth, as his mother Hecuba had a dream foretelling how the boy would bring Troy to destruction. The baby was entrusted to a herdsman, Agelaus, who, instead of killing him, abandoned him on Mount Ida. Paris, however, was suckled by a bear and survived. A group of shepherds found him alive and raised him. Even without Giorgione's original, Teniers's copy preserves the composition of the painting. Without Michiel's description, the subject of the painting would be difficult to determine. It is not surprising that already in the 1630s the canvas was believed to represent something altogether different: Amazons were said to abandon their newborn boys.[178] The subject matter of *The Three Philosophers* and of the *Tempest* may have been equally obscure and seldom represented narratives.

The third Giorgione in Taddeo Contarini's collection is altogether lost. Both Michiel and the 1556 inventory indicate that the painting was large ("tela grande"

Fig. 25. Giovanni Bellini, *Christ Carrying the Cross*, ca. 1500–1510.
Oil on panel, 19½ × 15¼ in. (49.5 × 38.7 cm). Toledo Museum of Art, Ohio; Purchased with
funds from the Libbey Endowment, Gift of Edward Drummond Libbey

and "quadro grando") and that its main subject was Hell (the word *Inferno* is used in both sources). Michiel further specifies that the painting included the figures of Aeneas and Anchises ("con enea et anchise"). The painting may have represented the episode of Aeneas's visit to the underworld, from Book 6 of Virgil's *Aeneid*, or, as argued by Alessandro Nova, the destruction of Troy (the fire of the city being interpreted as an "inferno"), with Aeneas fleeing with his father on his shoulders.[179] In both cases, the *Hell with Aeneas and Anchises*, like the *Finding of the Infant Paris*, would have represented a subject linked to Troy and the Trojan War, suggesting that the two canvases might have been related in some way. Since the painting has disappeared without a trace, it is impossible to determine, as both Anderson and Nova suggest, if "the painting of a night" ("pictura de una notte") in the letter from Taddeo Albano to Isabella d'Este in November 1510 was one and the same picture.[180] Nova argues that the painting was left unfinished at Giorgione's death and that is why Vittorio Becharo's painting was of "much better design and better finished." If "the painting of a night" was, instead, a separate painting—potentially a *Nativity*—it must have left the Contarini collection before 1525 and certainly before 1556.

When Morelli and Frizzoni published Michiel's notes, they attempted to identify other paintings in the Contarini collection. They hypothesized that Bellini's *Christ Carrying the Cross* was the painting belonging to Count Zileri dal Verme and on view at Palazzo Loschi in Vicenza.[181] The painting was subsequently acquired, in 1898, by Isabella Stewart Gardner and is part of the museum founded by her in Boston.[182] In 1939, though, George Martin Richter linked the painting described by Michiel with another that had a provenance from the La Châtre and Brissac families in France during the nineteenth century and which is now in the Toledo Museum of Art (fig. 25).[183] Most scholars have agreed with this.[184] The provenances of both paintings, however, make it impossible to determine which of these two—if either of them—was the Contarini painting. The Toledo panel, albeit much abraded in the face of Christ, probably gives a good indication of what Taddeo Contarini's *Christ Carrying the Cross* may have looked like.

The Romanino painting must have been an impressive, large canvas, although by 1556 it is inventoried as ragged ("strazado")—if not slashed—and must have been in poor condition, as it is also described as "old" ("vecchio"), probably a reflection of its condition rather than its actual age. Having been painted in tempera, it probably suffered from the humidity in Venice more than the other paintings. What the "drawing up of horses" or the "number of figures on horseback" were meant to represent in this painting is unknown. A drawing

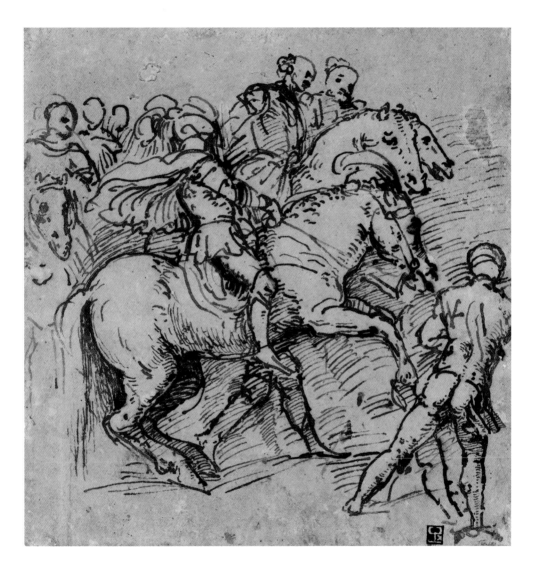

Fig. 26. Girolamo Romanino, *Men on Horseback*, ca. 1525–35.
Pen and ink on paper, 11 × 10⁹⁄₁₆ in. (280 × 270 mm). Szépmüvészeti Múzeum, Budapest

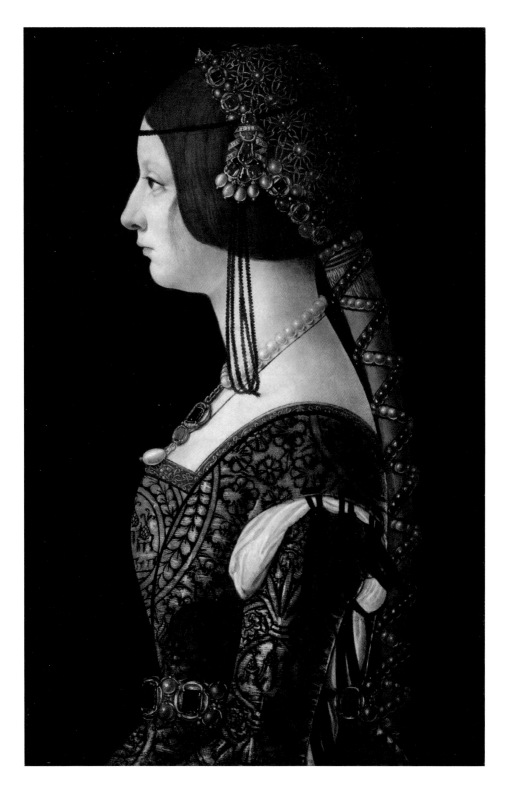

Fig. 27. Ambrogio de Predis, *Bianca Maria Sforza*, ca. 1493. Oil on panel,
20 1/16 x 12 13/16 in. (51 x 32.5 cm). National Gallery of Art, Washington; Widener Collection

(fig. 26), now in Budapest, is reasonably thought to provide a general idea of what the large canvas may have looked like, even though it probably postdates the Contarini painting.[185]

If Michiel was correct about the identification of the Milanese portrait, its subject was Bianca Maria Sforza. Morelli and Frizzoni, however, tried to identify it, unconvincingly, with a portrait believed to be of Beatrice d'Este (1475–1497) by Ambrogio de Predis (ca. 1455–1510) in the Pinacoteca Ambrosiana in Milan.[186] No one has attempted to locate this portrait since. Another portrait by Ambrogio de Predis and believed to be of Bianca Maria Sforza (fig. 27) fits, in general, Michiel's description.[187] Unfortunately, the portrait has no provenance before 1888, when Friedrich Lippmann (1838–1903) purchased it from an undisclosed private collection in England. However, even if it cannot be said with certainty that these two paintings are the same, the painting seen by Michiel must have been similar and possibly more tightly cropped—"in profile, up to the shoulders" ("in profilo insino alle spalle")—and by a Milanese painter, like De Predis.

<p style="text-align:center">✳ ✳ ✳</p>

To this day, Taddeo Contarini is best known for his ownership of two masterpieces of Venetian Renaissance painting: Bellini's *St. Francis in the Desert* and Giorgione's *Three Philosophers*. These are also the most important paintings surviving from his collection; the only other one that can be identified with certainty is Palma il Vecchio's *Three Women*. Most probably, Bellini's late *Woman with a Mirror* in Vienna also belonged to Contarini, while Giorgione's *Finding of the Infant Paris* is known only from the copy by Teniers. Proposals to identify Bellini's *Christ Carrying the Cross* are, at present, inconclusive, while the large canvases by Romanino and Giorgione and the portrait of Bianca Maria Sforza are lost. The painting by Palma that Michiel leaves undescribed cannot be identified, though it could be the "largish painting with the figure of Our Lord and other figures" in the *portego* in 1556.

Notwithstanding the attention that has been lavished on the paintings from his collection, Contarini remains an elusive figure, one we can only understand through some glimmers of information across his life. The reunion of these two paintings brings an important part of Contarini's collection back to life in New York, the city that is now home to Bellini's *St. Francis*. It is hoped that future research in the archives in Venice will result in more knowledge about Taddeo, his career, his family, his palazzo, his interest in the visual arts, and his relationships with Giovanni Bellini and Giorgione.

Notes

1 For Michiel, see, in particular, Fletcher 1973;
Fletcher 1981a; Fletcher 1981b; Anderson 1997,
53–60; Lauber 2002; Schmitter 2003; Lauber 2007;
Lauber 2010.

2 The manuscript in the Biblioteca Nazionale
Marciana (hereafter BNM) is Ms. It. XI, 67
(=7351, *olim* Apostolo Zeno 346). For printed
editions of the manuscript, see Morelli 1800;
Morelli and Frizzoni 1884; Frimmel 1896; De
Benedictis 2000.

3 My transcription of Michiel, and subsequent
ones, are based on the original manuscript and not
on the subsequent printed editions. Translations
in English are mine. BNM, Ms. It. XI, 67 (=7351,
olim Apostolo Zeno 346), f. 54r: "In casa de Ms.
Tadio Contarino. 1525. La Tela a oglio delli 3
phylosophi nel paese, dui ritti et uno sentado che
contempla gli raggii solari cum quel saxo finto
cusi mirabilmente, Fu cominciata da Zorzo da
Castel Franco, et finita da Sebastiano Venitiano."

4 BNM, Ms. It. XI, 67 (=7351, *olim* Apostolo Zeno
346), f. 54v: "La Tavola del S. Franc.o nel diserto,
a oglio, Fu opera de Zuan bellino, cominciata da
lui a Ms. Zuan michiel, et ha un paese propinquo
finito et ricercato mirabilmente."

5 BNM, Ms. It. XI, 67 (=7351, *olim* Apostolo Zeno
346), ff. 54v:
"La Tela grande a colla, dil'ordinanza di cavalli,
Fu de mano de hier.mo romanin bressano
La Tela grande a oglio del'inferno con enea et
anchise, Fu de mano de Zorzo da castel Franco
El quadro de Fu de mano de Jac.o Palma
bergamasco
El quadro delle 3 donne retratte dal naturale
insino al cinto, Fu de man del Palma
El quadretto della dona retratta al naturale insino
alle spalle, Fu de man de Zuan bellino
El quadro del christo con la croce in spalla insino
alle spalle fu de mano de zuan bellino
El retratto in profilo insino alle spalle di m.a
fiola del sig.r lodovico da Milano maritata nello
imperatore Maximiliano, Fu de mano de
Milanese.
La Tela del paese con el nascimento de paris con
li due Pastori ritti in piede, Fu de mano de Zorzo
da castel Franco et Fu delle sue prime opera."

6 S. Rutherglen in Rutherglen and Hale 2015, 56.

7 For this theory, see Maze 2021. For the
controversy it generated, see, in particular,
Calogero 2021; Brooke 2022a; Brooke 2022b;
Maze 2022. For the early biographies of Bellini,
see Gasparotto 2018.

8 Gasparotto 2018, 14.

9 For the most complete discussion of the
painting, see Rutherglen and Hale 2015.

10 Christiansen 2009, 26.

11 For St. Francis's biography, see Frugoni 1995 and
Frugoni 2011.

12 Clark 1949, 24–25.

13 For Francis and the stigmatization, see Frugoni
1993.

14 Meiss 1964.

15 Mather 1936, 99–101; Turner 1966, 59–65; Wohl
1999.

16 Robertson 1968; Janson 1994; Fleming 1982; Hirdt
1997, 29–74; Lavin 2007.

17 "l'opera è divenuta un banco di prova
dell'iconologia selvaggia, inventando iconografie
altrimenti non attestate"; De Marchi 2012, 194.

18 Fletcher 1972a, 211.

19 Fletcher 1972a, 212.

20 Fletcher 1972a, 209.

21 Fletcher 1972a, 209. See also S. Rutherglen
in Rutherglen and Hale 2015, 49–55; Lucco,
Humfrey, and Villa 2019, 441.

22 "Nel caso del *San Francesco* possiamo invece
argomentare che esso nacque come dipinto da
stanza, che ricalca la forma di una pala quadra";
De Marchi 2012, 194.

23 "l'argomento di Giorgione che, purtroppo, si
usa trattare dall'alto ed avvolgendosi di cortine
fumogene. Se si riuscirà un giorno a parlarne
più semplicemente senza discorrere di musica, di
liuti, di poesia e senza intossicarsi di 'tono,' sarà
tanto di guadagnato"; Longhi 1985, 22.

24 "quasi impossibile, infine, render conto dell'arte di
Giorgione"; Chastel 2012, 11.

25 Vasari 1976, 41–47.

26 A clear example are the seven cumbersome
volumes of Ballarin 2016, proving that size and
length are not necessarily connected to usefulness.

27 "fu dipinto forse per lo stesso gentiluomo
veneziano, Taddeo Contarini, nella cui casa lo
registra nel 1525 Marcantonio Michiel"; Settis
1978, 19.

28 Settis (1978, 26) clearly identifies it as a sunset but without any specific evidence.

29 Settis 2021, 12.

30 Conway 1929, 28.

31 Hope 1985, 428.

32 Gasparotto 2018, 94.

33 For a link between *The Three Philosophers* and the Giulio Campagnola print, see, for example, Anderson 1997, 154–55.

34 See, for example, among many, Venturi 1913; Mather 1923; Richter 1937; Fiocco 1941; Morassi 1942; Fiocco 1948; Pallucchini 1955; Berenson 1957; Zampetti 1968; Anderson 1997; Gabriele 2004.

35 Williams 1968, 66.

36 Anderson 1997, 154.

37 Baldass 1922.

38 Parducci 1935.

39 Wischnitzer-Bernstein 1945.

40 Nardi 1955a; Nardi 1955b; Nardi 1971.

41 Pignatti 1955.

42 Anderson 1997.

43 Hartlaub 1925; Hartlaub 1953.

44 Ferriguto 1933.

45 Venturi 1954.

46 Meller 1981.

47 Tolnay 1963; Calvesi 1970; Cohen 1995; Borchhardt-Birbaumer 2004.

48 Zeleny 2007, Zeleny 2008; K. Zeleny in Vienna 2008.

49 Crowe and Cavalcaselle 1871, 135–36.

50 See, among others, Mechel 1781; Mechel 1784; Engerth 1884; Morelli and Frizzoni 1884; Hourticq 1930a; Wilde 1932; Gilbert 1952; Klauner 1955; Shapley 1959; Wind 1969; Wilde 1974; Settis 1978; Oberhuber 1979; Vasoli 1981; Gombrich 1986; Settis 2021.

51 Schaeffer 1910.

52 Pigler 1935.

53 Wickhoff 1893; Wickhoff 1895.

54 Schier 2017.

55 Parronchi 1965.

56 MacLennan and Kilpatrick 2001.

57 Hornig 1979.

58 Nichols 2020, 8.

59 Settis (1978, 125) was already writing about Giorgione's "ambiguità iconografica," and Nichols (2020) chose to use the word *ambiguity* in

the title of his book on Giorgione. Baldass (1953) proposed that the paintings had no subject at all.

60 Settis 1978, 16.

61 "Se da una parte c'è chi—senza sempre negare il soggetto—studia quasi solo lo stile, dall'altra chi—senza voler trovare simboli e allegorie a tutti i costi—studia quasi solo i significati, allora la separazione di forma e contenuto è diventata in un certo modo un'opposizione, si è risolta in una drammatica lacerazione non solo nell'individualità dell'artista, ma anche *dentro* ogni singola 'opera d'arte'. . . . Se ha senso dire anche una verità assolutamente banale, forma e contenuto nascono insieme; e lo stile muta in funzione della miglior espressione del soggetto"; Settis 1978, 13.

62 Wilde 1932.

63 Mucchi 1978, 52–53; Oberthaler 2004, 267–68.

64 For the misunderstandings in the X-ray, see Anderson 1997, 86–87.

65 Settis 1978, 22, 36–41.

66 "Said to have been finished by Sebastian del Piombo, of which there is no trace"; Crowe and Cavalcaselle 1871, 136n.1.

67 Settis 1978, 19.

68 Hourticq 1930a, 63.

69 Baldass 1953.

70 Morassi 1951, 215.

71 Richter 1934, 274, 277.

72 Richter 1934, 274.

73 "in merito alla collaborazione di Sebastiano del Piombo, di cui parla il Michiel, è ben difficile dire in che cosa essa consista e problematico rintracciarne con sicurezza gli elementi: l'opera infatti appare mirabilmente unitaria"; P. Zampetti in Venice 1955, 38.

74 J. Anderson in Washington 2006, 164–66.

75 Oberthaler 2004, 267–68.

76 Hope 2016.

77 The same could be said about Giorgione's *Sleeping Venus* in Dresden, generally believed to have been finished by Titian. In fact, it is likely to be entirely the work of the young Titian.

78 Wickhoff 1893, 9–11; Wickhoff 1895.

79 Settis 1978, 36.

80 Klauner 1955.

81 Turner 1966, 86.

82 Waterhouse 1974, 19.

83 "a Christian counterpart to Giorgione's philosophical picture"; Anderson 1997, 158.

84 Nichols 2020, 137.

85 "i Contarini sono forse la piú vasta e ramificata tra le famiglie patrizie veneziane"; Settis 1978, 139.

86 Magno 2019, 196.

87 Morelli and Frizzoni 1884, 164.

88 Fletcher 1972a, 209–10.

89 Ferriguto 1933, 191.

90 Sanudo's surname is often Italianized as Sanuto, and so it appears in the publication of the *Diaries*.

91 Sanuto 1879–1903, 8: 276, 366, 442, 465; 9: 561; 10: 796; 17: 391; 23: 259.

92 Sanuto 1879–1903, 36: 618.

93 Sanuto 1879–1903, 3: 302, 589; 5: 88, 187, 379, 398, 434, 530, 653, 694, 703, 731, 788, 816; 6: 229, 277, 285, 311, 317, 324, 335, 345, 348; 7: 114, 123, 134, 148, 156, 170, 172, 227, 243, 272, 305, 310, 336, 363, 384, 413, 557, 587, 602, 614, 618, 642, 735, 754; 8: 489; 9: 192, 313, 418, 422.

94 Sanuto 1879–1903, 20: 436.

95 Settis 1978, 141. Fletcher (1972a, 209n.7) also was close in identifying the owner of the collection with this Taddeo Contarini: "Yet another eligible Taddeo Contarini married the sister of Gabriel Vendramin whose famous art collection is also described by Michiel but from documents concerning the family in the Correr library it is clear that he joined the Vendramin family and kept no establishment of his own but lived in the Vendramin palace at Santa Fosca."

96 R. Lauber in Hochmann, Lauber, and Mason 2007, 263.

97 "4 da cha' Contarini, gran richi"; Sanuto 1879–1903, 23: 413; 38: 153. For more on his business, see 15: 57; 20: 459; 24: 589, 25: 110; 27: 631; 34: 279; 35: 470; 36: 350; 45: 627; 46: 38; 55: 36, 322, 552.

98 Sanuto 1879–1903, 1: 508.

99 Sanuto 1879–1903, 9: 485.

100 Sanuto 1879–1903, 19: 357; 29: 495; 33: 612.

101 "pani d'oro e di seda per gran valuta"; Sanuto 1879–1903, 27: 237; R. Lauber in Hochmann, Lauber, and Mason 2007, 263.

102 Sanuto 1879–1903, 38: 153; 41: 74, 628; 43: 79–80, 377; R. Lauber in Hochmann, Lauber, and Mason 2007, 263.

103 Sanuto 1879–1903, 10: 44, 57, 644; 11: 789; 12: 336, 493; 13: 487; 20: 539–40; 21: 172, 174; 22: 521, 678; 23: 316, 375, 377, 390–91, 426, 428, 537; 47: 566; 49: 321.

104 Sanuto 1879–1903, 17: 45; 21: 193, 444; 23: 185, 375, 377, 426, 428, 537; 25: 110; 28: 490; 45: 451.

105 "molti di caxe grande insoliti a venir, fra li qual sier Tadio Contarini qu. Sier Nicolò et fioli" and among those "insoliti venir a Conseio"; Sanuto 1879–1903, 45: 483, 560.

106 "parenti dil Doxe vestiti di seda, veludo, et damaschin, et scarlato"; Sanuto 1879–1903, 34: 159; see also 5: 441.

107 Sanuto 1879–1903, 46: 26.

108 Sanuto 1879–1903, 17: 506; 37: 375.

109 Sanuto 1879–1903, 2: 1248; 3: 109, 114, 372; 6: 23; 24: 269, 342, 356; 25: 71, 79; 26: 17.

110 Padoan 1979, 33–34; Settis 1981, 385–87; Battilotti 1994a; Anderson 1997, 148–60; R. Lauber in Hochmann, Lauber, and Mason 2007, 263–64.

111 Archivio di Stato, Venice (hereafter ASV), Avogaria di Comun, *Cronaca di Matrimoni*, 107/2, f. 63r; Settis 1978, 141, 151n.62; R. Lauber in Hochmann, Lauber, and Mason 2007, 263. For Gabriele, see, especially, Battilotti 1994b; R. Lauber in Hochmann, Lauber, and Mason 2007, 317–19.

112 Sanuto 1879–1903, 33: 311. For the four sons, see Settis 1978, 151n.59; R. Lauber in Hochmann, Lauber, and Mason 2007, 263.

113 For Girolamo, see Sanuto 1879–1903, 37: 266; 38: 135, 162; 39: 328, 391; 42: 360–62; 43: 162–63; 46: 184, 656; 47: 55, 356; 48: 157; 54: 57, 363, 603; 56: 69; 57: 106, 663.

114 "Dario Contarini di sier Tadio, è mato"; Sanuto 1879–1903, 45: 560. For Dario's political career, see 35: 148, 155, 172, 176; 36: 283, 458.

115 ASV, Avogaria di Comun, Necrologi, b. 159; Settis 1978, 141; Battilotti 1994a, 207n.26; R. Lauber in Hochmann, Lauber, and Mason 2007, 263.

116 "Taddeo Contarini, uno degli intellettuali piú in vista del tempo"; Pallucchini 1955, tav. XVI. "uno degli intellettuali più famosi del tempo"; Perissa Torrini 1993, 88.

117 Settis 1978, 142; Nichols 2020, 25.

118 *Libri commemoriali* 1904, 156, 162; Settis 1978, 140; R. Lauber in Hochmann, Lauber, and Mason 2007, 263.

119 Coggiola 1908, 54; Settis 1978, 141; Anderson 1997, 152; R. Lauber in Hochmann, Lauber, and Mason 2007, 263.

120 "Ms. Hieronimo figlio de Ms. Thadio Contarino"; Settis 1978, 141. R. Lauber in Hochmann, Lauber, and Mason 2007, 263. The episode is best explained in Vescovo 2000, 115–16.

121 Vescovo 2000, 116; R. Lauber in Hochmann, Lauber, and Mason 2007, 263.

122 J. Anderson in Washington 2006, 164.

123 "un ricchissimo mercante specializzato nel commercio marittimo e in particolare nell'importazione di generi alimentari e sopratutto di carne, finanziere potente, uomo raffinato e senza scrupoli"; Vescovo 2000, 114.

124 "Nei suoi *Diarii*, Sanudo delinea un poco lusinghiero cammeo del personaggio; potente finanziere, uomo raffinato, ma senza scrupoli"; R. Lauber in Hochmann, Lauber, and Mason 2007, 263.

125 "Ho Inteso quanto mi scrive la Excellentia Vostra per una sua de XXV del passato, facendome intender haver inteso ritrovarsi in le cosse et eredità del quondam Zorzo de Castelfranco una pictura de una notte, molto bella et singular; che essendo cossì si deba veder de haverla. A che rispondo a Vostra Excellentia che ditto Zorzi morì, più dì fanno, de peste, et per voler server Quella ho parlato con alcuni mie' amizi, che havevano grandissima praticha cum lui, quali mi affirmano non esser in ditta heredità tal pictura. Ben è vero che ditto Zorzo ne feze una a messer Tadeo Contarini, qual per la informatione ho autta non è molto perfecta sichondo vorebe Quella. Un'altra pictura de la nocte feze ditto Zorzo a yno Victorio Becharo, qual per quanto intendo è de meglior desegnio et meglio finitta che non è quella del Contarini. Ma esso Becharo al presente non si atrova in questa terra, et sichondo m'è stato afirmato né l'una né l'altra non sono da vendere per pretio nessuno, però che li hanno fatte fare per volerle godere per loro; sicché mi doglio non poter satisfar al dexiderio de Quella." Archivio di Stato, Mantua (hereafter ASM), Archivio Gonzaga, b. 1893, f. 68. The letter is published and discussed by Maschio 1994, 196, tavv. 372–73; Vescovo 2000, 109; R. Lauber in Hochmann, Lauber, and Mason 2007, 263. Isabella's letter of October 25, 1510, is in ASM, Archivio Gonzaga, b. 2996, copialettere 28, f. 70r.

126 Vescovo 2000, 109; Nichols 2020, 22, 130.

127 R. Lauber in Hochmann, Lauber, and Mason 2007, 263.

128 "Taddeo Contarini abitò fino alla morte nella parrocchia di Santa Fosca, e dunque nel gotico Palazzo Contarini, poi Correr, sulla Strada Nuova (Cannaregio 2217)"; Settis 1978, 142.

129 For the palazzo, see Bassi 1976, 460–63.

130 "A cento passi di distanza, varcato appena il rio di Santa Fosca sul ponte omonimo, o sull'altro che ha serbato il nome di Vendramin, è il palazzo (Cannaregio 2400), di eleganti forme lombardesche, dove abitò Gabriele, e dunque la *Tempesta* … Gabriele Vendramin e Taddeo Contarini, la *Tempesta* e i *Tre Filosofi* erano dunque anche vicini di casa"; Settis 1978, 142.

131 For Gabriele Vendramin and his collection, see Battilotti 1994b; R. Lauber in Hochmann, Lauber, and Mason 2007, 317–19.

132 Battilotti 1994a.

133 "in una casa dei Vendramin a S. Fosca 'per lui fabrichada,' contigua all'abitazione del cognato"; Battilotti 1994a, 205, 207n.13, citing ASV, Savi sopra le decime, 1514, b. 76–82, f. 12.

134 "In Santa Foscha, una casa da statio, in la qual sta messer Tadio Contarini per lui fabrichada"; Battilotti 1994a, 207n.13.

135 Appendix, doc. 1. The document is cited by Battilotti 1994a, 229, doc. 8b.

136 "il quale [Taddeo Contarini], come abbiamo visto, abitava in un palazzo di proprietà dei Vendramin a S. Fosca, contiguo al suo"; Battilotti 1994b, 226.

137 "il mio punto essenziale era, e resta, accanto alla stretta parentela fra Gabriele Vendramin e Taddeo Contarini, la loro stretta prossimità fisica; e la casa indicata dalle due studiose è *più vicina* al palazzo Vendramin, di quella che avevo indicato io"; Settis 1981, 387. Donata Battilotti and Maria Teresa Franco had shared their information with Settis before its publication in 1994. Therefore, Settis's answer strangely predates the publication of Battilotti's information.

138 "anche se resta un po' strano che il Contarini, uno degli uomini più ricchi di Venezia, abitasse in casa non propria"; Settis 1981, 387.

139 "una caxeta la qual tien messer Tadio Contarini nostro cugnado per andar a solazo"; Battilotti 1994a, 207n.13.

140 Vescovo 2000, 117. "In una casa dei Vendramin a Santa Fosca"; R. Lauber in Hochmann, Lauber, and Mason 2007, 263. "A residence adjacent to that of the Vendramin family at Santa Fosca"; S. Rutherglen in Rutherglen and Hale 2015, 55. "Taddeo Contarini, Vendramin's brother-in-law who lived in a building adjacent to his palazzo at Santa Fosca"; Nichols 2020, 25.

141 I would like to thank the owner of the house for allowing me to visit it in December 2022 and Gianmario Guidarelli for discussing the architectural spaces and features of the palazzo over several hours.

142 This space is today transformed to such an extent that it is not possible to determine exactly what was there in the sixteenth century.

143 The document is transcribed here in full for the first time.

144 See Appendix, doc. 2.

145 See Appendix, doc. 2.

146 For the inventory, see Anderson 1997, 365; Vescovo 2000, 117–19; R. Lauber in Hochmann, Lauber, and Mason 2007, 263.

147 "Uno quadreto schieto con la figura del nostro signor misser Iesù Christo … Un quadro grando con sue soazze indorade con l'immagine di San Francesco … Uno altro quadro grandeto con tre figure di donne nude con sue soazze dorade"; see Appendix, doc. 3.

148 "Un quadro fatto de man de Zuan Bellin con una figura d'una donna. Un quadro grandeto con sue soazze intordo dorade con una donna che si varda in specchio"; see Appendix, doc. 3.

149 For the painting, see Tempestini 1997, 188, 232; Brown 2019, 217–29; Lucco, Humfrey, and Villa 2019, 586–88, no. 192.

150 S. Rutherglen in Rutherglen and Hale 2015, 57; A.-M. Eze in Rutherglen and Hale 2015, 61.

151 "Do quareti con la figura della nostra Donna. Un quaro grando con do figure depente in piedi puzadi a do arbori con una figura de un homo sentado che sona de flauto videlicet. Uno altro quareto piciolo con diverse figure tra le qual li è depento una donna con una lira in man et un homo appresso"; see Appendix, doc. 3.

152 S. Rutherglen in Rutherglen and Hale 2015, 56–57; A.-M. Eze in Rutherglen and Hale 2015, 61.

153 "Una figura della Nostra Donna in un quadro piciolo indorado. Un quadro grandeto con la figura della Nostra Donna et di San Zuanne con le sue soazze de nogara perfilade d'oro. Uno altro quadro grando soazado vecchio con la figura della Nostra Donna"; see Appendix, doc. 3.

154 "libri diversi de humanità et filosophia de grandi et de pizoli, stampadi et scritti a pena … Item una scanzia con libri diversi del ditto magnifico misser Andrea per il suo studiar"; see Appendix, doc. 3.

155 "si dileta di litere … a ti Andrea fiol carissimo ti prego che si desideri far cossa gratta alle mie osse, volgi continuar in studiar et farti honor et ritornar nella caxa"; see Appendix, doc. 2.

156 "Un quadro grando di tela soazado sopra il qual è depento l'inferno. Un quadro vecchio strazado soazado con certe figure a cavallo. Un altro quadro grandeto di tela soazado di nogara con tre figure sopra"; see Appendix, doc. 3.

157 "Un quadro grandeto con la figura del Nostro Signor et altre figure con sue soaze dorade intorno"; see Appendix, doc. 3.

158 For the portego of Taddeo Contarini's house, see Schmitter 2011, 722–28.

159 "Volgio che quando piaserà a nostro Signor Idio chiamarmi assì per sua misericordia esser sepolto nella chiesia de madona Santa Maria di Miracholi dove fo sepolto il quondam mio padre et el quondam mio fratello misser Zuanandrea et volgio sii fatta una archa in ditta chiesia dinanzi l'altar fece far il quondam mio padre in ditta chiesia, che el qual altar de marmori con una immagine in pitura de misser San Ierolemo qual sii condecente rispetto alla chiesia sincomo parerà alli infrascriti mei comissarii, nela qual archa volgio sian poste le osse del quondam carissimo mio padre et del quondam misser Zuanandrea fo mio fratello qualli tutti dui son in deposito in ditta chiesia et il corpo mio e poi della mia carissima et amatissima consorte et de tutti mei figlioli et loro descendenti in perpetuum"; see Appendix, doc. 2.

160 "Voglio, che quando piacerà al Nostro Signor Iddio di chiamarmi à sè per sua Misericordia esser Sepolto nella Chiesa di Madonna Santa Maria di Miracoli, dove fù Sepolto la qu. Clarissima mia Madre, e li Clarissimi miei Fratelli, voglio, che in detta Chiesa sij fatto

una Arca dinanzi all'Altar, che fece far il
qu. Clarissimo mio Avo, che è quell'Altar di
Marmori con una Imagine in Pittura di Mis.
San Gieronimo, qual Arca voglio sij condecente
rispetto alla Chiesa, sicome ne cometè il qu.
Clariss: nostro Padre à tutti noi Fratelli nel suo
Testamento, qual Arca voglio, che quando sarà
per farsi, voglio, che li miei Heredi, e Commissarij
doppo la mia morte, se però non fusse fatta la
facci far subito, acciò sij mandato ad essecutione,
quanto ne cometè il qu. Clarissimo nostro Padre,
e per ciò vi prego, quanto sò, e posso, voi miei
Heredi, & Commissarij à non mancar, che detta
Arca sij fatta subito"; ASV, Ospedali e luoghi pii,
Atti, b. 481, fascicolo 7, 1–2.

161 Settis 1978, 151n.61.
162 "Gian Bellino vi fece un San Hieronimo nel
 deserto"; Sansovino 1581, 63.
163 "Entrando in Chiesa, per la Porta Maggiore, a
 mano sinistra vi è la Tavola, con San Girolamo; e
 da' lati di detto Altare, vi sono li Santi Francesco,
 e Chiara; il tutto di mano di Giovanni Bellino";
 Boschini 1664, 414.
164 Rearick 2003, 181–84.
165 Rearick 2003, 182.
166 For the painting, see Tempestini 1997, 116–18,
 209; A. Tempestini in Schmidt et al. 2018, 82–85;
 Lucco, Humfrey, and Villa 2019, 443–45, no. 83.
167 Lauber 2005, 101; R. Lauber (in Hochmann,
 Lauber, and Mason 2007, 263–64) connects the
 painting to Contarini. A.-M. Eze (in Rutherglen
 and Hale 2015, 62) and Lucco, Humfrey, and Villa
 (2019, 443) instead suggest that Contarini may
 have commissioned the painting ("sarebbe stato
 commissionato da Taddeo Contarini da Santa
 Fosca").
168 Rearick 2003, 181.

169 See, for example, Vescovo 2000, 116–17.
170 Lauber 2004; R. Lauber in Hochmann, Lauber,
 and Mason 2007, 263; A.-M. Eze in Rutherglen
 and Hale 2015, 59–79.
171 For the inheritance and family tree, see ASV,
 Ospedali e luoghi pii, Atti, b. 481, fascicolo 7,
 1–2.
172 For Dalla Nave, see S. Furtlehner and R. Lauber
 in Borean and Mason 2007, 258–61.
173 Morelli and Frizzoni 1884, 165; A.-M. Eze in
 Rutherglen and Hale 2015, 63–64.
174 S. Rutherglen in Rutherglen and Hale 2015, 57;
 A.-M. Eze in Rutherglen and Hale 2015, 61.
175 Anderson 1997, 149, 317.
176 Waterhouse 1952, 16.
177 Waterhouse 1952, 16.
178 Anderson 1997, 317.
179 Nova 1998, 48–54.
180 Anderson 1997, 149; Nova 1998, 51–52.
181 Morelli and Frizzoni 1884, 166.
182 For the painting, see Ghiotto and Pignatti 1969,
 108, no. 200; G. C. F. Villa in Rome 2008, 304–5,
 no. 55; Lucco, Humfrey, and Villa 2019, 523–24,
 no. 152.
183 Richter 1939. For the painting, see Ghiotto and
 Pignatti 1969, 103, no. 56; Tempestini 1997, 221–22,
 no. 90; G. C. F. Villa in Rome 2008, 306–7, no. 56;
 Lucco, Humfrey, and Villa 2019, 533–54, no. 158.
184 R. Lauber in Hochmann, Lauber, and Mason
 2007, 263; A.-M. Eze in Rutherglen and Hale
 2015, 61.
185 Nova 1995, 163; A. Nova in Trent 2006, 343–44,
 no. 78; R. Lauber in Hochmann, Lauber, and
 Mason 2007, 263.
186 Morelli and Frizzoni 1884, 166–67.
187 For the painting, see Boskovits and Brown 2003,
 596–601.

Cat. 1

Giovanni Bellini (Venice ca. 1424/35–1516 Venice)

St. Francis in the Desert, ca. 1475–80, oil on panel, 49¹⁄₁₆ × 55⅞ in. (124.6 × 142 cm)

The Frick Collection, New York (1915.1.03)

Provenance

Painted for Zuan Michiel (d. 1513), Venice; Taddeo Contarini (ca. 1466–1540), Venice, by 1525; by inheritance to his son, Dario Contarini (ca. 1503–1556), Venice; by inheritance to his granddaughter, Elisabetta Contarini, married to Giulio Giustinian (b. 1562), Venice; by inheritance to their grandson Giulio Giustinian (1624–1699); by inheritance to his grandson Zuan Giustinian (d. 1718); by inheritance to his widow, Alba Giustinian (d. 1771); by inheritance, through Alba's second marriage to Nicolò Corner (b. 1677), through the Corner family, Venice, until at least 1796; Carlo Massinelli (act. 1771–1822), Milan, by 1812; purchased by Joseph-Jacques-François Boucher-Desforges (1764–1838), Paris, 1812; by inheritance to his son Charles Boucher-Desforges (1797–1876); purchased by William Buchanan (1777–1864), London, 1850; Christie's, London, July 17, 1851 (lot 20), unsold; Christie's, London, June 19, 1852 (lot 48); purchased by Captain Joseph Dingwall (1806–1873), Sunninghill, Berkshire; purchased, with Dingwall's house, by Thomas Holloway (1800–1883), 1869; by inheritance to his sister-in-law Mary Ann Driver (1817–1900); by inheritance to her sister Lady Martin-Holloway (née Sarah Anne Driver) (1821–1911); by inheritance to her daughter, Celia Sabina Oliver (1859–1933), and her husband, Vere Langford Oliver (1861–1942), Whitmore Lodge, Sunninghill; purchased by P. & D. Colnaghi and Obach, London, 1912; purchased by Arthur Morton Grenfell, London, 1912; purchased by Knoedler and Agnew's, New York, 1913; purchased by Henry Clay Frick (1849–1919), New York, 1915; his bequest to The Frick Collection, 1919.

Select Literature

Lanzi 1837, 42; Manchester 1857, 21, no. 116; Crowe and Cavalcaselle 1871, 159–60; Morelli and Frizzoni 1884, 168; Frimmel 1896, 88; Crowe and Cavalcaselle 1912, I: 158–59; Venturi 1915, 310–14; Berenson 1916, 95–105; Mather 1923, 354; Gronau 1930, XXIV; Berenson 1932, 71; Venturi 1933, pl. 390; Mather 1936, 99–101; Gamba 1937, 107–8; Kimball and Venturi 1948, 58–59; Clark 1949, 24–25; Dussler 1949, 89; Longhi 1949, 281; Berenson 1957, 32; Hall 1958, 240; Pallucchini 1959, 66, 140–41; Arslan 1962, 48; Bottari 1962, 19, 39; Heinemann 1962, 65, no. 218; Meiss 1964; Boschini 1966, 344; Turner 1966, 59–67, 86; *Catalogue* 1968, 203–9; Robertson 1968, 76–78, 87, 91, 111, 151; Ghiotto and Pignatti 1969, 97, no. 98; Marandel 1969; Fletcher 1972a; Fletcher 1972b; Huse 1972, 38–39; Pochat 1973, 351–53; Waterhouse 1974, 19; Wilde 1974, 29–30; Fowles 1976, 94–95; Settis 1978, 36, 39–40, 123, 141; Eisler 1979; Land 1980, 40–41; Pallucchini 1981, 391–93; Settis 1981, 391–93; Fleming 1982; Castelfranchi Vegas 1983, 159; Goffen 1986, 54; Goffen 1989, 107–13; Land 1989; Huse and Wolters 1990, 212–13; Hall 1992, 82–83; Janson 1994; Humfrey 1995, 80–81, 96, 111, 120; Anderson 1997, 149–50, 158–60; Hirdt 1997; Tempestini 1997, 39, 48, 112–14, 206; Grave 1998; Land 1998, 21–23; Helke 1999, 36–37; Wohl 1999; Aikema and Brown 2000, 182–83; Vescovo 2000, 116–17, 119; Hammond 2002; Lauber 2002, 105; Pächt 2002, 232; K. Christiansen in Humfrey 2004, 72; Grave 2004, 29–69; M. Lucco in Humfrey 2004, 83–84; Lauber 2004; Lauber 2005, 100–101; De Marchi 2006, 125–27; Hammond 2007; M. Hochmann in Hochmann, Lauber, and Mason 2007, 21; R. Lauber in Hochmann, Lauber, and Mason 2007, 60, 263–64; Lavin 2007; Bätschmann 2008, 110–15, 136; P. Humfrey in Rome 2008, 73–74; Agosti 2009, 39, 41, 83n.88, 135, 143; Christiansen 2009; Lugli 2009; Pergam 2011, 150–51, 318; Cottrell 2012, 623; De Marchi 2012, 194–95; Rutherglen and Hale 2015; Ballarin 2016, 1: XVIII, 65–67, 69, 109, 115–16, 145, 153–54, 156–61, 164–65, 176, 197, 207–8, 211, 214, 226, 248, 264, 275–76, 281, 293, 410, 413, 451, 454, 472–74, 493, 510–16, 537, 539, 547–52, 559, 617, 638, 679, 686, 700, 707; 2: 766, 768–70, 775–78, 782, 875–76, 917, 920, 940, 957, 1000, 1002–3, 1006, 1036, 1395–1405; 4: XIV, XXIV, XXVII, XXVIII, XXXII, XLI–XLIII, LX; 5: XIII, XXIII, XXV–XXVII, XXIX, XXXVII, XXXVIII, XL; 6: XLI; 7: XIV; S. Facchinetti in London 2016, 72–73; H. Belting in Los Angeles 2017, 27; D. Gasparotto in Los Angeles 2017, 12, 17, 19–20; D. Wallace Maze in Los Angeles 2017, 51; Gasparotto 2018, 24, 29, 108–11; Lucco, Humfrey, and Villa 2019, 10, 429–30, 440–46, 448, 462, 482–83, 531, 547, no. 82; Nichols 2020, 50–51, 124–26, 137–38; Maze 2021, 15–16, 68, 78.

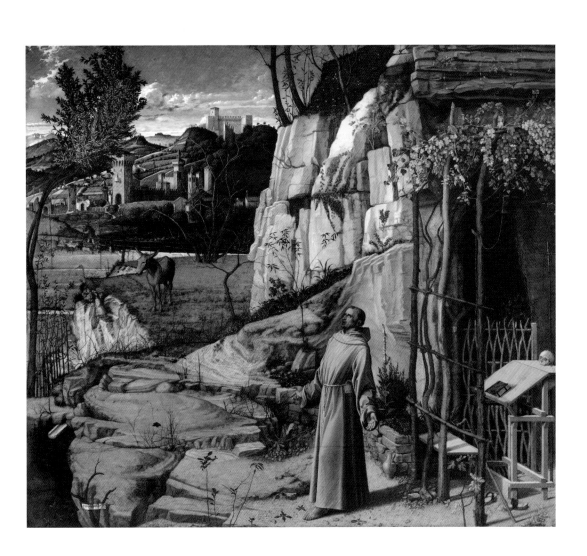

Cat. 2

Giorgio da Castelfranco, known as Giorgione (Castelfranco Veneto ca. 1477–1510 Venice)
The Three Philosophers, ca. 1508–9, oil on canvas, 49⁷⁄₁₆ × 57⁹⁄₁₆ in. (125.5 × 146.2 cm)
Kunsthistorisches Museum, Vienna (Gemäldegalerie III)

Provenance

Taddeo Contarini (ca. 1466–1540), Venice, by 1525; by inheritance to his son, Dario Contarini (ca. 1503–1556), Venice; Bartolomeo dalla Nave (1571/79–1632), by 1636; acquired in Venice by Basil Fielding (ca. 1608–1675) for James Hamilton, 3rd Marquess of Hamilton (1606–1649), 1638; Archduke Leopold Wilhelm of Austria (1614–1662), Brussels and Vienna, by 1659; by inheritance to his nephew, Emperor Leopold I (1640–1705); imperial collection; at Kunsthistorisches Museum, Vienna, since 1891.

Select Literature

Teniers 1673; Mechel 1781, 10, 334; Mechel 1784, 10, no. 36; Crowe and Cavalcaselle 1871, 135–36; Engerth 1884, 168, no. 239; Morelli and Frizzoni 1884, 164–65; Wickhoff 1893, 9–11; Wickhoff 1895; Frimmel 1896, 86–87; Schaeffer 1910; Venturi 1913, 90–96; Baldass 1922; Mather 1923, 376–78; Hartlaub 1925, 7–8; Justi 1926, 13–28, 97, 178–79, 205–13; *Katalog* 1928, 89–90, no. 16; Conway 1929, 21, 28, 39–40, 54; Hourticq 1930a, 31–32, 34–36, 60–64, 81; Hourticq 1930b, 558–62; Wilde 1931, 97–100; Berenson 1932, 233; Wilde 1932, 141–51; Ferriguto 1933, 29–34, 61–102; Richter 1934, 272, 274–77; Parducci 1935; Pigler 1935; Richter 1937, 5–6, 28, 79, 83, 119–20, 122, 254–56, no. 98; Fiocco 1941, 26–28; Morassi 1942, 13, 15, 80–84; Ferriguto 1943, 404–7; Wischnitzer-Bernstein 1945; Fiocco 1948, 9–11, 29–31, 40; Morassi 1951, 215; Waterhouse 1952, 8, 80; Gilbert 1952, 214–16; Baldass 1953; Hartlaub 1953, 57–72; Venturi 1954, 12, 15–17, 25, 28–32, 38; Coletti 1955, 9, 56–57; Della Pergola 1955, 26, 33–36; Klauner 1955; Nardi 1955a; Nardi 1955b; Pallucchini 1955, 9–10, tavv. XVI–XVII; Pignatti 1955, 76, 112, 143; P. Zampetti in Venice 1955, 34–38, no. 16; Berenson 1957, 84; Auner 1958, 151–57; Drost 1958, 46–47; Shapley 1959; *Katalog* 1960, 59–60, no. 551; Tschmelitsch 1962, 14–18; Tolnay 1963, 130; Baldass and Heinz 1964, 16, 29–32, 131–34; Goetz 1965, 100–101; *Katalog* 1965, 62–63, no. 551; Parronchi 1965; Turner 1966, 84–87, 91, 103–6, 191; Garas 1967, 53, 72, 76; Williams 1968, 66–67; Zampetti 1968, 90–91; Gould 1969, 208; Wind 1969, 4–7; Pignatti 1969, 20, 34–38, 64–67, 104–5, no. 18; Calvesi 1970, 184, 191–92, 202, 223–30; Nardi 1971, 111–20; Robertson 1971, 475–76; Pochat 1973, 406–11; Waterhouse 1974, 18–19; Wilde 1974, 66–69, 75, 77, 79, 94–95; Bettini 1975; Zampetti 1977, 31; Mucchi 1978, 9, 17, 52–53; Settis 1978, 19–45, 124–26, 137–44, 142, 146; Calvesi 1979; Gould 1979, 254; Hornig 1979; Klauner 1979, 264–67; Muraro 1979, 176; Oberhuber 1979, 315–16; Padoan 1979, 32–34; Rosand 1979, 137; Settis 1979, 74; Meller 1981; Pignatti 1981, 132, 143, 146–47; Settis 1981, 385–88, 390, 393–96; Sgarbi 1981, 32–34; Vasoli 1981, 51–54; Longhi 1985, 25; Gombrich 1986; Hornig 1987, 199–203, no. 18; Perissa Torrini 1993, 86–93, no. 21; Battilotti 1994a, 205; Cohen 1995; Humfrey 1995, 285; Anderson 1997, 31, 54, 57–58, 78, 83, 86–90, 102, 106, 149, 152–58, 160, 237, 298–99; Borchhardt-Birbaumer 1999; Helke 1999, 35–62; Pignatti and Pedrocco 1999, 164–66, no. 25; Brandt 2000, 82–90; Vescovo 2000; MacLennan and Kilpatrick 2001; Lauber 2002, 105–7; Borchhardt-Birbaumer 2004; Gabriele 2004; G. Nepi Scirè and S. Ferino-Pagden in Venice 2004, 124–33, no. 4; G. Nepi Scirè and S. Ferino-Pagden in Vienna 2004, 179–82, no. 5; Oberthaler 2004, 267–68; Lauber 2005, 100–101; J. Anderson in Washington 2006, 164–67, no. 30; Barry 2006, 150, 158–73; E. Oberthaler and E. Walmsley in Washington 2006, 293–95; R. Lauber in Hochmann, Lauber, and Mason 2007, 60, 263–64; Zeleny 2007; Zeleny 2008; K. Zeleny in Vienna 2008, 74–77, no. 23; J. Anderson in Castelfranco Veneto 2010, 134; Lauber 2010, 191–92, 195, 197; Schmitter 2011, 724–28; Chastel 2012, 20–21, 27, 71; De Marchi 2012, 195; Swoboda 2013, 35, 139, 176; Ballarin 2016, 1: XVIII, 65–67, 69, 109, 115–16, 145, 153–54, 156–61, 164–65, 176, 197, 207–8, 211, 214, 226, 248, 264, 275–76, 281, 293, 410, 413, 451, 454, 472–74, 493, 510–16, 537, 539, 547–52, 559, 617, 638, 679, 686, 700, 707; 2: 766, 768–70, 775–78, 782, 875–76, 917, 920, 940, 957, 1000, 1002–3, 1006, 1036, 1395–1405; 4: XIV, XXIV, XXVII, XXVIII, XXXII, XLI–XLIII, LX; 5: XIII, XXIII, XXV–XXVII, XXIX, XXXVII, XXXVIII, XL; 6: XLI; 7: XIV; S. Facchinetti and A. Galansino in London 2016, 27; Hope 2016; Schier 2017; Schier 2019, 64, 66–67; Nichols 2020, 7–9, 13, 25, 50–51, 123–24, 135–44, 203–4; Settis 2021, 22–23.

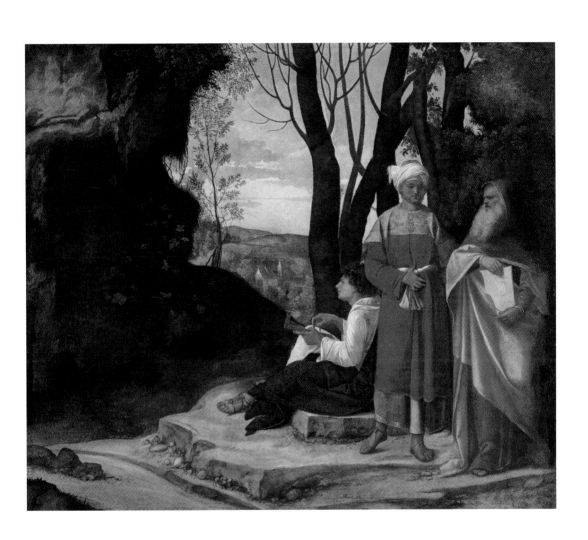

Appendix

Doc. 1
Codicil to Will of Gabriele Vendramin—March 11, 1552
(Archivio di Stato, Venice. Notarile. Testamenti, b. 772, n. 220)

Codicillum magnifici domini Cabrielis Vendramino quondam clarissimi domini Leonardi de quo ego Vincentio Pilotus notarius Venetiarum accepi pretes die 13 mense martii 1552.
Presentatum in Cancellarie die 15 mensis suprascripti.

Obiit die 15 mense martii 1552.

[f. 1r]

Die XIII mensis martii 1552, inditione X, Rivoalti.
Quomodo per tanto io Cabriel Vendramin del quondam clarissimo misser Lunardo havendo fatto il mio testamento de mano mia propria et quello apresentato al quondam misser Michiel Rampano nodaro al qual li promissi vinti ducati, stimulato da lui ma perché per la verità lui non ha messo riceuta del suo, salvo securado cum la copia ho apresso de mi perhò mi par el si possi contentar per legato special de ducati diexe da esser datto alla sua comissaria.
Item alli Cancellieri il suo ordinario qual è ducati cinque.
Item perché io ordino in esso testamento quanto che alhora mi pareva dovesse importar il vitto et monachar de Diana mia neza perhò per il presente codicillo li lasso ducati tre millie per il suo maridar zentilhomo de voluntà de i sui altramente non cum questa condition, che il ditto legato sua madre contribuisca ducati mille cinquecento dela sua dotte et dimissoria. Item che ditta Diana habbi ducati cinque millia netti computa quello ha sucesso in sua parte per la morte dela quondam Chiara fu maridà in misser Francesco Malipiero de ser Marco fo de ser Perazo et a questo sia comoda la mia comissaria da dui mille ducati in suso de quel termine che se potria, et perché in ditto testamento è messo uno ordine tra mei nevodi che longo saria a volerlo repeter ma in substantia dove dice che a bossoli et ballote se debba elezer uno fra loro che debba ministrar la marchadantia et altro per uno certo quid de tempo et poi tornar esser reballottà et se a loro paresseno de confermar, perhò mi par esser corso fino al presente et honor iusto la natura de tutti loro che in questo conto del governo solum debba torme quella eletion a mi, pregando tutti i altri che debba esser contadi de esser fatta tal eletion per mio ordine che certo non reputo falir immo metter il fiado et anime in questa facultà de grandissima importantia, perhò recevendo così il bisogno per anni diexe io voglio che il cargo sia de Bortholamio mio nipote il qual tuti loro sano ben di quanto vallor et de quanta expettation sia per vedersi in lui, il qual perhò prego per causa dela sia ioventù non vogli usir

[f. 1v]

de termine alcun contra sui fradelli ma come il minimo da loro et come quello che è successo in luogo mio menor de cinque fradelli messo alle fatiche che Dio li varda et la Verzene Maria provar quel che ho provatto io, ma usando quelli debiti et [...] de amorevolezza contra de loro togliando li sui consegni sempre cum quella carità che ricerca una fraterna la qual i prego tutti che li sia recomandà, perché come ho ditto nel testamento unida la tanto bella quanto facile sia in Venetia, disunitta maxime dilli[...] questo non son per altro salvo prometter ordine non per diminuir l'honor di altri che certo et me sono de molti de loro sufficientissimi et legalissimi, et perché el misser Signor Dio ha fatto differente l'homo l'uno de l'altro; perhò io né in facultà né in honor non pretendo diminuirli ponto, ma per tuor le diversità della opinion adciò la barcha vidi dretta, mi ha parso de far così et quelli che non verano

asserir cascha alle pene messe nel testamento al qual se habbi relation in omnibus et per omne et perché non mi aricordo i legati che per quelle familie si è caschadi in debito; pervenudi in la famiglia perhò non havendo fatto mention nel testamento per questo codicillo ordino che in termine de anni quatro deba esser dà execution ad unquam ai legati ad pias causas lassadi per laquondam Diana fo moglier de misser Lunardo Vendramin mio padre dovendo esser scontro il testamento cum i libri.

Item lasso a Marina fiola che fu de Alvixe Vendramin existente al presente per casa nostra saldar i sui salarii ducati cento da lire 6 soldi 4 per ducato et questo per il suo maridar apresso quello è suo.

Item lasso non essendo fatto mention nel testamento ai frati de San Job dove se atrova il mio confessor fra' Michiel da Schio ducati vinti quali siano a benefitio del monestier regoladi per mano di esso fra' Michiel ma per quello sia altera in reliquis il testamento fatto per mia man.

[f. 2r]

Item che esso codicillo non possi impedir in parte alcuna ad esso testamento de mia mano ma quello resti in suo vigor et robor salvis promissis et perché io mi atrovo esser uno di comissarii del quondam misser Alvise di Prioli fo de misser Francesco eletto per la bancha de la schola de San Zuane iuxta il testamento di esso misser Alvixe di Priuli nella administration del qual occorse che fu scosso uno pro non per mano di niuno di mei d[...] ducati cinquanta otto come tutti sano né per nome mai nella borsa mia et cetera in esser il magnifico ser Zuan Andrea Badoer et misser Alvise dalla Gata mei collega precipue misser Alvise Malipiero fo de misser Zuane herede de dui terzi dela familia testimonii deli qual ducati 58 apud dictum non posso esser fato debitor et Dio perdoni a chi tocha a render conto di tal cosa, perhò lasso sora le conscientie di quelli ministrarà et de chi ha l'interesse de farmi debitor et creditor et perché el se atrova mei nevodi misser Piero Francesco et misser Dario Contarini homeni de quella integrità si de intelletto come de bontà haver habità fino il tempo de suo padre in una nostra casa da statio posta in Santa Foscha per causa de haver de danari olim per essa fabrica passadi già anni 50 salva la verità per l'amor et per la reverentia portada a suo padre, perché altramente non si puol rasonar, siamo occorsi fino qui che dovendoli restituir li sui danari non prestadi non pagano più de ducati 50 al anno che non è dubio quanto sora il centener la merita et poleno esser certissimi che nui havemo potutto havere purassai partidi dal cento in su cum la zonta de danari prestadi, né mai l'havessemo fatto tal partido cum alcuno mettendo quella parola apresso de nui brutta cum li danari tolti in prestido sopra ditta casa haver mandà fuora de casa essi mei nepoti i qual come i sano ho in quelle diletion et dolcezza, in amor filial come cadauno de mei nepoti

[f. 2v]

et perhò i prego che loro sia quelli che mettano fin a tal longeza de tempo et non dar materia l'amor de Dio contra quel ch'io scio quel che debbo a casa sua in materia de ditta casa vegnise su una massime altercation che mai io l'ho volesta veder et si vivesse cento anni io li diria mai parola.

Io Titian Vecellio condam misser Gregorio fui testimonio zurato et pregatto.

Io Vielmo chondam misser Zuane depentor foi testimonio zurado et pregado.

Doc. 2
Will of Dario Contarini—August 24, 1556
(Archivio di Stato, Venice. Testamenti, b. 1203, n. 59)

<center>+ 1556 .24. avosto</center>
Testamento fatto per me Dario Contarini fo de misser Thadio et scrito de mia mano.

Caedula testamentaria quondam viri nobilis ser Darii Contarini quondam ser Thadei manu eius propria scripta, relevata per gratia illustrissimi Ducalis Dominii in visu publici et authentici testamenti. Die quo supra per me Albertum Marconum aule ducalis cancellarium in secundo prothocollo ad cartam 58.

[f. 1r]

+ 1556. adì .24. avosto .in. Venetia

Al nome del nostro Signor Idio et de la gloriosa Verzene Maria. Amen.

Volendo io Dario Contarini de misser Thadio per la Idio gratia sanno de la mente e del corpo ordinar et disponer questa mia ultima volontà, ho scrito questo mio testamento de mia propria manno. Prima racomando humilmente l'anima mia al nostro Signor Idio et alla gloriosissima Verzene Maria et a tuta la corte celestial.

Volgio che quando piaserà a nostro Signor Idio chiamarmi assì per sua misericordia esser sepolto nella chiesia de madona Santa Maria di Miracholi dove fo sepolto il quondam mio padre et el quondam mio fratello misser Zuanandrea et volgio sii fatta una archa in ditta chiesia dinanzi l'altar fece far il quondam mio padre in ditta chiesia, che el qual altar de marmori con una immagine in pitura de misser San Ierolemo qual sii condecente rispetto alla chiesia sincomo parerà alli infrascriti mei comissarii, nela qual archa volgio sian poste le osse del quondam carissimo mio padre et del quondam misser Zuanandrea fo mio fratello qualli tutti dui son in deposito in ditta chiesia et il corpo mio et poi della mia carissima et amatissima consorte et de tutti mei figlioli et loro descendenti in perpetuum. Alle qual monache lasso per l'anima mia ducati diexe aziò abiano a pregar nostro Signor Idio per le anime del quondam mio padre et di tuti li mei fratelli et per l'anima mia et de la mia carissima consorte, et volgio sii fatta una mansonaria in ditta chiesia et investidi ducati tresento in tanti livelli in Friul che renda all'anno almancho ducati vintiquatro, qual livello ho livelli sia fatti su fondi seguri et con condition de livel perpetuo et fatti con quelle caution et solenità si che mai non li possi esser intrigo né che si possi franchar. Qual mansonaria volgio sii datta in perpetuum per li infrascritti mei comissarii et filgioli et poi manchadi essi mei comissarii per essi mei figliolli et loro desendenti in perpetuum per linea masculina a bosoli et balotte quel sacerdote a chi serrà conferita ditta mansoneria, volgio habi obligo de dir almen iorni quatro dela settimana messa a ditto altar la domenega, marti, zobia et sabado con pregar nostro Signor Idio per l'anima mia et dona Isabeta mia carissima consorte et per le anime del quondam mio padre, madre et del quondam reverendissimo Patriarcha di Venetia misser Pierofrancesco fo mio carissimo fratello et de tutti li altri mei fratelli, figlioli et de tutti li mei passadi et desendenti in perpetuum. Il sacerdote havrà cargo di celebrar ditta mansonaria, di tempo in tempo sii tenuto sempre pagar le angarie coreranno sopra ditti livelli, sichè non si minuischa ho per debito di angarie sii allienadi ma sii obligatto mantener esso livello o livelli et dar idenota fideiusion di pagar di tempo in tempo le angarie potessero quovismodo corer sopra esso livello ho livelli.

Lasso ad Isabetta mia carissima consorte tuta la sua dote integra segondo la ho havuta come per il contratto, vedovando perhò la qual prego et astrenzo quanto piui posso ad esser amorevolle egualmente a ditti mei filgioli et usar verso di loro quella materna carità et amorevoleza in ogni sua attion si convien et a voi mei carissimi filgioli comando, prego debiate esser ubedientissimi ad essa vostra madre et portarli quel amor, rispeto, riverentia et ubidientia faresti alla persona mia et quello farette ad essa vostra madre reputate far alla persona mia.

Voglio et ordino a voi mei carissimi figlioli Nicolò, Andrea, Ierolemo, Tadio, Ferigo, Marcantonio, ancor che Tadio, Ferigo, Marcantonio non sianno in hetà di poter disponer ma si li dice come sentano che per modo niuno volgio vi possiate divider né partir ma vi commando et cossì volgio che dobiate viver et star sempre uniti insieme come sempre è stato costume di caxa nostra et s'el farete sarete temuti et reputatti, ma se farrete altramente serrà fatto et tenuto pocho conto di noi et perchè Thadio, Ferigo, Marcantonio son di l'età minori, volgio quando si atrovasse niun di noi volese conosser la sua parte non volgio lo possi far né venir a parte né division ho ad altro modo che dir ho inmaginar si possi

dividersi ho partirsi fino che Marchantonio over il minor di essi mei filgioli non habi ani vintiquatro compidi et il primo di noi farrà motto ho in particular ho in inditio ho ad altro modo che dir ho inmaginar si possi di division ho altra separation quovismodo fino como è ditto, ch'el minor non habi anni vintiquatro compidi, quello tal perdi et s'intendi haver perso il quanto over quanta parte di quello li potese tochar in parte de li mei beni cossì mobelli como stabeli et nientedimeno non si possi divider nè li altri li possino dar fatta la sua parte amodo niuno et se niuno deli altri consentisse a tal dimission ho separation per modo ho via niuna incori in la medesma pena con il modo sopra ditto et il quanto perdese li desubidienti vada nelli altri harano ubedito a questa mia ultima volontà. Como Marcantonio over il minor di essi mei filgioli serrà in hetà de anni vintiquatro compidi, volgio siano in libertà far quanto a loro

[f. 1v]

ma ben vi prego et astrenzo a star et viver sempre insieme in amor et carità da boni et amorevolli fratelli che prego l'Omnipotente Idio cossì lassi seguir.

In caxo veramente che per diffetto di essi mei filgioli Isabetta mia carissima consorte et sua madre non potesse star con loro et che essi mei filgioli non li fussero ubidienti et la tratassero come è conveniente et lei vedoando et menando quella vitta si convien in tal caxo volgio che oltra la sua dotte sii in sua libertà galder in vitta sua la caxa et brolo da Merlengo con obligo perhò di tenir essa caxa et tuti li coperti in conzo fino la galderà, le tese, caneva et locho del lavorador resti con le terre a mei filgioli. Iten sianno tenuti essi mei filgioli dar ad essa sua madre ogni anno fino la vedoerà carra dui de vino de qual dele mie possession lei vorà et starra diexe farina dele mie intrade et uno porcho de lire cento et cinquanta et da Pasqua ovi cento, da Carneval galline bone pera quatro fino la viverà et tutto si intende vedoando et non altramente. Dechiarando perhò che volendo lei pagarsi de la sua dotte, sii tenuta far quella comodità alla mia comessaria che io feci ad essa over al quondam suo padre di essa dotte come per il contratto. Dechiarando etiam che li ducatti mille la doveria perder della sua dotte come per il contratto la non possi disponer di essi in niun tempo se non in li mei et sui figlioli possendoli lasar a qual li parrerà di loro harano ho piui o tuti ho parte ad uno et parte a l'altro, la qual prego et astrenzo quanto piui posso a star sempre con essi mei filgioli et tenirli sempre in union et amor, como son certissimo farrai et non a[...]rà niuna di queste assignation perché conoscho et so quanto sei amorevole verso essi nostri filgioli qualli ti racomando quanto piui posso.

A mia fiola Helena non essendo monachada ho altramente allei provisto fino al mio manchar volgio che la habi deli mei beni per il suo monachar quello fu dato a suo[r] Maria Colombina mia fiola et sua sorella monacha nel monasterio de misser San Zacharia di osservantia et non parendo allei farsi monacha che non lo credo in tal caxo volgio la stii con sua madre et fratelli qualli sian tenutti farli le spexe, vestirla et darli ducati dodexe all'ano per sui bisogni fino la starà in caxa con loro et piui volgio che stando in caxa con sua madre et fratelli la habi de li mei beni ducati mile qualli li siano investidi in tanti fondi de fuora dove lei vorà ma non deli fondi della mia comessaria, ma volgio sii investidi ducati mille de contadi deli qual ducati mille et fendo compunto di essi ducati mille stando lei con sua madre et fratelli possi galder l'usufruto di essi in vitta sua et se mai in alcun tempo essi mei figlioli si dividesseno, sii in libertà di essa mia fiola andar a star cum qual de sui fratelli allei parerà, ma volendo sua madre sii tenuta star in caxa con lei et con qual de sui fratelli si havrà accosta sua madre, quello con chi lei si acosterà sii tenuto a farli le spexe allei et una masara et darli una camerra fornida di quello accade et per li altri sui fratelli ho sui heredi cadauno per rata sian tenuti dar quello con chi lei et sua madre si havrà accostato ducati sesanta all'anno oltra la sua portion si che quello la tenirà in caxa sii inborsado dali altri per rata de ducati sesanta all'ano liberi, et questa hobligation volgio habi locho stando lei con sua madre et fratelli ho fratello et essendo quella bona et honesta filgiola si convien che facendo altramente non volgio la habi cossa niuna slavo che galder l'usufruto deli ducati mille investidi in vita sua et manchando lei torni in mei figlioli et sui fratelli et sui desendenti per linea masculina ma monachandossi over stando con sua madre et fratelli volgio la habi quanto è ditto di sopra et che alli

ducati mille la possi disponer facendossi monacha in darli tanti ho parte per sua dotte al monasterio hove la intrerà ho como in tal caxo allei parerà et similmente sendo lei con sua madre et fratelli possi disponer di essi ducati mille alla sua morte como allei parerà dechiarando che dividendosi sui fratelli la non habi piui li ducati dodexe all'ano per sui bisogni ditti si sopra. Dechiarando etiam che volendo li ducati mille da esser investidi over per monacharsi per li mei comissarii et filgioli non li sii dato altramente la dotte havè sua sorella suor Maria Colombina per intrar nel monasterio de San Zacharia perché in locho de quelli la ha li ducatti mille sichè sii in sua libertà ho haver quello havè la ditta sua sorella ho li ducati mille con le condition di sopra dechiaride. Facendosi monacha ditta mia fiola Helena volgio che como la havrà fatto profession et serà fatta professa per mei filgioli ho sui heredi li sian datti ducati diexe all'ano in vita sua per sui bisogni ogni mexi dui la rata et simelmente volgio sian dati a mia fiola suor Maria Colombina monacha nel monasterio di oservantia di San Zacharia ducati diexe all'ano in contadi per sui bisogni ogni mexi dui la rata per ciascheduna di esse in vita sua, qual danari da esser dati a ditte mie fiole per essi mei comissarii et filgioli volgio dona Isabeta mia carissima consorte sua madre habi lei la curra et cargo de portargelli dele intrade dela mia comessaria.

Ad Isabeta mia consorte carissima volgio che stando lei insieme con li sui et mei figlioli la possi et debi aver anche lei per suo spender in quello melgio allei parerà esser ducati quatro al mexe oltra quello li farrà bisognio per suo vestir, necesario et altro li potesse far bisognio.

[f. 2r]

Et perché el potria acader che alcun de mei filgioli fusse piui longo nel spender uno de l'altro non essendo honesto uno spendi la parte de l'altro, perhò ordino et volgio che Nicolò et Andrea mei figlioli insieme con sua madre siano quelli habiano a manizar et administrar questa nostra comessaria, scoder et pagar, spender et comprar et tenir conto si dele intrade como spexe di qualunque sorte et denari serano investidi per conto di essa mia commissaria et aquisto volgio pagino, uno tengi libro ordinario dela administration di essa mia comessaria et questo fino che Marcantonio over il minor di essi mei figlioli sii in età di anni vintiquatro compidi, né volgio a modo sia non possino dar piui de ducati otto al mese per uno di essi sui fratelli et cossì tor per loro per suo vestir ho altre spexe a quelli di l'età de anni vintido in suso et quelli serano di l'età da ani disdotto fino vintido ducati sette al mexe, a quelli serà di l'età di anni disdotto fino a quindexe habiano per spese di suo vestir et altro ducati cinque al mexe et questo si dice al piui che se li possi dar per spexe de vestir ho altre spexe accadesse alloro far si alli mazori como a tutti li altri né volgio a modo siano se li possi dar piui per esser questa spexa piui che conveniente a chi non nol dissipar il suo rispetto alla numerosa famelgia, a quelli seranno di l'età de ani quindexe in zoso habiano et li sii provisto do vestimenti, tenirli maestri et darli qualche volta qualche denaro secondo la loro hetà, se non li mancherà in conto niuno et anche quando fusse bene tenirli in studio a Padoa sino ho piui di loro farlo et a questo ag[i]rano molto le consientie di noi havutte. Il cargo et manezo di far ogni cosa et non guardar a spexa che Thadio, Ferigo, Marcantonio imparino et faciano profitto nelle literre et intorno apnplichar che ognuno molto le consientie nostre in questo et in comando che a spexe dela mia comessaria non volgiate manchar in conto niuno a ditti tutti fratelli si in mandarli in studio et meter con loro uno sufitiente precetor che sii de boni costumi et literre et darli ogni modo et comodità inparino nè guardar a spexa et perché Andrea mio fiol si dileta di litere et quello fino hora si po comprender volendo continuar e prensir molto bene, perhò volgio che volendo lui farsi lezer ad alguno per essa mia comissaria volgio li sii pagato quanto lui darà a quello si lezese et a ti Andrea fiol carissimo ti prego che si desideri far cossa gratta alle mie osse, volgi continuar in studiar et farti honor et ritornar nella caxa. Il nome et fama et honor ha posto in caxa il quondam reverendissimo Patriarcha di Venetia fo mio fratello che sai par quanta essisitimation han fatto di lui per le litere et bontà hera in lui. A Ierolemo mio fiol non dago cargo di governo per non si diletar lui de casi et per non meter mazor confusion mel governo et administration che saria anche a suo dano ma non mancherà deli cargi s'el si vorà et di drento et di fora et son piui che certo per esser lui di bonissima natura non mancherà insieme con li altri a governar et augmentar et tor quel cargo che per sua madre et sui mazor fratelli et mei

comissarii li seran imposti. Non volgio amodo niuno che oltra le spexe ordinarie di viver et necesarie di caxa come medici, medicine, fito di caxa, angarie ho spexe si convenisse far in difender le cosse et ragion dela comissaria si possi far altre spexe straordinarie per conto dela caxa a preiuditio deli minori, salvo come è ditto in mandar essi mei figlioli minori in studio ho in tenirli precetori et in pagar uno lezese ad Andrea. Il soprabondante delle intrade che si attroverà aver la mia comesaria al mio manchar che son certo essandoli qual debito governo che son certo serà si meterà ogni anno in sopravanzo una bona suma volgio che il sopravanzo ogni anno sii investido et investido sempre pro sopra cavedal tal che ogni anno sii investido tuto quello sopravanzasse insieme con quello si trarà di utile detti denari si investirano ogni anno del sopravanzo, volgio che atrovandossi denari al mio manchar siano subito investidi in tante possession di fora et anche sii vendutto tutte le zolgie, ori, arzenti, mobelli superflui, crediti de offitii ecetuado quello si atrovasse alla Camera d'imprestidi et tutto investir in fondi di fora, in lochi seguri et di bon havere et piui propinqui et comodi alle altre possession vi lasso et vi aricordo a far qualche spexa nelle possession et lochi del Castegnaro che si li vorete a tender et farli far di cortivi et cassamenti si ne trarà grossa intrada et sopra tuto tovar uno fator sufitiente et daben con darli bono sallario et non guardar a spexa per trovar persona sufitiente et daben et vi aricordo in po[...] molto et il tutto a far tenir li arzeri et penelli di esse possession in aconzo, vi aricordo tenir sempre in contadi ducati mille per molte occorentie si de guerre che si convenisse pagar molte angarie come per altri bisogni potria accader. Non volgio che a modo niuno si per caxo alcun de mei figlioli si maridasse innanzi che el minor fusse di età de ani vintiquatro si possi aseaurar le loro dotte sopra li beni alla mia comessaria a preiuditio deli minori maridandosi alcun di essi mei filgioli et tolendo dona che non sii nobile di questa città et di bonissima fama, volgio che quel de mei filgioli tolesse dona non havesse le condition sopraditte, voglio che inmediate el perdi et si intendi haver perso la mità de tuti li mei beni li potesse tochar in parte hover li havesse tochado imparte cossì mobelli come stabelli, possession di fora er altro, cossì di quelli lasserò alla mia morte come di quelli fusse sta aquistadi per li mei comissarii dapoi la mia morte qual beni l'averà perso venga per li altri mei filgioli et heredi di cadaun loro egualmente

[f. 2v]

per stirpe in li mascoli et la parte di quello tal sarà incorso in tal heror resti et romanga conditionata che non si possi mai vender né impegniar et resti sotto quel piui streto fidei comisso che si possi far et vada sempre di herede in heredi mascoli et disessi per linea mascolina et manchando in tempo vicino la linea masculina di quel tal mio fiol fusse in tal heror quella parte de beni torni et pervenga in li heredi mascoli et disessi per linea masculina de altri mei fioli per stirpe egualmente.

Mancando io innanzi per me fusse sta fatta far l'archa aver deposito in la chiesia de misser San Pietro de Castello dove si harà a metter il corpo del quondam reverendissimo patriarcha di Venetia misser Pierofrancescho fo mio carissimo fratello, volgio che per ditti mei comissarii sii spexo in esso deposito et archa almen ducati cinquecento et da la in suso tanto quanto a loro parerà per honor et debito io ho et noi, mei filgioli et heredi havuto verso quella benedeta et santa anima di esso quondam reverendissimo Patriarcha di Venetia mio fratello per esser lui stato qual massimo et singolarissimo homo che ha hauto pochi pari si in bontà et sufitientia et in ogni sientia profondissimo che merita ogni grande honor, al qual io son molto tenuto et obligato si per l'amor grande sempre in vita mi ha portado che mai mi disdisse in cossa niuna ancor stesse a sua posta reportandosi et contentandosi sempre di quanto hera il voler mio et si ben non facea conto di roba et non la voleva sempre mi iutò et si affatichò in conservarmilla, difenderla et augumentarla et noi, mei filgioli Nicolò, Andrea, Ierolemo sapete con quanto amor, carità, rispetto vi amava et tratava non come nepoti ho filgioli ma da fratelli perhò vi aricordo et commando ha non esser ingrati et ad honorarlo che l'onor serrà nostro et non suo et volgio si faria tal opera che sii laudabille et di qualche magnificentia et non essendo come è ditto fatta al mio manchar, volgio subito si li dii principio et seguitar si che in spatio de dui anni la sii finitta et farli meter quelli epitafii et laude che merita uno tanto et cossì raro homo.

Nicolò, Andriana, Lugretia mei fratelli et sorelle naturalli vi li racomando quanto piui posso qualli dieno haver ducati mille per cadauno come hordinò il quondam reverendissimo Patriarcha di Venetia misser Pierofrancesco fo mio fratello cioè Andriana et Lugretia ducati mille per una con le cosse per il suo maridar over monachar come meglio alloro parerà, le prego volgiano esser contente tor ditti ducati mille per una con quella comodità honesta che la mia comessaria non patischa che son certo per esser fiole di bonissima natura e sempre hano portado grande amor et rispeto a me et a mei filgioli serano contente farlo volentiera et il simile farà Nicolò perché sempre ho conossiudo lui amarmi et haver molta afflition a mei filgioli serà contento anche lui di tor li ducati mille con ogni comodità et volgio che volendo star in caxa ditte mie sorelle et fratello possino star anto quanto alloro parerà con essi mei filgioli fino si marideranno hover si farrano monache et per il tempo starano in caxa con essi mei figlioli habieno le spexe, vestide et calzade et si poi maride venisse il caxo che restaseno vedoe che Dio non el volgi, volgio possino ritornar in caxa er haver le spexe per la loro persona in caxa de mei filgioli et non altramente né che possino estrazer essi mei filgioli ho comissarii a farli le spexe for di caxa ma volendo star in caxa de mei figlioli con essi mei figlioli possino star et haver le spexe et una camera vivendo perhò et havendo menà et menando quella vita honesta che hanno fatto fino al presente che son certo faranno et facendo altramente non volgio habiano locho né habitation niuna in caxa mia et de mei filgioli. Prego esso Nicolò mio fratello volgi sempre star in caxa con mei filgioli et amarli, consilgiarli et reprenderli in quello fusse bisognio et habi volendo star in caxa con mei figlioli una camera et le spexe et sii atesso né li possino essi mei figlioli dimandar cosa niuna né lui a mei figlioli per questo come né per altro salco che lui Nicolò sempre possi et debi haver li ducati mille di sopra dechiariti.

Il residuo veramente di tuti li mei beni cossì stabeli come mobeli, si presenti come futri et che per alcun modo ho via a me hover alla mia comessaria quomodocumque aspetar potesse lasso a mei figlioli Nicolò, Andrea, Ierolemo, Ferigo, Thadio, Marcantonio egualmente con li modi, condition di sopra dechiarite. Mia fiola Helena volgio la sii contenta et quieta né altro possi dimandar deli mei beni se non quanto li lasso come di sopra è dichiarito.

De elimosine et lochi pii non volgio altro ordinar ma ricomando l'anima mia a nostro Signor Idio pregandolo humilmente volgi per sua infinita misericordia haver remission alli nei infiniti pechati et prego mei filgioli et comissarii volgiano loro far quelle ellimosine che alloro parerà convenirsi et far far atione far pregar nostro Signor Iddio per l'anima mia et pro remission deli mei pechati prego etiam mie fiole suor Maria Colombina et Helena volgio ricordarsi nele loro oration pregar et suplichar nostro Signior perdoni alli mei pechati.

[f. 3r]

Io resto haver dal magnifico misser Alexandro Bon fo de misser Marco per conto de fiti dele possession da Castegnaro in denari come per instrumento fatto adì 21 zugnio 1555 per la qual sua madre mi ha obligado in solido ducati 1623 denari 12 oltra molte regalie et obligarie come per esso instrumento noder Ierolemo Partho et anche del fitto del .55. non son integralmente pagado come per li conti si po veder olim ch'el mi ha debitor stian de ducati 45.1.47 ho pagato per lui al magnifico misser Marco Morexini per el livello dele possession del Castegnaro perché mi franchai de ducati 65 de livello che si pagava et si pagava ducati 15 per livello del Castegnaro per la nostra portion et ducati 150 a misser Marco Morexini per loro nome si ha a bater ducati 65 mi ho franchado resteria ducatti 100 tamen ho pagato l'anno passado ducati 143 in zercha et promessi dar al ditto Morexini. Il resto fino alla suma de ducati 150 che son ducati sette in cercha, perhò volgio vi faciate inmediate pagar dele rate corse et dele rate coreranno di tempo in tempo et far satisfaria ale obligation come per essa composition oltra che si die haver molti denari per conto vechio fo scriti alle Cazude al quondam suo avo materno da Cha' Faxuol et anche vi cedesseno za molti anni al Offitio di Sopragastaldi del suo credito de livelli per certa intromission da ducati 150 ho piui ho manco bisognarà veder et del tuto farsi satisfar holtra che le tenuto a far riparar li arzeri per li anni l'avesse manchado et de conzar le croxe et altro conto per la affittation apar dele qual cosse mai fin hora ho potuto venir a fin per havermi menado in parole de ozi in diman sichè in conforto

ad expedirla et farvi pagar si resta etiam haver dal quondam serenissimo Prencipe misser Andrea Griti per conti vechi delli viazi de Costantinopoli de navi perhò bisognia far comandar li sui comissarii et farsi pagar.

Comissarii et executori di questo mio testamento et ultima volontà voglio sii Isabetta mia carissima consorte, Nicolò et Andrea mei carissimi filgioli et misser Francesco Corner fratello de Isabeta mia carissima consorte et mio carissimo cognato qual prego quanto piui posso volgi tor la protetion di essi sui nepoti mei filgioli et non manchar del qual ofitio che sempre et in ogni occasion ho fatto per loro in quello li ho potuto zovar et fatto quello che fprsi altri non haria fatto perhò il prego ad esser sempre suo difensor in titte quelle cose haran bisogno di aiuto, ricordo et reprension et a voi mei filgioli comando che sempre in tutte le nostre operation debiate far et operar con il consiglio et saputa di esso misser Francesco Corner vostro barba, recordandovi sopra ogni altra cossa che in tute le nostre attion et operation sempre habiate el nostro Signor Idio dinnanzi li ochi né far cosse se non ben fatte et cristiane che facendo cossì non potrete se non far bene et le cosse nostre prosperreranno sempre de ben in megio et facendo fine vi do la mia beneditione che prego nostro Signor Idio sempre eterno vi benedischa et costudischa. Amen.

Io Dario Contarini fo de misser Thadio ho scrito questo testamento de mia mano et confermo questa esser la mia ultima volontà et in fede ivi ho sottoscritto.

Adì 17 novembre 1556

Essendo adì mandato io Lorenzo di Motoni dala Croxe fo de misser Piero se io cognoso la letera scrita nel prexente sfogio per li magnifici signori Sopragastaldi et Canzelieri inferiori, dico per mio zuramento parermi esser letera scrita de manu propria del quondam magnifico misser Dario Contarini fo de misser Tadio, et questo per la amicitia aveva con sua magnificiencia et di sue scriture per esser lui stato Proveditor ali Tre savii sopra i conti dove io son raxonato et averlo visto a scriver neli zornali de dito offitio et cuxì afermo esser la verità.

Iuravit

Adì 18 novembre 1556

Essendo dimandato io Hieronimo Zorzi fu de misser Bernardo se io conoso la littera scrita nel presente sfoglio per li magnifici signori Sopragastaldi et Cancellieri inferiori dico per mio zuramento dico parermi esser litera scripta de mano propria del quondam magnifico misser Dario Contarini fu del magnifico misser Tadio la scriptura scripta nel presente foglio et questo dico perché essendo suo advocato in diverse sue cause sua magnificentia mi scriveva diverse polize pagandomi et ordenandomi quel che voleva che io facesse in le sue cause et così affermo esser la verità

Iuravit

[f. 3v]

1556 die XVIII novembris

Essendo addimandato io Hieronimo Regazzola nodaro all'Avogaria per li magnifici signori Sopragastaldi er Cancellieri inferiori se io cognosco la littera scritta nel presente folio dico per mio giuramento parerà esser littera scritta di mano propria del quondam magnifico misser Dario Contarini fo del magnifico misser Thadio et questo per pratica et gradne amicitia haveva con sua magnificentia et haverlo veduto a scriver et haver havuto delle sue polizze et cossì affermo esser la verità.

Iuravit

[f. 4r]

Laurentius Priolus Dei gratia Dux
Venetiarum et cetera

Supplicarunt Domino nostro humiliter nobilis mulier domina Helisabet relicta quondam ser Darii Conreni quondam ser Thadei et nobilis viri ser Nicolaus et Andreas filii ipsorum iugalium, necnon ser

Franciscus Cornelio quondam ser Fantini omnes comissarii predicti quondam ser Darii quod quandam ipsius ser Darii cedulam testamentariam post eius obitum repertum manu propria dum viveret scriptam sub die XXIIII augusti proximi elapsi ac ipsius ultimam voluntatem continentem dignaremur per unum ex cancellariis nostris inferioribus in […] publici et autentici testamenti redigi mandare cum clausulis solitis et opportunis ut pia testamentis voluntas executioni debite mitti possit ut iustum et conveniens est, sicuti in eorum humili supplicatione coram Domino nostro ac consiliis nostris ordinatis lecta latius continetur, visa responsione virorum nobilium officialium nostrorum Supergastaldionum cum consilio et opinione Cancellariorum nostrorum Inferiorum mandato nostro superinde factam consulentiam supplicantes ipsos gratia nostra dignos esse omnibusque

[f. 4v]
optime consideratis, cum dictis nostris ordinatis consiliis nemori videlicet de Quadraginta et maiori supplicantis prefatis gratiam fecimus quod fiat et petitur et consulitur quare et cetera. Datum die XXIX novembris 1556.

<div align="right">

Ioannes Marius Navis
Ducalis notarius et cancellarius
capserius

</div>

<div align="center">

+

1556. Die .29. novembris

</div>

Pars publicata in Maiori Consilio pro relevanda caedula testamentaria quondam viri nobilis ser Darii Contareni quondam ser Thadei in visu publici et authentici testamenti.

Doc. 3
Inventory of Dario Contarini—October 17–November 16, 1556
(Archivio di Stato, Venice. Notarile. Atti, b. 2567)

[f. 76v]
Viri nobiles domini Nicolai, Andree et ser Hieronimi Contareno quondam magnifici domini Darii. Presentatio testi.

<div align="center">1556 .13. novembrio.</div>

Recevi io Andrea Contarini fo del contrascritto magnifico misser Dario il contrascritto testamento qual era de man del quondam contrascritto magnifico mio padre il qual subito presentai a misser Anzolo nodaro del offitio dei Sopragastaldi, alla qual presentation fu presente misser Girolamo mio fratello.

Io Hieronimo Contarini del quondam magnifico misser Dario fui presente e afermo quanto è sopra scritto.

<div align="center">Die 17 mensis octobris 1556</div>

Constituti coram me notario et testibus infrascriptis magnifica domina Helisabeth filia quondam magnifici domini Fantini Cornelio et relicta quondam viri nobilis domini Darii Contareno quondam clarissimi domini Thadei, nec non viri nobiles dominus Nicolaus, dominus Andreas et dominus Hieronimus Contareno fratres maiores natis filiis prefatorum iugalium, agentes omnes predicti tam nominibus suis propriis quam nominibus dominorum Thadei, Phederici et Marciantonii eorum fratrum minorum ac domine Helene eorum sororis sponte dederunt et presentarunt mihi notario infrascripto quandam, ut asseruenrunt, cedulam testamentariam manu ut dixerunt eorum patris clausam et sigillatam

[f. 77r]

sigillo suo repertam in quodam eius scrinio, quam per me aperiri voluerunt, et deinde illam de verbo ad verbum eis legere, qua lecta rogarunt me notarium ut ipsam cedulam apud me tenerem sub bona custodia, ut possint deinde procedere servatis servandis in similibus ad ipsam testamentariam cedulam in publicam formam relevari faciendo per unum ex dominis Cancellariis inferioribus ut in similibus fieri solet.

Actum Venetiis in domo suprascriptorum nobilium de Ca' Contareno posita in confinio Sancte Fusce. Presentibus ad presentia venerabile domino presbiter Girardo Giraldo quondam domini Petri ferrariense preceptore predictorum filiorum minorum in dicta domo de Cha' Contareno et domino Nicolao quondam ser Iohannis famulo ad stateram comunis de confinio Sancti Marcialis Venetiarum testibus vocatis et rogatis.

Quondam viri nobili domini Darii Contareno quondam clarissimi ser Thadei.
Inventarium.
<div align="center">Die dicta</div>

Inventarium quarundarum rerum, denariorum, scripturarum et josalium inventorum et repertorum in quadam capsula sive scrinio quondam viri nobilis domini Darii Contareno que capsula erat in talamo sue solite habitationis factum ad instantiam nobilis domine Helisabeth relicte prefati quondam magnifici domini Darii, ac virorum nobilium dominorum Nicolai, Andree et Hieronimi Contareno eius filiorum.

<div align="center">Cuius quidem inventarii tenor
Sequitur et est talis videlicet</div>

Et primo ducati sie di moneda venetiana da lire 6 soldi 4 per ducato posti in un sacchetto di tella verde

Item sacchetti numero nuove con ducati cinque di moneda per cadaun sachetto fano in tutto ducati quarantacinque

Item in uno sachetto di tella rossa toleri numero cinque et uno mezzo toler solea valer ditti toler lire 5 soldi 2 l'uno. Item nello estesso sachetto uno altro sachetto piciolo con dodeci marcelli forestieri. Item in uno

[f. 77v]

altro sacchetto con sessanta monede forestiere soleassi spender grossi 18 l'una et con undese altre monede forestiere solea valer soldi 12 l'una.

Item un sacchetto di tella negra pezzi d'oro numero tredese cioè una moneda d'oro papal de precio de ducati diese, scudi quatro vecchi zenovini. Item tre ongari, un raines, un doppion et tre venetiani.

Item un sacchetto con uno saffil grando affazette ligado in anello d'oro.

Item un altro sacchetto con do vere d'oro dentro et una turchese ligada in uno annelo d'oro da bolla fu del quondam reverendissimo Patriarcha di Venetia.

Item in una scatoletta una perla granda bassa da una banda solea esser ligada in annello. Item il ditto suo annelo d'oro et una cadenella d'oro a martello piciola revolta in una carta.

Item una altra scatoletta con una cadenella in ruoda d'oro et uno annello da bolla d'oro con una ciera d'oro qual cose dissero esser per pegno.

Item do tazze d'arzento quale dissero esser per pegno.

Item uno scriminal d'arzento da donna.

Item in uno altro scrigno grando di nogara con la sua seradura et chiave posto nella ditta camera appresso il foger li era l'infrascritte cose, videlicet

Doi taze d'arzento mezane delle qual li era una scatola con una spinella ligada in uno anello d'oro et uno sachetto con scudi forestieri numero settanta sette e mezo et uno da do soldi.

Item nel fiorio de ditto scrigno uno sachetto di tella rossa nel qual li era quatordese sachetti uno con ducati dento di moneda et li altri tredese con ducati diese di moneda per cadauno sono in tutto ducati dusento et trenta.

[f. 78r]
Item un sachetto di tella rossa con cento et settanta otto scudi d'oro forestieri et soldi 6 de moneda.
Item uno altro sachetto di tella rossa con venetiani d'oro numero cento et cinquanta tre et soldi 14 di moneda.
Item uno altro sacchetto di tella rossa con scudi d'oro forestieri numero cento e ottanta sette.
Item uno altro sachetto di tela rossa con scudi venetiani d'oro numero nonanta et lire 1 soldi 4 di moneda.
Item uno altro sachetto di tella rossa, tra fiorini, siori et diversi altri ori in tutto pezzi numero ottanta et soldi 10 di moneda.
Item uno altro sachetto di tella rossa con ottanta sette crusiati dalla crose longa et lire cinque di moneda.
Item uno altro sachetto rosso con ori diversi in tutto pezzi numero ottantado et lire do di moneda.
Item uno altro sachetto di tella rossa con ottantado ongari d'oro et soldi 32 de moneda.
Item diverse scritture le qual non furno altramente inventariate ma sono rimaste nel sopraditto scrigno con sopraditti ori, monede et annelli.
Claves vero suprascripti scrinei cum omnibus ipso contentis et in hoc inventario descriptis reperiunt et sunt in manibus viri nobiles domini Nicolai Contareno filii predicti quondam magnifici domini Darii presentibus ad hoc predicta magnifica domina Helisabeth eius matre et viris nobilibus dominis Andrea et Hieronimo Contareno fratribus suis ita contentantibus.

Actum Venetiis in domo suprascriptorum nobilium de Ca' Contareno posita in confinio Sancte Fusce presentibus ad predicta venerabile domino presbitero Girardo Giraldo quondam domini Petri ferrariense et domino Nicolao quondam ser Ioannis famulo ad stateras Comunis de confinio Sancti Marcialis Venetiarum vocatis et rogatis.

[f. 84r]
Die XII mensis novembris 1556
Nobilis mulier domina Helisabeth filia quondam magnifici domini Fantini Cornelio et relicta quondam viri nobilis domini Darii Contareno quondam clarissimi domini Thadei non intendens ac nollens se aliqualiter in com-

[f. 84v]
missaria dicti quondam viri sui impedire. Ideo omni quo potuit meliori modo solemniter constituit et ordinavit procuratorem suum legitimum et commissum dominum Nicolaum Contareno quondam clarissimi domini Thadei presentem et acceptantem specialiter et expresse ad ipsius muliere domine constituentis nomine et pro ea refutandum et renuntiandum quandocunque notam refutationis et renunciationis faciendum ut in similibus fieri solet. Et generaliter ad faciendum omnia et singula que circa refutationem predictam necessaria fuerint quomodolibet et opportuna, promittens debere firmum, rathum et gratum omnia et singula que in premissis et circa premissa factum et procuratum fuerit sub obligatione omnium et singulorum bonorum suorum presentium et futurorum.

Actum Venetiis in domo habitationis suprascripte magnifice domine constituentis posita in confinio Sancte Fusce presentibus ad predicta domino presbitero Girardo Giraldo quondam Domini Petri ferrariense et ser Ippolyto Brixiense quondam ser Andree magistro saponarie nobilium de Ca' Vendrameno testibus vocatis et rogatis.

Quondam viri nobilis domini Darii Contareno.

Inventarium.

Die 12 mensis novembris 1556

Inventarium quorundam denariorum, iosalium, rerum et bonorum mobilium repertorum in domo habitationis quondam viri nobilis domini Darii Contareno quondam clarissimi domini Thadei posita in confinio Sancte Fusce factum ad instantiam virorum nobilium domini Nicolai, domini Andree et domini Hieronymi Contareno fratrum et filiorum predicti quondam magnifici domini Darii.

Et primo in quadam capsula seu scrinio parvo una borsa di tella

[f. 85r]

con sessanta sette scudi d'oro venetiani et quaranta tre scudi d'oro forestieri et quatro ongari d'oro in do doppioni et un venetian vecchio.

Item una spinella et uno diamante ligadi tutti do in oro insieme in pendente, le qual dissero esserli sta restituite dal magnifico misser Silvestro Moresini, che l'haveva havute ad imprestedo dal ditto quondam magnifico misser Dario, delle qual tutte il predetto magnifico misser Geronimo Contarini disse haverli fatto di recever.

Item una fenice in medaglia d'oro et smalto adornata con sie diamanti et sie rubini in torno.

Item una medaglia d'oro da baretta da putto con uno homo a smalto sopra.

Item disdotto stellete d'oro da baretta, item 14 pontali d'oro da baretta.

Item un diamante in tavola ligado in anello d'oro.

Item un saphil biancho in tavola ligado in uno annelo d'oro.

Item una vera d'oro.

Item uno anneletto d'oro piciolo in fede.

Item un paro de manini da donna d'oro in cadena.

Item uno altro paro de manili d'oro con foglie lavoradi d'orese, nelli quali sono ligade trenta sie perle piciole, et sie rubini et sie diamanti.

Item trenta segnaleti, over groppetti picioli, che si suol metter a un fil de perle fra l'una et l'altra.

Item cinquanta do paternostri d'oro da cenzer lavoradi a fil con smalto.

Item tresento e sesanta sie paternostri picoli d'oro smaltadi da cenzer.

[f. 85v]

Item quatro cadenelete d'oro ligade in massa da metter al collo.

Item una altra cadenella d'oro piciola fatta a magiete smaltade.

Item una altra cadena d'oro da collo in ruoda dissero esser de valuta de ducati diese o 12 in circa.

Item un diamantin piciolo in ponta ligado in oro con otto perlette ad intorno ditto diamante.

Item un fil de perle da onza con li sui velliselli negri picioli et con un fiocho d'oro fatto per orese con una perla in pero.

Item trentasette perle rossegne et male avalide de grosse, mezane et piciole.

Item vinti tre ingranate.

Item trenta otto altre ingranate con li sui groppeti d'oro tra l'una et l'altra et con sette segnali, over paternostri d'oro lavoradi a smalto et con uno vaseto piciolo d'oro.

Item una corona de corniole di numero sessanta tre con li sui segnaleti over pater nostri d'arzento lavoradi a fil.

Item quaranta otto altre corniolete da disparte.

Item cinquanta do pater nostri d'ambracan da cenzer con sue stellete d'oro

Item una cassa da spechio d'arzento soazada, con l'arma Contarina et Cornara sopra il coverchio.

Item un officiol della Madonna con le coverte d'arzento soazade con il suo zolaggio d'arzento.

Item un bacil d'arzento con l'arma Contarina Cornara et Moceniga a mezzo.

Item nuove tazze d'arzento senza pe' et tre altre tazze d'arzento con il pe' un poco più piciole sono in tutto numero dodese.

[f. 86r]
Item do saliere d'arzento con tre pie l'una.
Item do dozene de pironi d'arzento vuodi nuovi.
Item disdotto pironi d'arzento vuodi vecchi.
Item vinti tre cuslier d'arzento.
Item disnuove cortelli de ferro vecchi con il manego d'arzento con l'arma Contarina.
Item undese altri cortelli de ferro da tagliar in tavola con il manego d'arzento. Item uno altro cortello di ferro simile con il manego de arzento lavorado a un altro modo.
Item una dozena de cortelli de ferro nuovi con il manegho di ferro lavoradi.
Item alcuni altri cortelli vecchi de ferro che se adopera per casa.
Item una cazetta d'arzento da acqua piciola con il suo manego d'arzento lavorado.
Item una scudella d'arzento.
Item un scudelin d'arzento.
Item un taglier d'arzento.
Item una taza d'arzento a sonde con doi maneghi.
Item do bossoli da specie lavoradi.
Li qual tutti ori, arzenti, zoglie et beni soprascritti presente li prefatti magnifici misser Andrea et misser Gierolemo Contarini et così contentati furno posti nel scrigno grando in ditta camera sotto chiave tenute per il magnifico misser Nicolò Contarini suo frattello.

Item similmente ad instantia delli prefatti fu inventariate tutto il restante dele robbe de la camera che solea habitar il ditto quondam magnifico misser Dario Contarini et prima in torno la camera.
Uno quadreto schieto con la figura del nostro signor misser Iesù Christo

[f. 86v]
Un quadro grando con sue soazze indorade con l'immagine di San Francesco.
Un quadro fatto de man de Zuan Bellin con una figura d'una donna.
Un quadro grandeto con sue soazze intordo dorade con una donna che si varda in specchio.
Uno altro quadro grandeto con tre figure di donne nude con sue soazze dorade.
Item un cesendello di crestallo di montagna et uno secchieleto con il spergolo tutti fornidi d'arzento a smalto.

Item otto casse di nogara a torno ditta camera tutte con le sue seradure et chiave.
Prima. Et prima nella prima cassa appresso il balcon li son l'infrascritte robbe videlicet
Una sottana da donna de samito zallo a filzete vechia.
Una sottana da donna de raso incarnà che dessegni de raso biancho usada.
Una altra sottana de raso festechin et cremesin usada.
Una altra sottana de raso turchin a filzete usada.
Una sottana de raso berettin usada.
Una sottana de damascho berettin usada.
Una sottana de raso zallo a filzete usada.
Una sottana de zambellotto biancho con striche d'ormesin biancho et cordoni de arzento falso usada.
Una sottana de damascho paonazzo usada.
Una sottana d'ormesin ganzante a filzette usada.
Item tutte le maneghe di ditte sottane.

[f. 87r]

Cinque pezzi de raso biancho da vestura vecchi tagliadi.

Item alcuni zupponi et calze vecchie della buona memoria del ditto quondam magnifico misser Dario Contarini.

2da. Item nella seconda cassa

Una sottanda da donna con quatro telli de panno d'oro et quatro de raso cremesin compano d'oro perfiladi, over tagliadi.

Una sottana de raso biancho usada.

Una sottanda de ormesin bianchi a filzete usada.

Una vesta da puto de veludo negro fodrà de dossi usada.

Un saggio da puto de veludo cremesin usado,

Una vesta da puto de damascho paonazzo usada.

Uno zupponetto et un per de calzoni da puto de raso biancho con ricami de panno d'oro usadi.

Un saggio da puto de damascho roan vecchio.

Un saggieto de raso incarnà tagliado et fodrado de ormesin.

Do zupponeti d'ormesin cremesin un più grando de l'altro.

Un zebellin

Una stolla de veludo paonazzo.

Un cavezzo de tella chiara da traverse.

Tre pezzi de tella per far do appara de linzuoli in circa.

Un pavion de rede lavorado d'azze.

Quatro pezzi de rede lavoradi d'azze da metter alla sponza d'il letto et

Do intimelle similmente lavorade d'azze.

3za. Item nella terza cassa

Camise del ditto quondam magnifico misser Dario tra nuove, usade et più vechie, in tutto numero trenta otto.

Do bochassini fatti in sottana videlicet uno a filzete et l'altro no.

[f. 87v]

Item camise da donna della magnifica madonna Isabetta Contarini numero disdotto, delle qual una è lavorada di seda cremesina et do di seda negra.

Un pavion di tella di renso con cordella ruzene a torno.

Diese faccioli da man lavoradi usadi.

Dodese facioli da man non lavoradi usadi.

Tre traverse tonde da donna vecchie.

Item calzette di tella, pezzi di tella et altre fusare vechie di poco valor.

4ta. Item nella quarta cassa

Quatro pezze de lisaro.

Tre pezze de bochassin.

Una pezza di tella di renso quasi integra.

Un cavezetto di tella di renso.

Do cavezzi di tella zalla da far traverse.

Sette zupponeti da putto videlicet un de ormesin paonazzo, un de raso zallo, un de ormesin biancho, un de raso verde, un de raso incarnà, un d'ormesin roan et un d'ormesin negro tutti vecchi et usadi.

Un faccio, de lisaro biancho.

Un tello de raso zallo da vestura.

Un cavezzo de rassa rossa.

Una pezza de mochaggiaro negro piciola.

Item diverse fusare di poco valor però non furno inventariate.

5ta. Item nella quinta cassa appresso la porta.

Sedese intimelle di tella.

Una pezza di tella grezza da linzuoli da ottanta brazza in circa.

Tre para de linzuoli do compidi et uno da compir.

[f. 88r]

6ta. Item nella sexta cassa in fazza della camera.

Una vesta da donna de burato negro usada.

Una vesta da donna de raso negro tessuda spina usada.

Una vesta da donna de samito negro fatta a filzete.

Una vesta da donna d'ormesin altro negro fatta a filzete.

Una vesta da donna de veludo negro schieta.

Una vesta de doblon da donna negro.

Una vesta da donna de damascho negro tessuda a striche.

Do cavezzi un più grando de l'altro di veludo negro a figure.

7ma. Item nella settima cassa posta appresso et sotto il balchon.

Un paro de linzuoli lavoradi d'oro con sue intimelle videlicet un paro de grande et un de piciole.

Un per de linzuoli di tella di renso lavoradi d'azze.

Do cai d'oro con franza d'oro da faccioli da specchio.

Sedese intimelle videlicet un per de piciole, tre para de tella de cambra et il resto di tella di renso.

Un per de linzuoli de cambra lavoradi de negro.

Cartoline d'oro larghe quatro deda da metter a torno un per de intimelle, un facial lavorado revolto a torno ditte robbe.

Un per de linzuoli di tella lavoradi a ponto tagliado che non sono finiti.

Item scuffie di tella, bavari, traverse et cose simile che adopera la ditta magnifica madonna Isabetta Contarini.

8va. Item nella ottava et ultima cassa posta appresso il fogher.

Una sottana da donna de zambellotto zallo con marizzo.

[f. 88v]

vecchissima con striche de raso turchin.

Una pellizza de dossi da donna senza coverta.

Una sottana de veludo verde.

Una sottana de veludo ruosa seccha.

Una sottana de panno roan intagliada da pe' con veludo negro con cordoni berettini.

Una sottana de veludo et raso verde.

Un pezzo de veludo paonazzo alto basso per una cariega et mancho.

Item una cariola di nogara indorada in collone con sue cortine roane a torno senza soffitta con l'arma Contarina et Cornera, con un letto de piuma usado et il suo cavazal, do stramazzi, un pagiarizzo, un per de linzuoli de lin usadi, un covertor di panno rosso vecchio, una felza rossa, una coltra di tella biava usada et il suo torno letto de mochaggiaro roan.

Item a mezza camera un scagno de nogara con sue casselle.

Un paro de cavedoni de ferro fornidi de lotton schieto, con sui fornimenti da fuogo et il suo ferro da cenere.

Item in fazza de ditta camera un spechio apichado grando indorado con l'arma Contarina et Vendramina.

Le qual tutte robbe furno lassade nelli suoi lochi della prima camera.

Actum Venetiis ubi supra presentibus ad predicta domino presbitero Girardo Giraldo quondam donimi Petri ferrariensis et ser Ippolito Brixiensis quondam ser Andree magistro saponarie nobilium de Ca' Vendrameno testibus habitis, vocatis, specialiter et rogatis.

[f. 89v]
Quondam viri nobili domini Darii Contareno.
Inventarium.
Die XIII mensis novembris 1556.
Inventarium aliarum rerum et bonorum mobilium quorum viri nobili domini Darii Contareno quondam clarissimi domini Thadei repertorum in domo solite sue habitationis factum ad instantiam virorum nobilium domini Andree et domini Hieronimi Contareno fratrum et filiorum predicti quondam magnifici domini Darii cuius quidem inventarii tenor sequitur et est talis videlicet

Et primo sopra il soraletto della camera del quondam magnifico misser Dario li sono l'infrascritte robbe videlicet nuove carieghe de nogara piciole de paglia vecchie.
Una valise de cuoro granda vecchia.
Un bazzil de lotton grando et doi altri bazzili de lotton picioli.
Una cuogoma de rame grandetta et do altre cuogomete de rame pizole vecchie.
Una forma de ferro da scalete.
Un scaldaletto de lotton vecchio all'antiga.
Diversi corli, naspi et robbe di poca valuta.

[f. 90r]
Item nella camera sopra il canal de Santa Foscha per mezzo la camera anteditta.
Do quareti con la figura della nostra Donna.
Un quaro grando con do figure depente in piedi puzadi a do arbori con una figura de un homo sentado che sona de flauto videlicet
Uno altro quareto piciolo con diverse figure tra le qual li è depento una donna con una lira in man et un homo appresso.

Item cinque casse de albeo con soaze dorade vecchie con sue seradure et chiave a torno ditta camera.
Prima. Et primo nella prima cassa posta appresso la porta si attrova l'infrascritte robbe cioè
Do tappedi grandi da tavola da cinque in sei brazza l'uno usadi
Do cortine d'ormesin cremesin lavorade d'oro a mordente con il suo sgazaron.
Do cussini de veludo paonazzo altobasso con sui fiochi.
Un cussinello de panno d'oro con la cordella d'arzento a torno.
Un covertor da letto de veludo zizolin con una lista di cartolina d'oro larga più di mezza quarta.
Una fodra de martori del sopraditto covertor vecchia.
Una fodra da vesta de martori nuova in do pezzi integri.

2da. Item nella seconda cassa.
Un duliman vecchio strazzado picciolo di panno negro ugnolo.
Do altri dulimani picioli de panno negro fodrà de volpe vecchie.
Una vestizuola piciola de mochaggiaro negro fodrà de volpe vecchie.

Una vesta granda de panno roan vecchia fodrà de volpe vecchissima.

Una vesta di panno negro a maneghe a comodo fodrà de dossi vecchi qual era del ditto quondam magnifico misser Dario.

Una vesta da portar per casa de panno negro fodrà de volpe nuova.

[f. 90v]

3°. Item nella terza cassa

Una centura de veludo negro vecchia con quatro passeti d'arzento et sue fiube.

Un saggieto d'ormesin negro altro vecchio.

Una vesta de zambelotto negro vecchissima.

Tre vestizuole piciole da puto de damascho negro strazade.

Do saggi de panno negro vecchi picioli.

Una vesta da portar per casa de panno negro usada.

Una vesta de mochagiaro negro solea portar il ditto quondam magnifico misser Dario per casa.

Do veste a maneghe a comedo de panno negro fodrade d'ormesin usade.

Do stolle de panno negro vecchie.

Una vesta de panno negro usada da portar per casa.

Cinque vestizuole de panno negro et roan triste et strazade.

4ta. Item nella quarta cassa.

Do brazza de franza d'oro antigha da metter a maneghe over camisuole.

Un poco de franzete d'oro.

Cinque pezzi picioli tra maneghe et pettoral antighi lavoradi de arzento et seda.

Do pezze di tella chiamate mussoli.

Un sguazaron strazzado di tella di renso imbottido.

Un cavezzo de bocchassin turchin da far una coltra.

Una sedola et una coda da petteni fornida con li sui maneghi d'arzento lavoradi et l'arma Contarina et Vendramina.

Do faccioli di tella grossa da mar nuovi.

[f. 91r]

Un altro faciol da man usado.

Do pezzi picioli de ormesin recchamadi d'oro da metter davanti li cassi alle donne.

Un faciol de seda et de bombaso bianco.

Quatro altri faccioli de diverse sorte, delli quali uno è lavorato con li sui cai negri.

Quatro faccioli de lisaro usadi con li sui cai.

Un bochasin alla antiga vechio bianco.

Tre pezze de bochassin nuovo.

Una pezza integra de lisaro.

5ta. Item nella quinta cassa.

Otto mantili nuovi di fil di stoppa grossi grandi da tavola con li sui cai torti.

Quatordese mantileti da credenza de opera di renso nuovi grossi di stoppa.

Do tovaglioli nuovi a opera di renso grossi di stoppa.

Un per de linzuoli de stoppa usadi.

Un per de linzuoli de lin usadi.

Una coverta da careta de feltron rosso vecchia.

Un torno letto de samito rosso vecchio fodrado di tella roana vechia, con li sui sguazaroni in tutto pezzi numero nuove.

Item un una cassella piciola biancha de albeo.

Un breviario de carta bona miniato scritto a penna coverto de veludo cremesin.

Un paro de intimelle di tella rechamade a figure.

Item diverse scatole et scatolete da donna con diverse cosete di poca valuta.

[f. 91v]

Item sopra la ditta cassella una altra cassella de albeo simile.

Tre pezzi de panni verdi da brazza X in XII in circa quali solea star nel mezzado.

Item un tappedo da tavola da 4 brazza in circa vecchissimo solea tenirsi importego.

Item nella litiera de casa nella ditta camera un letto de piuma, un stramazzo di lana, un paggiarizzo, un cavazal de piuma, un cusinello de piuma piciolo, un per de linzuoli de lin grossi usadi, una felza biancha et una coltra de tella biava vecchie, do pezzi de coltrina de tela biava vecchie, do pezzi de coltrina de sarza negra con il suo sguazaron.

Item a mezza camera un scagno de nogara usado con le sue casselle.

Item un per de cavedoni de ferro fornidi de lotton picioli a l'antica con il suo ferro da fuogho.

Item nel studiol in ditta camera una cassella piciola con un paramento da sacerdote turchin a fioroni et un calese et patena d'arzento mezzati qual ha sie cantonali intorno il groppo.

Item nel solaruol sopra il letto de ditta camera

Do gargatoni mezani da acqua ruoa.

Quatro lavezzi de terra picioli.

Una scatola in tre scatole con il suo coperchio de rame lavorada alla damaschina.

Una padella de rame piciola.

Un bazil de lotton piciolo.

Una caldiera de rame granda et do calderuole piciole.

Una concha de rame mezana vecchia.

Sie fersore de ferro tra pizole et mezane tutte rotte.

Una stagna da carne de rame mezana.

Do stagnae de rame picioline.

Quatro spedi de ferro picioli.

[f. 92r]

Do parra de cavedoni de ferro da cucina vechi et ruzeni.

Alcuni vasi de terra pizoli et mezani.

Item nella camera appresso l'anteditta nel qual sta le massare.

Una cassa de albeo depenta con sua seradura et chiave nella qual li sonno l'infrascritte robbe.

Quindese tappedi da cassa tra buoni, vechi et strazzadi, Item do tappedi picenini da casseletta.

Item in una altra cassa de albeo biancha con sua seraduta et chiave posta in ditta camera.

Un razzo vecchio a brochà con l'arma Contarina.

Tredese pezzi de spaliera a brochà vecchi con sue armi Contarina.

Tre antiporte a brochà vecchie et strazade con l'arma Contarina.

Alcuni pezeti de banchaleti vecchi.

Item in una altra cassa simile d'albeo biancha con sua seradura et chiave posta in ditta camera.

Do razzi a fogiazzi vecchi et strazzadi.

Sie antiporte a brichà vecchie con l'arma Contarina,

Vintidò tappedi da cassa vecchi.

Un pezzo de rassa verde vecchia.

Item sopra la ditta cassa quatro pezzi de spaliera a brocchà vecchissimi, strazadi.

Item nella litiera dilla casa posta in ditta camera.

Un letto vecchio con do soi cavazali di piuma, una schiavina vecchissima, un per de linzuoli grossi vechi, et atorno ditta letiera un per de coltrine di tella biava a mordente vecchie et strazade.

[f. 92v]

Item nella camera granda posta sopra il canal de San Marcilian si attrova l'infrascritte robbe. cioè.

In una cassa d'albeo soazada depenta et dorada con sua seradura et chiave posta nel cameroto nel intrar in ditta camera.

Trenta do mantilli de renso tra grandi et mezani tra li quali ne sono quatro che son lavoradi.

Do mantili di stoppa grossi.

Vintiquatro tovaglioli di renso lavoradi.

Ottanta tre tovaglioli di renso tra usadi et rotti.

Una pezza da mantili a occhieti de lin da trenta brazza in circa.

Un matil con li cavi bravi grosso da altar.

Otto linzuoli di tella lavoradi.

Sie cavezzi de renso sotil da far tovaglioli.

Vinti quatro tovagiete da man tra grosse et sottile.

Item a torno la ditta camera.

Una figura della Nostra Donna in un quadro piciolo indorado.

Un quadro grandeto con la figura della Nostra Donna et di San Zuanne con le sue soazze de nogara perfilade d'oro.

Uno altro quadro grando soazado vecchio con la figura della Nostra Donna.

Item otto casse de albeo con le sue soaze dorade et con le sue seradure et chiave poste a torno ditta camera. Et prima

Nella prima cassa. Cinque pezzi de spaliera a figure per la camera granda.

Sie pezzi de panno verde a colone depente per la ditta camera.

Item nella seconda cassa.

Veste do di panno negro a menege a comedo fodrade de

[f. 93r]

vari vecchia et erano del quondam magnifico misser Dario.

Una vesta de zambeloto negro fodrà de vari, vecchia et straza.

Una vesta de samito negro fodrà de albertoni negri usada.

Una vesta de tabì negro ugnola da portar per casa nuova.

3°. Item nella terza cassa.

Nuove linzuoli de tella grezza.

Cinque linzuoli de tella usadi.

Cento tovaglioli niovi in una pezza.

Un cavezzo de tella da tovaglioli d'opera de renso da 14 brazza in circa.

Un altro cavezzo di tovaglioli de stoppa grossi da brazza 13 in circa.

Tovaglioli trentado in do cavezi di opera di renso nuovi.

Un cavezeto di dimito.

Un cavezo di tella da linzuoli de brazza 14 in circa.

Un altro cavezzo de tella da linzuoli de brazza 20 in circa.

Un altro cavezo de de stoppa da brazza 20 in circa.

Un cavezzo de tella de lin da far un per linzuoli.
Un altro cavezzo de tella de lin da far un altro per de linzuoli.
Una pezza de tella de lin da mantili a opera di renso.

4ta. Nella quarta cassa.
Un pezzo de intima da letto usada et vecchia.
Un pezzo di tella grossa di stoppa da brazza quatro in circa.
Un cavezzo di tella di stoppa da mantili bassi da brazza 12 in circa.
Un cavezzo de brazza 12 in circa de tella de lin.
Un altro cavezzo di tella da far facioli da brazza 24 in circa.
Un covertor da cuna de carisea lata vecchio.
Do schiavine bianche.
Una carpeta de carisea strazada fodrà de pelesine bianche vecchia.

5ta. Item nella quinta cassa.

[f. 93v]
Una vesta da portar per casa de zambelotto negro vecchia fodrà de volpe.
Una fodra de vesta de volpe nuova.

6ta. Nella sexta cassa.
Un torno letto de bottana de stagia de tella lascha intaglià con cordoni in torno tra cortine,
sguazaroni et torno pe', sonno dodese pezzi in tutto.
Item la sua coverta del ditto torno letto da metter sopra il letto.
Un torno letto de bochassin biancho con sui sguazaroni in tutto sono sei pezzi.
Sie coltre bianche inbotide usade.
Quatro coltrete ugnole de cordelae bianche.
Un moschetto nuovo de tella lascha con le cordelle zo per le cusadure.
Un dulimanetto alla moresca de tella biancha.

7ma. Item nella settima cassa.
Facioli alla moresca coloradi numero quatro in una foreta vecchia.
Un razzo a fogiazze strazade.
Sette pezzi de bochasin biavo cusidi insieme da far coverte di coltra.
Un panno de altar de zambelotto rosso vechio fodrà de tella verde et listado a torno con ormesin
biavo.
Un fornimento da cariola de sarza verde tutto strazado con le sue bandinelle.
Alcuni altri pezzi de sarza verde et rossa strazadi.

[f. 94r]
Una coltra de posta carnada imbottida vechia strazada
Tre pezzi de rassa verde per coverta da careta, vecchi.
Una vesta over bernusso alla cuschocha negro dissero esser de seda.

Item della ottava et ultima cassa.
Piatelli mezzani de peltre numero vintiquatro.
Trenta sie piatelli de peltre un poco più pizoli.
Disnuove taglieroli de peltre pizoli.
Quatro pezzi de spalierie a broccha con l'arma Contarina con la mitria et crose.

Do pezzi de spaliera a brochà, et a agere usadi.

Cinque pezzi de spaliere a brochà vecchie strazade con l'arma Contarina che si sol metter a torno ditta camera.

Otto tappedi da cassa usadi et vecchi et uno altro tappedo da scagno.

A meza camera un scanzello pizolo di nogara vecchio.

Do chariege de nogara con il pozzo di veludo cremesin alto et basso.

Un scrigno de nogara con la sua seradura et chiave vuodo.

Do casselette pizole da letto d'albeo simelle alle preditte 8 casse.

Una casseleta de nogara pizola vuoda.

Un per de cavedoni pizoli de ferro fornidi de lotton all'antica vecchi con la sua paleta et moleta.

Item nella littiera della casa posta in ditta camera do stramazzi schietti vecchi, et un letto di piuma con un cavazal.

[f. 94v]
Item nel studieto de ditta camera. Alcuni ferramenti vecchi et altre bagagne di poca valuta.

Item nel mezzado nel qual sta il predetto magnifico misser Andrea, quatro casse de albeo depente con l'arma Contarina et con sue seradure et chiave con le robbe infrascritte et una altra cassa simile vuoda.

Nella prima cassa. Vinti candelieri de lotton lavoradi alla damaschina tra buoni et cattivi.

Dodese candelieri de lotton lavoradi con arzento alla damaschina.

Sette candelieri pizoli de lotton schieti.

Quatro secchieli da acqua per tavola de lotton lavoradi alla gemina.

Un secchielo de lotton schietto da acqua per tavola.

Quattro cazete de lotton da acqua sciette et una altra con il manegho despicado.

Do baziletti de lotton rotti lavoradi alla gemina,

Un bazil de lotton lavorado alla gemina profilado de arzento et il suo ramin similmente lavorado alla gemina profilado de arzento.

Tre ramini de lotton lavoradi alla damaschina vecchi et rotti.

Un bazil de lotton schietto con il suo ramin schieto.

Item nella seconda cassa.

Dodese pezzi de panno verde tra grandi, et picioli da metter a torno il portego, vecchi.

Un tabaro de panno negro era del ditto quondam magnifico misser Dario.

Un saggio de panno negro vecchio, un saggio de damascho negro usado et un saggio d'ormesin negro usado eran del ditto

[f. 95r]
quondam magnifico misser Dario.

Nelle altre do casse, libri diversi de humanità et filosophia de grandi et de pizoli, stampadi et scritti a pena.

Item una scanzia con libri diversi del ditto magnifico misser Andrea per il suo studiar.

A mezzo ditto mezzado un scagno de nogara con le sue casselle vecchio.

Item nella lettiera della casa posto in ditto mezzado un letto di piuma, do cavazali et do cussini vecchi, un stramazzo, una coltra biava, una felza bianca vecchia et un per de linzuoli et un per d'intimelle vecchie.

Item nel mezado de misser Nicolò fiol del quondam magnifico misser Thadio, otto casse vuode vuode d'albeo depente vechie con l'arma Contarina, con sue seradure et chiave eccetto una di esse

quale tutte erano del ditto quondam magnifico misser Dario.

Item nella camera contigua al predetto mezzado nella qual sta et habita il reverendo maistro di casa. Un per de cavaleti de legno con le sue tavole con il letto de piuma, un stramazo de lana vecchi, uno cavazal, un cussin con la sua intimella, un per de linzuoli vecchi, un pano de lana biancha con un pavion di tella biancha vecchio attorno ditti cavaleti.

Actum Venetiis in domo suprascripta posita in confinio Sancte Fusce presentibus ad predicta reverendo domino presbitero Girardo Giraldo quondam domini Petri ferrariensis et ser Silvestro Balazino de Merlengo territorio trivisano quondam ser Francisci testibus vocatis specialiter et rogatis.

[f. 95v]
Quondam viri nobilis domini Darii Contareno.
Continuatio inventarii.
Die XIIII mensis novembris 1556
Continuatio inventarii aliorum bonorum et rerum mobilium et mobilium que fuerunt quondam viri nobilis domini Darii Contareno quondam clarissimi domini Thadei de confinio Sancte Fusce repertorum in domo solite habitationis posite in confinio Sancte Fusce factum ad instantiam virorum nobilium dominorum Andree et hieronimi Contareno fratrum et filiorum predicti quondam magnifici domini Darii.

Et primo nella cusina de ditta casa sopra la scanzia.
Trenta quatro piati de peltre tra grandi et picioli, disnuove piadene de pltre mezane, vintiquatro tagieri de peltre, dodese tagieroli de peltre, sie scudelini de peltre, dodese scudelle de peltre et diese scudelle de peltre da l'oro largo.
Item sopra una altra scanzia diversi pezzi de magiolica cioè piadene, tagieri, scudelle, scudelini et altri piati.
Nuove secchi de rame tra grandi et picioli usadi.
Quatro caldiere de rame piciole usade et vecchie.
Sie stagnà de rame tra grandi et picioli usadi.
Quatro conchette de rame rotte.
Do cazze da acqua de rame vecchie.
Diese intiani de rame vecchi.
Tre scaldaletti de rame picioli vecchi.
Do cadene de ferro da fuogo.
Quatro fersore de ferro vecchissime.
Do gradelle de ferro.
Quatordese candelieri de lotton vecchi.
Do lavezzi de piera grandi.

[f. 96r]
Do lavezeti de bronzo mezani.
Un per de cavedoni de ferro picioli vecchi.
Tre spedi de ferro vecchi.
Una gramola de legno.
Item altre basinele da cusina di poco valor.

Item nella camera della Nena posta appresso il salva robba
Un quaro piciolo schieto della figura della Nostra Donna.

Do casse de albeo depente, soazade con sue seradure et chiave.
Prima. Nella prima cassa.
Vintido mantili grossi de stoppa a opera di renso da tavola usadi.
Quatordese credentiere de fil de stoppa vecchie.
Sette altre credentiere simile assai bone,
Otto dozene de tovaglioli d'opera de renso grossi tra buoni et tristi.

2da. Item nella seconda cassa.
Quindese linzuoli grossi di stoppa usadi.
Trenta linzuoli de lin grossi usadi,

Item nella lettiera della casa posta in ditta camera.
Un letto de piuma vecchio, un stramazzo vecchio, una paggiarizzo vecchio, do cavalzali vecchi, un paro de linzuoli grossi di stoppa vecchi et una coltra de tella biava vecchia strazada.
Item nella ditta camera una cuna de nogera vecchia.

Item nel salva robba.
Trenta sette tovaglioli grossi de stoppa vecchi.
Quatro mantili de stoppa mezani vecchi.
Quatro credenciere de fil de stoppa vecchie.
Do secchieli picioli de lotton da aqua.

[f. 96v]
Do sechieli da acqua re rame picioli.
Un armer d'albeo, do casselete piciole, un rampegon, alquanti cesti et alcune altre cose vecchie di poco valor.

Item nel mezado sopra la scala granda de ditta casa si attrova l'infrascritte robbe cioè
Nel andedo un napamondo de carta incolado su la tella con il suo teller indorado et soazado.
Item cinque forcieri d'albeo fodradi et soazadi de nogara con la arma Contarina su il pe' con sue seradure et chiave posti nel ditto mezzado. Et prima

Primo. Nel primo forcier
Un torno letto de tabì verde con marzi usado in pezzi numero diese fodrà di tella verde.
Un fornimento da letto de damascho turchin ugnolo in sette pezzi usado.
Un fornimento da letto usado d'ormesin ganzante fodrà de tella verde in otto pezzi includendo li sguarzaroni.
Un altro fornimento da letto d'ormesin naranzato et turchin in cinque pezzi.

2do. Nel secondo forcier.
Quaranta do tovaglioli de fil de stoppa usadi.
Do facioli da man de renso usadi.
Nuove mantileti de fil de stoppa vecchi.
Cinque pezzi de torno letto de bottana biancha strazadi.

3zo. Nel terzo forcier.
Sie pezzi de pano verde strazadi curti da mezado.
Un covertor da cuna de raso zallo fodrà de tella verde scietto usado

[f. 97r]

un covertor da cuna de raso cremesin fodrà de vari vecchissimi.

Un altro covertor da cuna de raso roan fodrà de dossi usado.

Un covertor da cuna de raso bianco fodrà de pelle de lovi cervieri vecchi.

Una carpetta de raso roan fodrà d'ormesin turchin vecchia da puto.

4to. Item nel quarto forcier simile.

Sette pezi de tornoletto de bottana biancha computado il sguazaron.

Nuove pezi de tornoletto de bochassin over bottana biancha usadi con sue franze negre.

5to. Item nel quinto et ultimo forcier.

Quindese linzuoli de fil de lin usadi.

Item nella lettiera de ditto mezado.

Un letto di piuma vecchio.

Do stramazzi de lana vecchi.

Un cavazal de piuma

Una coltra di tella biava in bottida straza et

Un torno letto de bochasin biancho con sui sguazaroni con cordelle et franze vecchissimo.

Item sopra li ditti cinque forcieri, tappedi turcheschi vechi numero cinque.

Item uno canzello over tavola de nogara con sue casselette piciolo sopra il qual li era un tapedo simile alli altri sopraditti.

Item sopra la nappa del camin de ditto mezado, due figure di marmoro fornide con le sue casse di nogara videlicet una Portia et l'altra Dido.

Item nel contor appresso ditto mezado fu trovato l'infrascritte robbe.

Et prima in una cassa d'albeo depenta vecchia tre tappedi grandi da tavola usadi.

Item sopra un bancho una casseletta vechia et rotta di osso lavorada con figure.

Item una altra casseletta de nogara vecchia pizola.

Item una stagiera granda de più di mezzo mier con la cassa d'albeo.

Item sopra una tavola di albeo diverse scritture et libri di cento et una

[f. 97v]

cassa d'albeo depenta con scritture dentro.

Item nella camera a banda destra sopra il rio de San Marcilian. Tre forcieri un driedo l'altro de albeo depenti vuodi con l'arma Contarina vecchi e una cassella d'albeo vechia appresso ditti forcieri con un covertor da letto di tella biancha, et quatro intimelle vecchie.

Item uno altro forcier simile vechio in fazza de ditta camera con sette mantili de lin vecchissimi tutti rotti et strazadi.

Item tre altri forcieri simili vuodi vecchi et marzi.

Item un sacco a meza camera con stoppa e un poco de fil di stoppa.

Item undese pezzi d'ormesin cremesin laorado d'oro a mordente per un torno letto et con sui sguazaroni.

Item sopra la littiera de ditta camera.

Nuove stramazzi de lana tra nuovi et vecchi.

Sie cussini di lana.

Do cavazali de piuma vecchi et un cussin de pouma.

Item nel portego grando di sopra.

Un quadro grandeto con la figura del Nostro Signor et altre figure con sue soaze dorade intorno.

Un quadro grando di tella soazado sopra il qual è depento l'inferno.

Un quadro vecchio strazado soazado con certe figure a cavallo.

Un altro quadro grandeto di tella soazado di nogara con tre figure sopra.

Una credenziera de nogara con le sue casselete et scanzia assai buona et con sua seradura et chiave

Item sette banche d'albeo vecchie depente di rosso.

Item una tavola de albeo con li sui trespedi.

Item do casse d'albeo vechie depente poste appresso la giesiola con alcune peze da barcha, in una et nel altra alcune scritture dissero esser da un Bragadin.

[f. 98r]

Item appresso il lavello una cassa de albeo vechia depenta con sedese tappedi da cassa vechi, rotti et chazadi et pezzi do di tappedo da terra simili.

Item in una cassa de nogara soazada con sua seradura et chiave, diese linzuoli de fil di stoppa grossi vecchi.

Otto mantiletti da tavola grossi di stoppa.

Quatro sachi vecchi.

Tre coltre bianche imbotide vecchie.

Item in una altra cassa de nogara simile otto candelieri de lotton vecchi schietti et rotti, quatro bazili de loton vecchi.

Una cazza de rame da liscia piciola vecchia e un lambicho di rame con il suo capello di piombo.

Item una altra cassa simile piena de lin non spinazado.

Item in una altra cassa simile de nogara, sie pezzi de panno verde tra grando et picioli vecchi, tre pezzi de spaliera a brochà da camera vechi et un razeto grosso a brochà vechio.

Item in una altra cassa simile robbe che fu del quondam reverendissimo misser Piero Francesco Contarini patriarcha di Venetia, et prima

Una vesta de panno negro piciola da portar per casa.

Una vestizuola de samito negro fodrà de pellesine bianche.

Do quarto de vesta de panno paonazzo vecchi.

Un bavaro de zambelotto paonazzo.

Do veste de cambelotto paonazzo da portar per casa usade.

Un mantello de zambelotto paonazzo.

Una vesta Pontifical di zambelotto paonazzo.

Item in una altra cassa di nogara simile.

Panni verdi tra grandi et pizoli pezzi numero undese tra boni, vecchi er strazadi.

Item una cassa de talpon con sua seradura et chiave, un felze

[f. 98v]

de rassa paonaza tenta in grana usada.

Do sacchetti un grando et l'altro piciolo con rede da oselar dentro.

Una celega de lana beretina da barcha.

Una vella vecchia da barcha.

Una lettiera de galia fatta in tappedo con i so marafoni.

Item per casa in portego dodese scagni di nogara da sentar vecchi.
Diese cariege grande di nogara da pozzo vecchie.
Do tavole grande d'albeo.

Item nel sopra letto delle fie.
In una cassa d'albeo vecchia con sua seraudra et chiave.
Una coltra tesdua de bavelle naranzato usada.
Dodese pezzi di torno letto di zambelotto cremesin rotto.
Otto pezzi di tornoletto di bavelle zalle et rosse vecchio.
Do coltre di mezza vita tessude di bavelle del ditto color rosso.
Una altra coltra de mezza vita tessuda come le altre di color verde fodrà di tella verde.
Una coltrina d'ormesin verde lavorada a mordente, un pezzo di faciol alla morescha vecchio.
Tre tondi grandoti de tabì verde a marizi fatti in scudi lavoradi d'oro et rechamadi a fogiame con l'arma Contarina et Vendramina a mezzo.
Brazza quatro di bandinella d'ormesin verde fatta a mordente d'oro.

Item in una cassa d'albeo sotto il balchon.
Do refrescadore de lotto vechie lavorade alla gemina et il resto con fil de lin et stoppa.
Item una cassa d'albeo vuoda assai bona.

[f. 99r]
Item nella letiera. Un letto vechio de piuma con do cavazzalli et do cussini, un stramazzo di lana, un pagiarizzo, un per de linzuoli de lin usadi et un pavion de bottana biancha vecchio strazado.

Item nella camera scura sotto la camera della nena, appresso il mezzado de misser Nicolò del quondam misser Thadio Contarini.
In una cassa di talpon con sua seradura et chiave quatro piati de peltre grandi, undese pezzi de mersori de peltre tra gradi et pizoli, tre piatelli grandi de peltre, diese tazoni de pletre, dodese piati de peltre grandi, tredese piateli pizoli de peltre, quaranta otto scudelle de peltre da l'oro grando et quatro altre con l'oro piciolo, quaranta nuove scudelini de peltre, quatro piadenete piciole de peltre, quaranta do taglieri de peltre et sie piadene de peltre piciole.

Item in do cassellette de albeo avanzi de euforbio vecchio.
Item do forcieri de albeo depenti con l'arna Contarina vechi et vuodi.
Item in un canton de ditta camera da 60 et più pezzi tra grandi et pizoli de verzi da levante.

Actum Venetiis in domo suprascripta posita in confinio Sancte Fusce, presentibus ad predicta reverendo domino presbitero Girardo Giraldo quondam domini Petri ferrariensis, ser Ippolito brixiensis quondam ser Andree magistro saponarie nobilium de Cha' Vendramino et ser Nicolao anchoniense cognominato Albanese quondam ser Petri Targa testibus vocatis et rogatis.

[f. 100r]
Quondam viri nobilis domini Darii Contareno.
Inventarii continuatio.
<div align="center">Die XVI mensis novembris 1556</div>
Inventarium aliorum bonorum et rerum mobilium que fuerunt quondam viri nobilis domini Darii Contareno quondam clarissimi domini Thadei repertorum in domo sue solite habitationis dum vixit posita in confinio Sancte Fsuce factum ad instantiam virorum nobilum domini Andree et Hieronimi Contareni fratrum et filiorum predicti quodanm viri nobilis domini Darii.

Et primo nella camera di famegli posta da basso.
Un stramazzo di pello con il suo cavazal vechio,
Un per de linzuoli di stoppa vecchi.
Do schiavine bianche vecchissime.
Un armer d'albeo vecchio.

Item nel magazen della lissia.
Do caldiere de rame vecchie in murade nel fornello.
Tre altre caldiere de rame mezane vecchie.
Sette mastelli con dentro l'altro vecchi.

Item nella caneva.
Sette botti candiote, quatro caratelli et tre mezarolete.
Item in altro magazen. Do pile d'oglio de piera viva, una granda et l'altra piciola.
Alcuni legnami marzzi.

Item nel portego da basso nel intrar.
Alcuni travi de diverse sorte da 18 in circa tra picioli et grandi et tra buoni et tristi.
Tre caratelli picioli vecchi.

[f. 100v]
Item do botte candiote piciole vecchie.
Item alla riva una gondola usada con suo felce, remi et tutti li sui fornimenti. Et hic finis est dicti inventarii.

Actum Venetiis in domo suprascripta posita in confinio Sancte Fusce, presentibus ad predicta reverendo domino presbitero Girardo Giraldo quondam domini Petri ferrariensis, et ser Iohannes de Castrofrancho fi ser Stephani Gibbi patavini testibus vocatis et rogatis.

Bibliography

Agosti 2009 Agosti, Giovanni. *Un amore di Giovanni Bellini*. Milan, 2009.

Aikema and Brown 2000 Aikema, Bernard, and Beverly Louise Brown. "Painting in Fifteenth-Century Venice and the *ars nova* of the Netherlands." In *Renaissance Venice and the North: Crosscurrents in the Time of Bellini, Dürer, and Titian*, edited by Bernard Aikema and Beverly Louise Brown, 176–83. Exh. cat. Venice (Palazzo Grassi), 2000.

Anderson 1997 Anderson, Jaynie. *Giorgione: The Painter of "Poetic Brevity."* Paris and New York, 1997.

Arslan 1962 Arslan, Edoardo. "Studi belliniani." *Bollettino d'Arte* 47, ser. 4, no. 1 (1962): 40–58.

Auner 1958 Auner, Michael. "Randbemerkungen zu zwei Bildern Giorgiones und zum Brocardo-Porträt in Budapest." *Jahrbuch der Kunsthistorischen Sammlungen in Wien* 54 (1958): 151–72.

Baldass 1922 Baldass, Ludwig von. *Giorgiones "Drei Philosophen."* Vienna, 1922.

Baldass 1953 Baldass, Ludwig von. "Zu Giorgiones *Drei Philosophen*." *Jahrbuch der Kunsthistorischen Sammlungen in Wien* 50 (1953): 121–30.

Baldass and Heinz 1964 Baldass, Ludwig von, and Günther Heinz. *Giorgione*. Munich, 1964.

Ballarin 2016 Ballarin, Alessandro. *Giorgione e l'umanesimo veneziano*. 7 vols. Verona, 2016.

Barry 2006 Barry, Michael. "Renaissance Venice and Her 'Moors.'" In *Venice and the Islamic World, 828–1797*, 147–73. Exh. cat. Paris (Institut du Monde Arabe) and New York (Metropolitan Museum of Art), 2006.

Bassi 1976 Bassi, Elena. *Palazzi di Venezia*. Venice, 1976.

Bätschmann 2008 Bätschmann, Oskar. *Giovanni Bellini*. London, 2008.

Battilotti 1994a Battilotti, Donata. "Taddeo Contarini." In Maschio 1994, 205–7.

Battilotti 1994b Battilotti, Donata. "Gabriele Vendramin." In Maschio 1994, 226–28.

Berenson 1916 Berenson, Bernard. *Venetian Painting in America: The Fifteenth Century*. New York, 1916.

Berenson 1932 Berenson, Bernard. *Italian Pictures of the Renaissance*. Oxford, 1932.

Berenson 1957 Berenson, Bernard. *Italian Pictures of the Renaissance: Venetian School*. London, 1957.

Bettini 1975 Bettini, Sergio. "Copernico e la pittura veneta." *Notizie da Palazzo Albani* 4, no. 2 (1975): 22–30.

Borchhardt-Birbaumer 1999 Borchhardt-Birbaumer, Brigitte. "Drei Anwälte der Toleranz: Giorgiones *Philosophen* und Ramon Lulls *Buch vom Heiden und den Drei Weisen*." *Mitteilungen der Gesellschaft für Vergleichende Kunstforschung in Wien* 51, no. 2/3 (1999): 1–7.

Borchhardt-Birbaumer 2004 Borchhardt-Birbaumer, Brigitte. "On the Topicality of Tolerant Dialogues: Giorgione and Ramon Lull." In Vienna 2004, 71–77.

Borean and Mason 2007 Borean, Linda, and Stefania Mason. *Il collezionismo d'arte a Venezia: Il Seicento*. Venice, 2007.

Boschini 1664 Boschini, Marco. *Le minere della pittura.* Venice, 1664.

Boschini 1966 Boschini, Marco. *La carta del navegar pitoresco.* Edited by Anna Pallucchini. Venice and Rome, 1966.

Boskovits and Brown 2003 Boskovits, Miklós, and David Alan Brown, eds. *Italian Paintings of the Fifteenth Century,* The Collections of the National Gallery of Art, Systematic Catalogue. Washington, 2003.

Bottari 1962 Bottari, Stefano. *Tutta la pittura di Giovanni Bellini.* Vol. 1, *1425–1485.* Milan, 1962.

Brandt 2000 Brandt, Reinhard. *Philosophie in Bildern: Von Giorgione bis Magritte.* Cologne, 2000.

Brooke 2022a Brooke, Irene. "Recent Publications on Giovanni Bellini." *The Burlington Magazine* 164, no. 1431 (2022): 586–91.

Brooke 2022b Brooke, Irene. Letter to the editor. *The Burlington Magazine* 164, no. 1431 (2022): 956.

Brown 2019 Brown, David Alan. *Giovanni Bellini: The Last Works.* Milan, 2019.

Calogero 2021 Calogero, Giacomo Alberto. "A proposito di un nuovo libro su Giovanni Bellini." *Prospettiva* 183 (2021): 84–101.

Calvesi 1970 Calvesi, Maurizio. "La 'morte di bacio.' Saggio sull'ermetismo di Giorgione." *Storia dell'Arte* 7/8 (1970): 179–233.

Calvesi 1979 Calvesi, Maurizio. "Il tema della Sapienza nei *Tre Filosofi.*" In *Giorgione: Atti del convegno internazionale di studio per il 5 centenario della nascita, 29–31 maggio 1978,* 83–90. Castelfranco Veneto, 1979.

Castelfranchi Vegas 1983 Castelfranchi Vegas, Liana. *Italia e Fiandra nella pittura del Quattrocento.* Milan, 1983.

Castelfranco Veneto 2010 Enrico Maria Dal Pozzolo and Lionello Puppi, eds. *Giorgione.* Exh. cat. Castelfranco Veneto (Museo Casa Giorgione), 2010.

Catalogue **1968** *The Frick Collection: An Illustrated Catalogue.* Vol. 2, *Paintings: French, Italian, and Spanish.* New York, 1968.

Chastel 2012 Chastel, André. *Giorgione, l'inafferrabile.* Milan, 2012.

Christiansen 2009 Christiansen, Keith. "Facts and Love: The Tender Power of Giovanni Bellini." *The New Republic,* April 15, 2009.

Clark 1949 Clark, Kenneth. *Landscape into Art.* Edinburgh, 1949.

Coggiola 1908 Coggiola, Giulio. "Il prestito di manoscritti della Marciana dal 1474 al 1527." *Zentralblatt für Bibliothekswesen* 25 (1908): 47–70.

Cohen 1995 Cohen, Simona. "A New Perspective on Giorgione's *Three Philosophers.*" *Gazette des Beaux-Arts* 126 (1995): 53–64.

Coletti 1955 Coletti, Luigi. *Tutta la pittura di Giorgione.* Milan, 1955.

Conway 1929 Conway, Martin. *Giorgione: A New Study of His Art as a Landscape Painter.* London, 1929.

Cottrell 2012 Cottrell, Philip. "Art Treasures of the United Kingdom and the United States: The George Scharf Papers." *The Art Bulletin* 94, no. 4 (2012): 618–40.

Crowe and Cavalcaselle 1871 Crowe, Joseph Archer, and Giovanni Battista Cavalcaselle. *A History of Painting in Northern Italy*. London, 1871.

Crowe and Cavalcaselle 1912 Crowe, Joseph Archer, and Giovanni Battista Cavalcaselle. *A History of Painting in North Italy: Venice, Padua, Vicenza, Verona, Ferrara, Milan, Friuli, Brescia; From the Fourteenth to the Sixteenth Century*. 3 vols. London, 1912.

De Benedictis 2000 De Benedictis, Cristina. *Marco Antonio Michiel: Notizia d'opere del disegno*. Florence, 2000.

De Marchi 2006 De Marchi, Andrea. "Per Speculum in Aenigmate." In *L'immagine di Cristo: Dall'acheropita alla mano d'artista; Dal tardo medioevo all'età barocca*, edited by Christoph L. Frommel and Gerhard Wolf, 117–42. Vatican City, 2006.

De Marchi 2012 De Marchi, Andrea. *La pala d'altare: Dal politico alla pala quadra*. Florence, 2012.

Della Pergola 1955 Della Pergola, Paola. *Giorgione*. Milan, 1955.

Drost 1958 Drost, Willi. "Strukturwandel von der frühen zur hohen Renaissance." *Konsthistorisk Tidskrift* 27, no. 1/2 (1958): 30–51.

Dussler 1949 Dussler, Luitpold. *Giovanni Bellini*. Vienna, 1949.

Eisler 1979 Eisler, Colin. "In Detail: Bellini's *Saint Francis*." *Portfolio* (April/May 1979): 18–22.

Engerth 1884 Engerth, Eduard von. *Kunsthistorische Sammlungen des Allerhöchsten Kaiserhauses: Gemälde*. Vienna, 1884.

Ferriguto 1933 Ferriguto, Arnaldo. *Attraverso i "misteri" di Giorgione*. Castelfranco Veneto, 1933.

Ferriguto 1943 Ferriguto, Arnaldo. "Ancora dei soggetti di Giorgione (ombre nei sottoquadri, stemmi nella *Tempesta*)." *Reale Istituto Veneto di Scienze, Lettere ed Arti, Venezia. Atti* 102, no. 2 (1943): 403–18.

Fiocco 1941 Fiocco, Giuseppe. *Giorgione*. Bergamo, Milan, and Rome, 1941.

Fiocco 1948 Fiocco, Giuseppe. *Giorgione*. Bergamo, 1948.

Fleming 1982 Fleming, John V. *From Bonaventure to Bellini: An Essay in Franciscan Exegesis*. Princeton, 1982.

Fletcher 1972a Fletcher, Jennifer. "The Provenance of Bellini's Frick *St Francis*." *The Burlington Magazine* 114, no. 829 (1972): 206–15.

Fletcher 1972b Fletcher, Jennifer. "Giovanni Bellini and Art Collecting." *The Burlington Magazine* 114, no. 831 (1972): 405.

Fletcher 1973 Fletcher, Jennifer. "Marcantonio Michiel's Collection." *Journal of the Warburg and Courtauld Institutes* 36 (1973): 382–85.

Fletcher 1981a Fletcher, Jennifer. "Marcantonio Michiel: His Friends and Collection." *The Burlington Magazine* 123, no. 941 (1981): 452–67.

Fletcher 1981b Fletcher, Jennifer. "Marcantonio Michiel, 'che ha veduto assai.'" *The Burlington Magazine* 123, no. 943 (1981): 602–9.

Fowles 1976 Fowles, Edward. *Memories of Duveen Brothers*. London, 1976.

Frimmel 1896 Frimmel, Theodor. *Der Anonimo Morelliano (Marcanton Michiel's "Notizia d'opere del disegno")*. Vienna, 1896.

Frugoni 1993 Frugoni, Chiara. *Francesco e l'invenzione delle stimmate: Una storia per parole e immagini fino a Bonaventura e Giotto*. Turin, 1993.

Frugoni 1995 Frugoni, Chiara. *Vita di un uomo: Francesco d'Assisi*. Turin, 1995.

Frugoni 2011 Frugoni, Chiara. *Storia di Chiara e Francesco*. Turin, 2011.

Gabriele 2004 Gabriele, Mino. "*The Three Philosophers*, the Magi, and the Nocturnal." In Vienna 2004, 79–83.

Gamba 1937 Gamba, Carlo. *Giovanni Bellini*. Milan, 1937.

Garas 1967 Garas, Klara. "Die Entstehung der Galerie des Erzherzogs Leopold Wilhelm." *Jahrbuch der Kunsthistorischen Sammlungen in Wien* 63 (1967): 39–80.

Gasparotto 2018 Gasparotto, Davide, ed. *Lives of Giovanni Bellini*. Los Angeles, 2018.

Ghiotto and Pignatti 1969 Ghiotto, Renato, and Terisio Pignatti. *L'opera completa di Giovanni Bellini*. Milan, 1969.

Gilbert 1952 Gilbert, Creighton. "On Subject and Non-Subject in Italian Renaissance Pictures." *The Art Bulletin* 34, no. 3 (1952): 202–16.

Goetz 1965 Goetz, Oswald. *Der Feigenbaum in der religiösen Kunst des Abendlandes*. Berlin, 1965.

Goffen 1986 Goffen, Rona. *Piety and Patronage in Renaissance Venice: Bellini, Titian, and the Franciscans*. New Haven and London, 1986.

Goffen 1989 Goffen, Rona. *Giovanni Bellini*. New Haven and London, 1989.

Gombrich 1986 Gombrich, Ernst H. "A Note on Giorgione's *Three Philosophers*." *The Burlington Magazine* 128, no. 1000 (1986): 488.

Gould 1969 Gould, Cecil. "The Pala di San Giovanni Crisostomo and the Late Giorgione." *Arte Veneta* 23 (1969): 206–9.

Gould 1979 Gould, Cecil. "Giorgionesque Problems in the National Gallery (With Some Reference to Craquelure)." In *Giorgione: Atti del convegno internazionale di studio per il 5 centenario della nascita, 29–31 maggio 1978*, 253–55. Castelfranco Veneto, 1979.

Grave 1998 Grave, Johannes. "Ein neuer Blick auf Giovanni Bellinis Darstellung des heiligen Franziskus." *Pantheon* 56 (1998): 35–43.

Grave 2004 Grave, Johannes. *Landschaften der Meditation: Giovanni Bellinis Assoziationsräume*. Freiburg, 2004.

Gronau 1930 Gronau, Georg. *Giovanni Bellini*. Stuttgart and Berlin, 1930.

Hall 1958 Hall, Douglas. "Nostalgia and Manchester in 1857." *The Connoisseur* 140, no. 566 (1958): 237–40.

Hall 1992 Hall, Marcia. *Color and Meaning: Practice and Theory in Renaissance Painting*. Cambridge, 1992.

Hammond 2002 Hammond, Norman. "Bellini's Ass: A Note on the Frick's *St. Francis.*" *The Burlington Magazine* 144, no. 1186 (2002): 24–26.

Hammond 2007 Hammond, Norman. "Bellini's Avifauna in the Frick's *St. Francis.*" *The Burlington Magazine* 149, no. 1246 (2007): 36–38.

Hartlaub 1925 Hartlaub, Gustav Friedrich. *Giorgiones Geheimnis: Ein kunstgeschichtlicher Beitrag zur Mystik der Renaissance.* Munich, 1925.

Hartlaub 1953 Hartlaub, Gustav Friedrich. "Zu den Bildmotiven des Giorgione." *Zeitschrift für Kunstwissenschaft* 7, no. 1/2 (1953): 57–84.

Heinemann 1962 Heinemann, Fritz. *Giovanni Bellini e i Belliniani.* Venice, 1962.

Helke 1999 Helke, Gabriele. "Giorgione als Maler des Paragone." *Jahrbuch des Kunsthistorischen Museums Wien* 1 (1999): 11–79.

Hirdt 1997 Hirdt, Willi. *Il "San Francesco" di Giovanni Bellini: Un tentativo di interpretazione del dipinto della Frick Collection.* Florence, 1997.

Hochmann, Lauber, and Mason 2007 Hochmann, Michel, Rosella Lauber, and Stefania Mason. *Il collezionismo d'arte a Venezia: Dalle origini al Cinquecento.* Venice, 2007.

Hope 1985 Hope, Charles. *Veronese and the Venetian Tradition of Allegory.* London, 1985.

Hope 2016 Hope, Charles. "At the Royal Academy: Giorgione." *London Review of Books,* March 31, 2016.

Hornig 1979 Hornig, Christian. "Una nuova proposta per i *Tre Filosofi.*" In *Giorgione: Atti del convegno internazionale di studio per il 5 centenario della nascita, 29–31 maggio 1978,* 47–51. Castelfranco Veneto, 1979.

Hornig 1987 Hornig, Christian. *Giorgiones Spätwerk.* Munich, 1987.

Hourticq 1930a Hourticq, Louis. *Le problème de Giorgione: Sa légende, son œuvre, ses élèves.* Paris, 1930.

Hourticq 1930b Hourticq, Louis. "La légende de Giorgione." *La Revue de Paris* 5 (1930): 539–69.

Humfrey 1995 Humfrey, Peter. *Painting in Renaissance Venice.* New Haven and London, 1995.

Humfrey 2004 Humfrey, Peter, ed. *The Cambridge Companion to Giovanni Bellini.* Cambridge, 2004.

Humfrey 2021 Humfrey, Peter. *Giovanni Bellini: An Introduction.* Venice, 2021.

Huse 1972 Huse, Norbert. *Studien zu Giovanni Bellini.* Berlin and New York, 1972.

Huse and Wolters 1990 Huse, Norbert, and Wolfgang Wolters. *The Art of Renaissance Venice: Architecture, Sculpture, and Painting, 1460–1590.* Chicago, 1990.

Janson 1994 Janson, Anthony F. "The Meaning of the Landscape in Bellini's *St. Francis in Ecstasy.*" *Artibus et Historiae* 15, no. 30 (1994): 41–54.

Justi 1926 Justi, Ludwig von. *Giorgione.* Berlin, 1926.

Katalog **1928** *Katalog der Gemäldegalerie.* Vienna, 1928.

Katalog 1960 *Katalog der Gemäldegalerie: Italiener, Spanier, Franzosen, Engländer.* Vienna, 1960.

Katalog 1965 *Katalog der Gemäldegalerie: Italiener, Spanier, Franzosen, Engländer.* Vienna, 1965.

Kimball and Venturi 1948 Kimball, Fiske, and Lionello Venturi. *Great Paintings in America.* New York, 1948.

Klauner 1955 Klauner, Friederike von. "Zur Symbolik von Giorgiones *Drei Philosophen.*" *Jahrbuch der Kunsthistorischen Sammlungen in Wien* 51 (1955): 145–68.

Klauner 1979 Klauner, Friederike von. "Über die Wertschätzung Giorgiones." In *Giorgione: Atti del convegno internazionale di studio per il 5 centenario della nascita, 29–31 maggio 1978,* 263–67. Castelfranco Veneto, 1979.

Land 1980 Land, Norman E. "Two Panels by Michele Giambono and Some Observations on St. Francis and the Man of Sorrows in Fifteenth-Century Venetian Paintings." *Studies in Iconography* 6 (1980): 29–51.

Land 1989 Land, Norman E. "A Note on Giovanni Bellini's *St. Francis* in the Frick Collection." *Southeastern College Art Conference Review* 11, no. 4 (1989): 300–304.

Land 1998 Land, Norman E. "Carlo Crivelli, Giovanni Bellini, and the Fictional Viewer." *Source: Notes in the History of Art* 18, no. 1 (1998): 18–24.

Lanzi 1837 Lanzi, Luigi. *Storia pittorica dell'Italia dal risorgimento delle belle arti fin presso al fine del XVIII secolo.* Vol. 4. Venice, 1837.

Lauber 2002 Lauber, Rosella. "'Et è il nudo che ho io in pittura de l'istesso Zorzi.' Per Giorgione e Marcantonio Michiel." *Arte Veneta* 59 (2002): 99–115.

Lauber 2004 Lauber, Rosella. "Da Venezia a New York, l'epopea del *San Francesco* di Bellini. Dal 1525, quando lo vide Michiel, ricostruite tutte le tappe (o quasi) della preziosa tavola." *Venezialtrove* 3 (2004): 79–89.

Lauber 2005 Lauber, Rosella. "'Opera perfettissima.' Marcantonio Michiel e la *Notizia d'opere di disegno.*" In *Il collezionismo a Venezia e nel Veneto ai tempi della Serenissima,* edited by Bernard Aikema, Rosella Lauber, and Max Seidel, 77–116. Venice, 2005.

Lauber 2007 Lauber, Rosella. "'Et maxime in li occhi': per la descrizione delle opere d'arte in Marcantonio Michiel." In *Testi, immagini e filologia nel XVI secolo,* edited by Eliana Carrara and Silvia Ginzburg, 1–36. Pisa, 2007.

Lauber 2010 Lauber, Rosella. "Una lucente linea d'ombra: note per Giorgione nel collezionismo veneziano." In Castelfranco Veneto 2010, 189–205.

Lavin 2007 Lavin, Marilyn Aronberg. "The Joy of St. Francis: Bellini's Panel in the Frick Collection." *Artibus et Historiae* 28, no. 56 (2007): 231–56.

Libri commemoriali 1904 *I libri commemoriali della Repubblica di Venezia: Regesti.* Vol. 6. Venice, 1904.

London 2016 Simone Facchinetti, Arturo Galansino, and Per Rumberg, eds. *In the Age of Giorgione.* Exh. cat. London (Royal Academy of Arts), 2016.

Longhi 1949 Longhi, Roberto. "The Giovanni Bellini Exhibition." *The Burlington Magazine* 91, no. 559 (1949): 274–83.

Longhi 1985 Longhi, Roberto. *Viatico per cinque secoli di pittura veneziana.* Florence, 1985.

Los Angeles 2017 Davide Gasparotto, ed. *Giovanni Bellini: Landscapes of Faith in Renaissance Venice*. Exh. cat. Los Angeles (J. Paul Getty Museum), 2017.

Lucco, Humfrey, and Villa 2019 Lucco, Mauro, Peter Humfrey, and Giovanni C. F. Villa. *Giovanni Bellini: Catalogo ragionato*. Treviso, 2019.

Lugli 2009 Lugli, Emanuele. "Between Form and Representation: The Frick *St Francis*." *Art History* 32, no. 1 (2009): 21–51.

MacLennan and Kilpatrick 2001 MacLennan, Neil K., and Ross S. Kilpatrick. "King Solomon and the Temple Builders: A Biblical Reading of Giorgione's Painting *The Three Philosophers*." *Heredom* 9 (2001): 111–34.

Magno 2019 Magno, Alessandro Marzo. *La Splendida: Venezia 1499–1509*. Bari, 2019.

Manchester 1857 *Catalogue of the Art Treasures of the United Kingdom*. Exh. cat. Manchester, 1857.

Marandel 1969 Marandel, J. Patrice. "Le *Saint François* de Giovanni Bellini." *L'Information d'Histoire de l'Art* 14, no. 1 (1969): 33–35.

Maschio 1994 Maschio, Ruggero, ed. *I tempi di Giorgione*. Rome, 1994.

Mather 1923 Mather, Frank Jewett. *A History of Italian Painting*. New York, 1923.

Mather 1936 Mather, Frank Jewett. *Venetian Painters*. New York, 1936.

Maze 2021 Maze, Daniel Wallace. *Young Bellini*. New Haven and London, 2021.

Maze 2022 Maze, Daniel Wallace. "Letter. Young Bellini." *The Burlington Magazine* 164, no. 1434 (2022): 837–38.

Mechel 1781 Mechel, Christian von. *Verzeichniss der Gemälde der Kaiserlich Königlichen Bilder Gallerie in Wien*. Vienna, 1781.

Mechel 1784 Mechel, Christian von. *Catalogue des tableaux de la Galerie Impériale et Royale de Vienne*. Basel, 1784.

Meiss 1964 Meiss, Millard. *Giovanni Bellini's "St. Francis" in The Frick Collection*. Princeton, 1964.

Meller 1981 Meller, Peter. "I *Tre Filosofi* di Giorgione." In Pallucchini 1981, 227–47.

Morassi 1942 Morassi, Antonio. *Giorgione*. Milan, 1942.

Morassi 1951 Morassi, Antonio. "The Ashmolean *Madonna Reading* and Giorgione's Chronology." *The Burlington Magazine* 93, no. 580 (1951): 212–16.

Morelli 1800 Morelli, Jacopo. *Notizia d'opere di disegno nella prima metà del secolo XVI*. Bassano, 1800.

Morelli and Frizzoni 1884 Morelli, Jacopo, and Gustavo Frizzoni. *Notizia d'opere di disegno*. Bologna, 1884.

Mucchi 1978 Mucchi, Ludovico. *I tempi di Giorgione: Caratteri radiografici della pittura di Giorgione*. Florence, 1978.

Muraro 1979 Muraro, Michelangelo. "Giorgione e la civiltà delle ville venete." In *Giorgione: Atti del convegno internazionale di studio per il 5 centenario della nascita, 29–31 maggio 1978*, 171–80. Castelfranco Veneto, 1979.

Nardi 1955a Nardi, Bruno. "*I Tre Filosofi* del Giorgione: la chiave di un dipinto famoso." *Il Mondo*, August 23, 1955.

Nardi 1955b Nardi, Bruno. "Postilla giorgionesca." *Il Mondo*, September 13, 1955.

Nardi 1971 Nardi, Bruno. *Saggi sulla cultura veneta del Quattro e Cinquecento*. Padua, 1971.

Nichols 2020 Nichols, Tom. *Giorgione's Ambiguity*. London, 2020.

Nova 1995 Nova, Alessandro. "The Drawings of Girolamo Romanino: Part I." *The Burlington Magazine* 137, no. 1104 (1995): 159–68.

Nova 1998 Nova, Alessandro. "Giorgione's *Inferno with Aeneas and Anchises* for Taddeo Contarini." In *Dosso's Fate*, edited by Luisa Ciammitti, Steven F. Ostrow, and Salvatore Settis, 41–62. Los Angeles, 1998.

Oberhuber 1979 Oberhuber, Konrad. "Giorgione and the Graphic Arts of His Time." In *Giorgione: Atti del convegno internazionale di studio per il 5 centenario della nascita, 29–31 maggio 1978*, 313–20. Castelfranco Veneto, 1979.

Oberthaler 2004 Oberthaler, Elke. "On Technique, Condition, and Interpretation of Five Paintings by Giorgione and His Circle." In Vienna 2004, 267–72.

Pächt 2002 Pächt, Otto. *Venezianische Malerei des 15. Jahrhunderts: Die Bellinis und Mantegna*. Munich, 2002.

Padoan 1979 Padoan, Giorgio. "Giorgione e la cultura umanistica." In *Giorgione: Atti del convegno internazionale di studio per il 5 centenario della nascita, 29–31 maggio 1978*, 25–36. Castelfranco Veneto, 1979.

Pallucchini 1955 Pallucchini, Rodolfo. *Giorgione*. Milan, 1955.

Pallucchini 1959 Pallucchini, Rodolfo. *Giovanni Bellini*. Milan, 1959.

Pallucchini 1981 Pallucchini, Rodolfo, ed. *Giorgione e l'umanesimo veneziano*. Florence, 1981.

Parducci 1935 Parducci, Domenico. "Vienna. *I Tre Filosofi* del Giorgione." *Emporium* 13 (1935): 253–56.

Parronchi 1965 Parronchi, Alessandro. "Chi sono 'I tre filosofi.'" *Arte Lombarda* 10 (1965): 91–98.

Pergam 2011 Pergam, Elizabeth A. *The Manchester Art Treasures Exhibition of 1857: Entrepreneurs, Connoisseurs, and the Public*. Burlington, Vermont, 2011.

Perissa Torrini 1993 Perissa Torrini, Annalisa. *Giorgione: Catalogo completo dei dipinti*. Florence, 1993.

Pigler 1935 Pigler, Andrea. "Intorno ai *Tre Filosofi* di Giorgione." *Bollettino d'Arte* 29 (1935): 345–49.

Pignatti 1955 Pignatti, Terisio. *Giorgione*. Milan, 1955.

Pignatti 1969 Pignatti, Terisio. *Giorgione*. Venice, 1969.

Pignatti 1981 Pignatti, Terisio. "Il 'corpus' pittorico di Giorgione." In Pallucchini 1981, 131–59.

Pignatti and Pedrocco 1999 Pignatti, Terisio, and Filippo Pedrocco. *Giorgione*. Milan, 1999.

Pochat 1973 Pochat, Götz. *Figur und Landschaft: Eine historische Interpretation der Landschaftsmalerei von der Antike bis zur Renaissance*. Berlin, 1973.

Rearick 2003 Rearick, William R. "La dispersione dei dipinti già a Santa Maria dei Miracoli." In *Santa Maria dei Miracoli a Venezia: La storia, la fabbrica, i restauri*, edited by Mario Piana and Wolfgang Wolters, 179–92. Venice, 2003.

Richter 1934 Richter, George Martin. "Unfinished Pictures by Giorgione." *The Art Bulletin* 16, no. 3 (1934): 272–90.

Richter 1937 Richter, George Martin. *Giorgio da Castelfranco called Giorgione.* Chicago, 1937.

Richter 1939 Richter, George Martin. "*Christ Carrying the Cross* by Giovanni Bellini." *The Burlington Magazine* 75, no. 438 (1939): 94–97.

Robertson 1968 Robertson, Giles. *Giovanni Bellini.* Oxford, 1968.

Robertson 1971 Robertson, Giles. "New Giorgione Studies." *The Burlington Magazine* 113, no. 821 (1971): 475–77.

Rome 2008 Mauro Lucco and Giovanni C. F. Villa, eds. *Giovanni Bellini.* Exh. cat. Rome (Scuderie del Quirinale), 2008.

Rosand 1979 Rosand, David. "Giorgione e il concetto della creazione artistica." In *Giorgione: Atti del convegno internazionale di studio per il 5 centenario della nascita, 29–31 maggio 1978,* 135–39. Castelfranco Veneto, 1979.

Rutherglen and Hale 2015 Rutherglen, Susannah, and Charlotte Hale, eds. *In a New Light: Giovanni Bellini's "St. Francis in the Desert."* New York, 2015.

Sansovino 1581 Sansovino, Francesco. *Venetia citta nobilissima et singolare.* Venice, 1581.

Sanuto 1879–1903 Sanuto, Marino. *Diarii.* 58 vols. Venice, 1879–1903.

Schaeffer 1910 Schaeffer, Emil. "Giorgiones *Landschaft mit den drei Philosophen*: ein Deutungsversuch." *Monatshefte für Kunstwissenschaft* 3, no. 8/9 (1910): 340–45.

Schier 2017 Schier, Rudolf. "Sailing to Byzantium: Giorgione's *Three Philosophers.*" *Predella* 41/42 (2017): 29–51.

Schier 2019 Schier, Rudolf. "Is Giorgione's *Inferno with Aeneas and Anchises* Really Lost?" *Vergilius* 65 (2019): 61–98.

Schmidt et al. 2018 Schmidt, Eike D., et al. *La collezione Contini Bonacossi nelle Gallerie degli Uffizi.* Florence, 2018.

Schmitter 2003 Schmitter, Monika. "The Dating of Marcantonio Michiel's *Notizia* on Works of Art in Padua." *The Burlington Magazine* 145, no. 1205 (2003): 564–71.

Schmitter 2011 Schmitter, Monika. "The Quadro da Portego in Sixteenth-Century Venetian Art." *Renaissance Quarterly* 64, no. 3 (2011): 693–751.

Settis 1978 Settis, Salvatore. *La "Tempesta" interpretata: Giorgione, i committenti, il soggetto.* Turin, 1978.

Settis 1979 Settis, Salvatore. "Intervento." In *Giorgione: Atti del convegno internazionale di studio per il 5 centenario della nascita, 29–31 maggio 1978,* 73–76. Castelfranco Veneto, 1979.

Settis 1981 Settis, Salvatore. "Giorgione e i suoi committenti." In Pallucchini 1981, 373–98.

Settis 2021 Settis, Salvatore. *Deeper Thoughts: Beyond the Allegory of Bellini, Giorgione, and Titian.* London, 2021.

Sgarbi 1981 Sgarbi, Vittorio. "Ricognizione del catalogo di Giorgione: con proposte per la sua formazione e per l'opera della maturità." In *Giorgione e la cultura veneta tra '400 e '500: Mito, allegoria, analisi iconologica,* 31–34. Rome, 1981.

Shapley 1959 Shapley, Fern Rusk. "A Note on *The Three Philosophers* by Giorgione." *The Art Quarterly* 22, no. 3 (1959): 241–42.

Smart 1973 Smart, Alastair. "The *Speculum Perfectionis* and Bellini's Frick *St. Francis.*" *Apollo* 97, no. 135 (1973): 470–76.

Swoboda 2013 Swoboda, Gudrun. *Die kaiserliche Gemäldegalerie in Wien und die Anfänge des öffentlichen Kunstmuseums.* Vienna, 2013.

Tempestini 1997 Tempestini, Anchise. *Giovanni Bellini.* Milan, 1997.

Teniers 1673 Teniers, David. *Theatrum Pictorium.* Antwerp, 1673.

Tolnay 1963 Tolnay, Charles de. "Tintoretto's Salotto Dorato Cycle in the Doge Palace." In *Scritti di storia dell'arte in onore di Mario Salmi*, vol. 3, 117–31. Rome, 1963.

Trent 2006 Lia Camerlengo et al. *Romanino: Un pittore in rivolta nel Rinascimento italiano.* Exh. cat. Trent (Castello del Buonconsiglio), 2006.

Tschmelitsch 1962 Tschmelitsch, Günther von. "Neue Bezüge in alten Bildern Giorgiones." *Speculum Artis* 14, no. 4 (1962): 14–23.

Turner 1966 Turner, A. Richard. *The Vision of Landscape in Renaissance Italy.* Princeton, 1966.

Vasari 1976 Vasari, Giorgio. *Le vite de' più eccellenti pittori, scultori e architettori nelle redazioni del 1550 e 1568.* Edited by Paola Barocchi and Rosanna Bettarini. Vol. 4. Florence, 1976.

Vasoli 1981 Vasoli, Cesare. "Il mito dell'età dell'oro nel Rinascimento." In Pallucchini 1981, 51–69.

Venice 1955 Pietro Zampetti, ed. *Giorgione e i Giorgioneschi.* Exh. cat. Venice (Palazzo Ducale), 1955.

Venice 2004 Giovanna Nepi Scirè and Sandra Rossi, eds. *Giorgione: "Le maraviglie dell'arte."* Exh. cat. Venice (Gallerie dell'Accademia), 2004.

Venturi 1913 Venturi, Lionello. *Giorgione e il Giorgionismo.* Milan, 1913.

Venturi 1915 Venturi, Adolfo. *Storia dell'arte italiana.* Vol. 7, pt. 4, *La pittura del Quattrocento.* Milan, 1915.

Venturi 1933 Venturi, Lionello. *Italian Paintings in America.* New York and Milan, 1933.

Venturi 1954 Venturi, Lionello. *Giorgione.* Rome, 1954.

Vescovo 2000 Vescovo, Piermario. "Preliminari giorgioneschi. II. Taddeo Contarini e i *Tre Filosofi.*" *Wolfenbütteler Renaissance–Mitteilungen* 24, no. 1 (2000): 109–24.

Vienna 2004 Sylvia Ferino-Pagden and Giovanna Nepi Scirè, eds. *Giorgione: Myth and Enigma.* Exh. cat. Vienna (Kunsthistorisches Museum), 2004.

Vienna 2008 Wilfried Seipel, ed. *Vom Mythos der Antike.* Exh. cat. Vienna (Kunsthistorisches Museum), 2008.

Washington 2006 David Alan Brown and Sylvia Ferino-Pagden, eds. *Bellini, Giorgione, Titian, and the Renaissance of Venetian Painting.* Washington (National Gallery of Art), 2006.

Waterhouse 1952 Waterhouse, Ellis K. "Paintings from Venice for Seventeenth-Century England: Some Records of a Forgotten Transaction." *Italian Studies* 7, no. 1 (1952): 1–23.

Waterhouse 1974 Waterhouse, Ellis. *Giorgione.* Glasgow, 1974.

Wickhoff 1893 Wickhoff, Franz. "Les écoles italiennes au Musée Impérial de Vienne." *Gazette des Beaux-Arts* 9 (1893): 5–18.

Wickhoff 1895 Wickhoff, Franz. "Giorgiones Bilder zu römischen Heldengedichten." *Jahrbuch der Königlich Preussischen Kunstsammlungen* 16 (1895): 34–43.

Wilde 1931 Wilde, Johannes. "Ein unbeachtetes Werk Giorgiones." *Jahrbuch der Preuszischen Kunstsammlungen* 52 (1931): 91–100.

Wilde 1932 Wilde, Johannes. "Röntgenaufnahmen der *Drei Philosophen* Giorgiones und der *Zigeunermadonna* Tizians." *Jahrbuch der Kunsthistorischen Sammlungen in Wien* 6 (1932): 141–54.

Wilde 1974 Wilde, Johannes. *Venetian Art from Bellini to Titian.* Oxford, 1974.

Williams 1968 Williams, Jay. *The World of Titian, c. 1488–1576.* New York, 1968.

Wind 1969 Wind, Edgar. *Giorgione's "Tempesta" with Comments on Giorgione's Poetic Allegories.* Oxford, 1969.

Wischnitzer-Bernstein 1945 Wischnitzer-Bernstein, Rachel. "*The Three Philosophers* by Giorgione." *Gazette des Beaux-Arts* 87 (1945): 193–211.

Wohl 1999 Wohl, Hellmut. "The Subject of Giovanni Bellini's *St. Francis* in the Frick Collection." In *Mosaics of Friendship: Studies in Art and History for Eve Borsook*, edited by Ornella Francisci Osti, 187–98. Florence, 1999.

Zampetti 1968 Zampetti, Pietro. *L'opera completa di Giorgione.* Milan, 1968.

Zampetti 1977 Zampetti, Pietro. "Giorgione e Tiziano: considerazioni." In *Tiziano nel quarto centenario della sua morte: 1576–1976*, 29–34. Venice, 1977.

Zeleny 2007 Zeleny, Karin. "Drei Philosophen und drei Humanisten." *Wiener Humanistische Blätter* 49 (2007): 40–69.

Zeleny 2008 Zeleny, Karin. "Giorgiones drei Philosophen: eine philologische Identifizierung." In *Giorgione Entmythisiert*, edited by Sylvia Ferino-Pagden, 191–98. Turnhout, 2008.

Index

Page numbers in *italics* refer to the illustrations.

A

Abraham (patriarch) 31, 32
Agnew's (art dealer) 60
Al-Battani, Abu Abdallah 31, 37
Albania 39
Albano, Taddeo 41, 64
Algarotti, Francesco 62
Anderson, Jaynie 31, 35–36, 64
Appian 40
Archimedes 31
Aristotle 31
Averroes 31

B

Battilotti, Donata 44–46
Beatrice d'Este, Duchess of Milan 67
Becharo, Vittorio 41–42, 64
Bellini, Gentile 22
Bellini, Giovanni 20, 33, 44
 biography 22
 lost paintings of 31
 Christ Carrying the Cross 21, 51, 63, 64, 67
 Coronation of the Virgin (Pesaro altarpiece) 22, 24
 St. Francis in the Desert frontispiece, *19*, 62, 67, *74*, *75*
 description 22–26, 59
 details *back cover, 12*
 documentation by Michiel 14–15, 27, 41, 51–52
 original location 26, 59
 provenance 60–61
 purchased by Henry Clay Frick 60
 similarities with Giorgione's *Three Philosophers* 27–28
 theory of pendant painting to 36–37
 St. Jerome in the Desert 57–60, *58*
 Stigmatization of St. Francis (ca. 1445) 23–24, *24*
 Stigmatization of St. Francis (ca. 1472–75) 24, *25*
 Woman with a Mirror 21, 51, 52, 62, 67
Bellini, Jacopo 22, 23
Bellini family, workshop 27
Belluno 40
Bembo, Pietro 40
Bergamo 14, 21
Berkshire 60
Bethlehem 32, 37
Boschini, Marco 57, 61

Brescia 21
Brissac family 64
British Museum, London 23
Brussels 61
Budapest 67

C

Campagna, Girolamo 59
Campagnola, Giulio, *The Astrologer* 32
Carpaccio, Vittore 33
Castelfranco Veneto 27
Cavalcaselle, Giovanni Battista 32, 35
Chastel, André 27
Chigi, Agostino 40
Christianity 31
Christiansen, Keith 22
Clare, St. 57–59
Clark, Kenneth 23
Colnaghi (art dealer) 60
Constantinople 32, 39
Contarini, Agustina 60
Contarini, Andrea (Giovanni Andrea, Zuanandrea) 40, 50
Contarini, Andrea (son of Dario) 50, 53
Contarini, Andriana 50
Contarini, Cecilia 60
Contarini, Dario 40, 45, 46
 commissions tomb 55
 will 50–55
Contarini, Elena (Nena) 50, 53, 54
Contarini, Federico 50
Contarini, Girolamo (son of collector Taddeo) 40
Contarini, Girolamo (son of Dario) 50
Contarini, Lucrezia 50
Contarini, Marcantonio 50
Contarini, Maria 60
Contarini, Maria Colombina 50
Contarini, Nicolò di Andrea 38
Contarini, Nicolò (son of collector Taddeo) 50
Contarini, Nicolò (son of Dario) 50, 51, 53, 55
Contarini, Nicolò (son of Dario's son Girolamo) 60
Contarini, Pierfrancesco, Patriarch of Venice (son of collector Taddeo) 40, 45, 50, 54
Contarini, Pietro Francesco (son of Dario's son Taddeo) 60
Contarini, Taddeo di Alvise 38

Contarini, Taddeo di Andrea 38
Contarini, Taddeo di Nicolò del Naso (collector, ca.
 1466–1540) 14, 21, 27, 28, 33, 37, 38–42
 collection 14, 16, 17, 36, 60–67
 commissions altarpiece 57–60
 house of 43–47
 inventory of collection 50–55, 62
 tomb 55–60
Contarini, Taddeo di Sigismondo 38
Contarini, Taddeo (son of Dario) 50, 55
Contarini family 38–40, 43, 45
 coat of arms 50, 51, 53, 54
 Santi Apostoli branch 38
Conway, Martin 28
Copernicus 31, 37
Corfu 39
Corner, Alba 62
Corner, Elisabetta 50, 51, 55
Corner family 50, 51, 61, 62
Correr family 43
 library 70n.95
Crema 14
Cremona 14
Crowe, Joseph Archer 32, 35

D
Dal Verme, Count Zileri 64
Dalla Nave, Bartolomeo 61, 62
Dalmatia 40
David, King 32
De Marchi, Andrea 26
De Predis, Ambrogio
 Bianca Maria Sforza 66, 67
 portrait of Beatrice d'Este 67
Didyma, Oracle of Apollo 32
Dresden 62

E
Eze, Anne-Marie 60

F
Ferriguro, Arnaldo 38
Fielding, Basil 62
Fletcher, Jennifer 26, 38
Foscarini family 14
France 64
Francis of Assisi, St. 22–25, 28, 37, 57–59
 Canticle of the Creatures 25
 stigmatization of 23–25

Frederick Augustus II, Elector of Saxony (later King
 of Poland) 62
Frick, Henry Clay 60
Frick Collection, New York 14, 60
Frizzoni, Gustavo see Morelli, Jacopo, and Frizzoni,
 Gustavo

G
Galen 40
Gardner, Isabella Stewart 64
Gennadios Scholarios, Patriarch 32
Germans 39
Giorgio da Castelfranco, known as Giorgione
 ambiguity in work of 33
 biography 27
 lost paintings of 27, 62–64, 67
 Vasari on 27
 The Adoration of the Shepherds (Allendale Nativity) 41–42, 42
 Birth of Paris (Finding of the Infant Paris) 21, 27, 36, 51–52,
 60, 62, 67
 copy by Teniers 61, 62, 64, 67
 Castelfranco Madonna 27
 Dead Christ 44
 Hell with Aeneas and Anchises 20, 21, 27, 54, 60, 62–64
 Judith 27
 Laura 27
 Sleeping Venus 27, 69n.77
 The Tempest 29, 44
 The Three Philosophers frontispiece, 18, 76, 77
 authorship 35–36
 in Contarini collection 44, 45, 54, 60, 67
 description 27–28
 details front cover, 6–7
 documentation by Michiel 14–15, 27
 interpretations of 28–33
 provenance 61
 similarities with Bellini's St. Francis in the Desert 27–28
 technical analysis 33–36
 theory of pendant painting to 36–37
 X-ray 33, 35
 Vecchia 27
Giustinian, Alba 61
Giustinian, Elisabetta (née Contarini) 60
Giustinian, Giulio 60
Giustinian family 61, 62
Grimani family 14, 31
Gritti, Andrea, Doge of Venice 39

H

Hamilton, James Hamilton, 3rd Marquess of 62
Hiram, King of Tyre 33
Hiram of Tyre the Master Craftsman 33
Hope, Charles 28–31, 36

I

Isabella d'Este, Marchioness of Mantua 41, 64
Isabella Stewart Gardner Museum, Boston 64
Islam 28, 31
Istria 39

J

Jerome, St. 33, 55, 57–59
Jerusalem 39
 Temple 33
Jesus Christ 32
Judaism 31

K

Klauner, Friederike von 36
Knoedler (art dealer) 60
Kunsthistorisches Museum, Vienna 14, 41, 61, 62

L

La Châtre family 64
La Verna, Casentino 2
Lauber, Rosella 41, 60
Legnano 38
Leo, Brother 24, 25
Leonardo da Vinci 27
Leopold Wilhelm, Archduke of Austria 61, 62
Lippmann, Friedrich 67
London 60
Longhi, Roberto 26–27
Louvre, Musée du, Paris 23
Luke, St. 32

M

Magi (Three Kings) 32, 33, 37
Malipiero, Dolfinella 38
Mantegna, Andrea 22
Marcello family 14
Marcus Aurelius, Emperor 32
Maximilian I, Holy Roman Emperor 20
Mehmet II, Sultan 32
Meiss, Millard 25
Michiel, Giovanni (Zuan) 14, 15, 22, 26, 37, 59

Michiel, Marcantonio
 and inventory of Contarini house 50–55
 Notizia d'opere di disegno 14–22, *16*, *17*, 23, 27, 28, 35,
 42–44, 62–64, *64*, 67
Michiel, Zuan Jacomo 26
Milan 14, 21, 60
 Pinacoteca Ambrosiana 67
Molin, Marco da 40
Morelli, Jacopo, and Frizzoni, Gustavo 38, 64, 67
Moses 31

N

Navagero, Andrea 40
New York 67
Nichols, Tom 41
Nova, Alessandro 64

O

Odoni, Andrea 14

P

Padua 14, 38
Palluchini, Rodolfo 40
Palma il Vecchio, Jacopo 20, 21, 54, 55, 67
 Three Women (The Three Sisters) 20, 21, *21*, 51, 52, 62
Paris 60
Pasqualino, Antonio 14
Pavia 14
Perissa Torrini, Annalisa 40
Pesaro, Franciscan church 22
Pherecydes of Syros 32
Philo Judaeus 40
Plato, *Republic* 31
Pliny 31
Pomponius Mella 31
Porta Salviati, Giuseppe 31
Pregadi 40
Ptolemy 31, 37, 40
Pythagoras 31, 32

R

Ragusa (Dubrovnik) 39
Ram, Giovanni 14
Rearick, Roger 57–59
Richter, George Martin 64
Ridolfi, Claudio 31
Romanino, Girolamo, *Men on Horseback* 20, 21, 54,
 64–67, *65*

Rome
 Caelian Hill 32
 Capitol 32

S
Sansovino, Francesco 57
Sanudo, Marin, *Diarii* 26, 38, 39, 40, 41
Sebastiano del Piombo (Sebastiano Veneziano) 14, 15,
 35–36, 40
Settis, Salvatore 28, 33, 38, 40, 43, 45
Sforza, Bianca Maria 20, 21, 55, 66, 67
Sforza, Galeazzo Maria 20
Sforza, Duke Ludovico ("il Moro") 20
Solomon, King 33
Strabo 31
"Syo" (Chios?) 39

T
Teniers, David, the Younger 33
 copy of Giorgione's *Finding of the Infant Paris* 61, 62, 64,
 67
 copy of Giorgione's *Three Philosophers* (detail from
 Archduke Leopold Wilhelm in His Gallery at Brussels) 34
 copy of Giorgione's *Three Philosophers* (from *Theatrum
 Pictorium*) 34
Thales of Miletus 32
Tintoretto, Jacopo 31
Titian (Tiziano Vecelli) 28, 44
Toledo Museum of Art, Ohio 64
Tolfa 40
Trojan War 64
Turkey, army 39

U
Uffizi Gallery, Florence 57

V
Valona (Vlorë) 39
Vasari, Giorgio 33
 Lives 27
Vendramin, Gabriele 39, 43–44, 45, 60, 70n.95
Vendramin, Maria (Marietta) di Leonardo 39, 44, 60
Vendramin family 14, 43, 44–45, 47, 70n.95
 coat of arms 51
Veneziano, Jacometto 26
Venice 21, 22, 27, 31
 Arsenal 40
 Biblioteca Nazionale Marciana 14, 40

butcher shops 39
Ca' Contarini Correr (Strada Nuova) 44–46
Ca' Corner (Ca' Granda) 61
Ca' Diedo 47
Ca' Giustinian 61
Ca' Vendramin 44–47, *44*, *46*, 51, 70n.95
Ca' Vendramin Costa (Ca' Contarini) 46, 47, *48*, *49*,
 50, 61
canal de San Marcilian (later Rio del Trapolin)
 46–47, 53, 54, 55
canal of Santa Fosca (later Rio de Santa Fosca) 43,
 46–47, 51, 52
Council of Ten 26, 38, 39
Council of Zonta (Senate) 39
Fondaco dei Tedeschi 27, 39
Fondamenta de Ca' Vendramin *46*
Giudecca 45
Library of St. Mark's 31, 40
Maggior Consiglio 38
San Francesco del Deserto 26
San Marco 38
San Stae 60, 61
Santa Fosca
 church 46
 Palazzo Contarini 43–47, *43*, *44*
Santa Maria dei Miracoli 55–60, *56*, *57*, *60*
Santa Marina 26
Santi Giovanni e Paolo 26
Santo Stefano 38
Scuola Grande di San Marco 26
Venier family 14
Veronese, Paolo 31
 Philosopher 30
Vescovo, Piermario 41
Vicenza, Palazzo Loschi 64
Virgil, *Aeneid* 36, 64

W
Waterhouse, Ellis 37
Wickhoff, Franz 36
Wilde, Johannes 33, 35
Williams, Jay 31

Z
Zampetti, Pietro 35
Zeleny, Karin 31–32
Zoroaster 31

Image Credits

Photographs have been provided by the owners or custodians of the works.
The following list applies to those photographs for which a separate credit is due.

Front cover; frontispiece (bottom); cat. 2; pages 6, 7, 13; figs. 3, 11, 13, 20:
© KHM-Museumsverband

Back cover; frontispiece (top); cat. 1; fig. 4: Photo Michael Bodycomb

Figs. 1, 2, 9: Su concessione del Ministero della Cultura / Biblioteca Nazionale Marciana

Fig. 3: Bayerisches Nationalmuseum / photo Karl-Michael Vetters

Fig. 5: bpk Bildagentur / Staatliche Kunstsammlungen Dresden / Elke Estel / Hans-Peter Klut /
Art Resource, NY

Fig. 6: © RMN-Grand Palais / photo Gérard Blot / Art Resource, NY

Fig. 7: Courtesy the City of Pesaro / Museum Service

Fig. 8: Su concessione del Ministero della Cultura / Archivio fotografico G.A.VE

Fig. 10: © The Trustees of the British Museum

Figs. 15, 17, 18: Photos Xavier F. Salomon

Figs. 16, 19: Drawn by Adrian Kitzinger

Figs. 21, 22: Save Venice Archives

Fig. 23: Su concessione del Ministero della Cultura

Fig. 24: Sotheby's London

Fig. 25: Photo Richard P. Goodbody Inc.